PROFESSIONAL WOMEN PAINTERS
IN NINETEENTH-CENTURY SCOTLAND

Professional Women Painters in Nineteenth-Century Scotland

Commitment, Friendship, Pleasure

Janice Helland

ASHGATE

Published by
Ashgate Publishing Limited
Gower House
Croft Road
Aldershot
Hants GU11 3HR
England

Ashgate Publishing Company
Old Post Road
Brookfield
Vermont 05036–9704
USA

British Library Cataloguing-in-Publication data

Helland, Janice
 Professional women painters in nineteenth-century Scotland:
 commitment, friendship, pleasure
 1. Women painters – Scotland 2. Painting, Scottish
 3. Painting, Modern – 19th century – Scotland 4. Women –
 Scotland – Social conditions
 I. Title
 759.2'911

 ISBN 0 7546 0068 8

Library of Congress Cataloging-in-Publication data

Helland, Janice
 Professional women painters in nineteenth-century Scotland : commitment, friendship, pleasure / Janice Helland.
 p. cm.
 Includes bibliographical references.
 ISBN 0–7546–0068–8
 1. Painting, Scottish. 2. Painting, Modern—19th century—Scotland. 3. Women painters—Scotland. I. Title.

ND478.H45 2000
759.2'911'082—dc21

00–036347

Printed on acid-free paper
Phototypeset in Palatino by Intype London Ltd
Printed in Great Britain at the University Press, Cambridge

Contents

FOR

MY GRANDMOTHER, ROENA CARY CLARK (1892–1958)
AND
HER MOTHER, CASSIE SCOTT COURSER (1867–1932)

List of figures

Acknowledgements

This book has been written with the support of a number of people and organizations in Britain and in Canada. I particularly wish to thank Joan Acland, Alan Crawford, Deborah Cherry, Tristram Clarke, Elizabeth Ewan, Loren Lerner, Clare McGread, Andrew Noble, Lorna Noble, Lynne Pearce, George Rawson, Alison Rosie, Bill Smith and Joanna Soden. Elizabeth Cumming and Jane Lindsey shared with me their extensive knowledge of Scottish art and provided me with information that made it possible for me to locate some of the difficult-to-find pictures made by the women artists in this study. Waverley Cameron and Vivien Cameron shared information and encouraged my research on Mary Cameron over a number of years; Alan Cameron, R. Alan Cameron and Beverley Morrison also helped me 'discover' Mary Cameron. Ailsa Tanner is a wonderful friend and is always willing to share her extensive information about Scottish women artists. Graduate student research assistants have helped collect material for this project and I should particularly like to thank Janice Anderson, Elaine Cheasley, Cynthia Hammond, Heather Haskins and Caroline Stevens. In addition, Cynthia Hammond, with enthusiasm, precision and creativity, made the maps that accompany the text. The staffs at the Edinburgh City Art Centre, Glasgow Museums, McManus Galleries in Dundee, National Library of Scotland, National Museums of Scotland, Perth Museum and Art Gallery and the Scottish Record Office deserve much more than mere mention in an acknowledgement. In addition, sources available to me at several libraries and archives helped me to gather the material I needed to write this book. I am indebted to the helpful staff at the Archive of Art and Design (London), Boston Public Library, British Library and Newspaper Library, Christie's (Glasgow), Edinburgh Public Library, Glasgow Room (Mitchell Library, Glasgow), Glasgow School of Art Library and Archives, National Art

Library (London), the Royal Scottish Academy Library, and Sotheby's (London).

Catherine MacKenzie read the entire manuscript at least twice, always offering challenging and thoughtful comments and criticisms; for that I am ever grateful. Pamela Edwardes made suggestions on the final text that were insightful and beneficial. All the research and the writing of this book was done while I was a faculty member at Concordia University, Montréal; the Faculty of Fine Arts provided a wonderfully supportive environment in which to work.

The Social Sciences and Humanities Research Council of Canada and the Fonds pour la Formation de Chercheurs et l'Aide à la Recherche (FCAR) provided funding – the research for this project could not have been completed without this assistance. In addition, I received a Concordia Assistance to Scholarly Activities grant from the Faculty of Fine Arts, Concordia University, which helped with the research of the first chapter. And, as always, many thanks to Christopher, Sandra and Tara.

Abbreviations

ARSA	Associate Member of the Royal Scottish Academy
GSA	Glasgow School of Art
RSA	Royal Scottish Academy
RSW	Royal Society of Painters in Water Colours
SSA	Society of Scottish Artists
SSW	Scottish Society of Water Colour Painters

Introduction

'Women are at last learning the lesson that "Unity is Strength" ' wrote C. Gasquoine Hartley in her review of the first exhibition of the Paris Club which had opened in London's Grafton Galleries in 1900. Organized in the spring of 1898, the Club intended to provide 'for the mutual help of all women artists who had been trained in Paris' and, accordingly, required two qualifications for membership: the artist must have studied in Paris and she must do 'strong work'.[1] Edinburgh artists Christina Paterson Ross (1843–1906), Florence Haig (1855–1952) and Mary Rose Hill Burton (1857–1900) exhibited pictures in the first exhibition; the slightly younger Scottish artist Mary Cameron (1865–1921) joined them within four years. Uniting with other women artists to exhibit and sell work was a concept familiar to the Edinburgh women – they had organized to form the Edinburgh Ladies' Art Club in 1889. Exhibiting work in Britain's art centre was also familiar – these women offered their pictures for sale in exhibition venues in London as well as in Edinburgh, Glasgow, Aberdeen, Manchester, Liverpool, Stirling and Kirkcaldy, to name but a few. Mary Rose Hill Burton, for example, in addition to participating in large exhibitions with organizations such as the Royal Scottish Academy and the Glasgow Institute of the Fine Arts had at least three solo exhibitions in London during the 1890s. Mary Cameron had solo exhibitions in London, Paris and Madrid as well as in her home city of Edinburgh.

These women and others like them worked and travelled. Some, like Christina Paterson Ross, based themselves in their home city travelling within Scotland and occasionally to the Continent. Others, like Mary Cameron and her Edinburgh friend Emily Murray Paterson, chafed at the city's conservative environment and spent large blocks of time away from Scotland. Cameron spent part of each year in Paris and lived for months at a time in Spain and London; Paterson lived between Edinburgh and London

and, at one point in her career, spent three years in Switzerland. Paterson's many and colourful pictures of Venice signal her attachment to a city distantly removed from her northern home, while her much later pictures (1919) of war-torn Belgium attest to her willingness to confront difficulties and challenges.[2] Mary Rose Hill Burton's travels took her to Japan but she remained firmly attached to Scotland's (or more specifically to Patrick Geddes's) Celtic revival. The mural she painted for the Geddeses' Ramsay Garden flat portrays the enigmatic mystery of a Walter Scott novel or an Ossian poem with its gloomy, dark castle barely visible through a Highland mist, the greyness relieved only by blooming yellow and purple flowers in the foreground.

While the women artists whose stories appear on the following pages often worked outside an established art centre, in this case London, they negotiated constantly with that centre in their attempts to sell their art. Selecting Scottish women for this discussion provides a case study informed by location, class and gender. Although most of the women studied art in Edinburgh or Glasgow, they moved in and out of those cities seeking subject matter for the pictures they needed to sell from exhibition venues, the most important of which in Scotland were the Royal Scottish Academy (Edinburgh) and the Glasgow Institute of the Fine Arts. In addition, I have selected artists whose careers are well documented in exhibition reviews and catalogues, who exhibited widely, but whose pictures remain virtually impossible to locate. My contention is that art history recycles information about established artists whose pictures exist in public collections; however, the conditions of production and consumption surrounding the art-making of (particularly) women has been ignored when pictures cannot be found, thereby perpetuating the discourse of art history within and around a commercial market-place. Social historians can discuss the work of female farmworkers, for example, without viewing their gleanings; female art-workers may have to be discussed without viewing their pictures.

Concomitantly, writers of history far too often have accepted an ideology of the female-occupied separate or domestic sphere as a confining, restrictive space; even though monographs and narratives of independent, adventurous women abound, the myth of domestic place and private space haunts historical women just as it does contemporary women, by 'exoticizing' those who 'make it' into the record and ignoring so many others. That the women in this study worked is clear from the number of pictures they exhibited and sold. However, the British census, which is not a reliable indicator of women's work, reveals that women artists were neither employees nor employers but 'independent workers'. Edinburgh artist Christina Paterson Ross, for example, listed herself as an 'artist' who was neither an employer nor employee but an independent worker. Because changing census classifi-

cations in the nineteenth century reflected and constructed a definition of work which increasingly was defined as an activity 'carried on outside the home, for a wage',[3] this categorization has relegated artists' labour to a liminal region which exists neither in the realm of waged labour nor in a capitalistic market economy. Thus, while some women artists entered census statistics as 'independent workers', the irregularity and non-permanence of their occupation ensured that they did not fare well in comparisons with the 'norm' which rapidly became the 'permanently employed' and 'waged' worker.

Looking at women who displayed artistic goods for sale in public venues highlights the working experience of the middle-class female, a category that remains elusive and defies definition. Catherine Hall insists upon the gendered development of the middle class between 1780 and 1850 which incorporated the ideals of masculinity and femininity into 'the construction of a specifically middle-class culture'. According to Hall it is this gendering of class that separated the middle class 'from the aristocracy and gentry above them and the working class below them', and characteristic of the designation was a tendency to consider man as having dependants and woman as being dependent.[4] However, by the last half of the nineteenth century numbers of women, including women artists, were working. Deconstructing the ideology of the so-called 'separate spheres' has been addressed and continues to be addressed by feminist historians and geographers.[5] For example, Esther Breitenbach and Eleanor Gordon suggested that 'the view of women as confined to the domestic sphere was not only inappropriate to the reality of working-class women's lives, but as the nineteenth century progressed it became less and less appropriate to the reality of middle-class women's lives'.[6] Rather than highlighting the 'conflict of interest between middle- and working-class women',[7] I shall attempt to elaborate upon middle-class women who sought to establish themselves as professional artists and often did this whether they required income or not. That is, rather than direct their energies toward philanthropic or 'rescue' work, they organized a career for themselves (sometimes this paralleled volunteer work), or, if the artist did require income, rather than work as, for example, a governess, she sought to work independently by locating markets for her product.

My intention is to explore a social history which accepts and emphasizes historical women producers of pictures and applied arts as middle-class workers. While, in the twentieth century artists are rarely referenced as workers, such was not the case in the late nineteenth century. The *Glasgow Herald*, for example, when it reviewed the 1888 annual exhibition of the Glasgow Society of Lady Artists, recognized the women as 'an earnest and painstaking band of workers in the field of art'.[8] The following year the

Scotsman applauded the Royal Scottish Academy exhibition as 'a genuine harvest of Scottish art' that represented 'workers in the West of Scotland' as well as Edinburgh artists.[9] Thus, in the following pages, I shall seek to understand how specific women worked, where they worked, where they exhibited and how their work was received by their viewing public. A concern I wish to weave through my discussion is one which brings the late-nineteenth-century artist together with the late-twentieth-century feminist historian. My contention is that until feminist historians and art historians write about the nineteenth-century artist as a working woman, that is until her place within an economy of production and consumption is insisted upon, women will continue to inhabit an insecure space within society. Our place is still underwritten by the historical ideology of the separate spheres which functioned to stabilize patriarchal capitalism; as long as the historical ideology remains intact, struggles for day care, equal pay for equal work, and equity in hiring will flounder. A displacement of the dichotomy of public and private requires more than a writing of unpaid labour – it requires also a recognition of self-employment and/or partial employment as it is found in cultural work.

In the winter of 1894, Christina Paterson Ross, an artist who supported herself by making art, exhibited two pictures with the Stirling Fine Art Association: *A Spanish Town Gate* (1894) and *A Corner in Crail, Fife* (1894).[10] A juxtaposition of the titles of the two pictures combined with the artist's inclusion in an exhibition venue located in the heart of Scotland where Highland and Lowland meet, could act as a metaphor for the following pages. Stirling is almost halfway between Scotland's two largest cities and, in addition to Ross's paintings, the gallery exhibited for sale pictures made by a number of Ross's Edinburgh colleagues including Mary Cameron, Margaret Dempster and Emily Murray Paterson as well as many Glaswegian artists such as Agnes Raeburn, Janet Aitken and Jane Cowan Wyper. The titles of Ross's pictures, one representing a foreign country she visited on at least one occasion and the other depicting a Scottish village north-east of Edinburgh, denote the kind of travelling women artists engaged in as they plied their trade. That all the pictures were for sale demonstrates intent on the part of the artists to earn money, perhaps even make a living, from their labour. Finally, Ross was typical of many late-nineteenth-century Scottish women artists: she was well-trained, began exhibiting when she was in her early twenties and exhibited widely, belonged to professional organizations which served her interests as an artist, and travelled either to further her education or to sketch and paint saleable pictures.

The story of Ross's activities weaves in or around the series of linked essays that follow. In one way or another she enters each narrative about women artists working in Scotland during the late nineteenth and early

twentieth centuries; for example, she plays a large role in the second essay about professional organizations and exhibition venues as well as in the later essay which focuses upon women as landscape painters, while she has only a tiny part in the essay about four Glaswegian women who were part of a group called the 'Immortals'.[11] Thus, while the story is not linear and each chapter is discrete, there are actors, of whom Ross is only one, who reappear in different guises throughout the text. The major players, however, share two characteristics: they all belonged to and supported women artists' societies, and they all exhibited regularly in a number of different venues. Ross was the first president of the Edinburgh Ladies' Art Club while Kate Macaulay, Ross's colleague in the Scottish Society of Painters in Water Colours,[12] belonged to London's Society of Female Artists. Both women exhibited pictures in venues throughout Britain. The stories represent the life and work of selected women rather than a comprehensive narrative, but all the artists provide what might be called display as insight. By exhibiting regularly and supporting professional organizations they were visible to their contemporaries and they can become visible to the late-twentieth-century reader when their working patterns and subject matter are reconstructed: the artists' intent to display their work provides the historian with insight into their practices and their lives.

The women regularly exhibited and belonged to artists' organizations. Thus Ross, for example, belonged to the Edinburgh Ladies' Art Club but was a member of and exhibited frequently with, the Glasgow-based Scottish Society of Painters in Water Colours (RSW); Kate Macaulay, born in Malta of Scottish descent, lived in north Wales but painted and exhibited extensively in Scotland and England; Georgina Greenlees taught at the Glasgow School of Art, belonged to the Glasgow Society of Lady Artists and was active from its inception in the RSW. Mary Cameron belonged to the Edinburgh Ladies' Art Club as well as to the Society of 25 English Painters.[13]

The women's education differed depending on where they lived. For example, Edinburgh's Board of Manufactures' School remained inextricably linked to the conservative and traditional Royal Scottish Academy. The Glasgow School of Art although it was, like Edinburgh, under the umbrella of the so-called South Kensington system, escaped the ever-watchful, conventional eye of the Academy. When women artists formed their own professional organizations, Glasgow's was related in almost every way to the Glasgow School of Art and fostered its ties with the School; Edinburgh women reacted against the Academy and founded their organization in opposition to, rather than in co-operation with, an established institution. The Scottish Water Colour Society, established in 1878, included women from both cities and from outlying areas but was more or less Glasgow-based; similarly, the Edinburgh-based Society of Scottish Artists, established in 1891,

also included women from both the major Scottish cities as well as artists from other areas. Efficient and cheap railway transportation had connected Britain's major centres since the 1850s making possible the movement of artists and their pictures from one place to another – by the 1870s pictures would be exhibited in a Glasgow venue in the spring, for example, and if not sold, could be exhibited again in Liverpool in the autumn. This kind of mobility combined with the increased number of artists' societies opened opportunities for sales and increased income more than ever before. It is hardly coincidental that education for women artists opened up at about the same time the railways introduced easier movement between cities and across the countryside.

For many women, the classroom presented the opportunity to interact with others who shared similar ideas and interests. This contact, which might represent the first time young women encountered other females who shared their goals and aspirations, continued as women who studied together frequently obtained adjoining studios or shared studios. Such associations and the attendant camaraderie intensified as women combined their experience in educational institutions with the exhibiting venue. Thus, formal education provided another link between the so-called private, domestic world and the public forum. In addition, the friendships consequently established represented support for mutual endeavours as well as companionship.[14] Friendship ranges across a broad spectrum from intimate relationships to relationships which offer 'utility value', that is, relationships in which one person is willing to use time or resources to help another meet her goals.[15] While friendship is a voluntary association, attachments are often formed when plans and activities are shared;[16] women attending classes together formed varying degrees of attachment which continued when they began careers as artists.

Other ways existed for young women artists to establish friendships and build support groups – certainly, the institution did not guarantee emotive or useful friendships any more than did family connections but, while friendship is usually defined as a characteristic of the private and domestic, friendships that grew within the institutional environment often led to an overlap of the private with the public. For example, public friendships or those more related to career than to family could provide the impetus for studio-sharing or travelling together in order to collect subject matter for pictures. In this way, the domestic (or private) and the institutional (or public) became more inter-related than separate amongst artists. Another example that follows on from this can be found amongst female and male artists who kept studios in their own homes, thereby conflating the professional world with the domestic world. Edinburgh artist Mary Rose Hill Burton, for example, worked out of a home shared with her mother, her

stepsister and a family friend, Jane 'Jeanne' Currie. While Hill Burton kept her studio in her mother's seven-room home, her friend, London-born Florence Haig, rented studio-space in Edinburgh's Shandwick Place then, after the turn of the century, in Chelsea: whether the artist worked inside or outside her home, the studio could never be designated 'private' for out of this space came the product that the artist sold in a public market-place (the exhibition venue).

By discussing the studios and exhibition venues used by a number of Glasgow and Edinburgh women artists during the late nineteenth century, I hope to construct a physical as well as a theoretical space for these women as workers. While it was significant that women were kept out of the inner circle of the most prestigious of the artists' groups (the Royal Scottish Academy), and while it was also certain that this affected the way in which society perceived them (as not serious) as well as the way in which career opportunities presented themselves, some women did have a regular venue for their work as early as 1878. The Scottish Society of Water Colour Painters, from its inception in 1878, accepted women as associate members in addition to providing them with exhibiting space. This is not to deny its exclusionary characteristics for it, too, had a select membership, limited the number of artists who could join, and usually restricted its venues to members only but, unlike the Royal Scottish Academy, women were not excluded simply for being women. Moreover, it would be venues such as the Scottish Society of Water Colour Painters that would provide a meeting place for women artists: those who had attended institutionalized art classes could meet with those who had trained privately. Professionalism and the enjoyment of their careers would bring them together.

Lynne Walker has aptly demonstrated that London women moved about in the city frequenting offices, shops, women's clubs and various entertainments and, by the 1890s, did so without chaperones.[17] Their place in the built environment which, according to Walker, was 'the buildings and the spaces between them' expanded during the last half of the nineteenth century even though an ideology of domesticity always threatened to contain or constrain these independent women. Women artists, whether in London, Edinburgh, or Glasgow moved in the urban environment of commerce and social activity, particularly when they travelled from their homes to their studios (often on foot), bought their supplies and visited galleries and museums. Often the artists either shared studios or rented studios near to other artists: Florence Haig and Margaret Dempster, for example, rented studios near to other artists in Edinburgh's Shandwick Place. Shandwick Place attracted a number of women artists beginning soon after the building of the Albert Gallery in 1876–7. Built as a gallery to sell the work of contemporary artists, it was a large building that included studio spaces and was

located conveniently near to the Caledonian Railway Station.[18] Perhaps because of the gallery, other buildings in Shandwick Place, particularly near its intersection with Queensferry Street, soon included artists' studios. These were interspersed amongst studios rented by musicians, language teachers, dance instructors and the Edinburgh Association for the University Education of Women.

This story is also concerned to relate work and pleasure. The pleasure of work obtained by the makers of art whether it be landscape painting or embroidery follows from their material conditions of production and my discussion of this owes much to William Morris's attempts to integrate socialism with art. Morris declared that people should have work to do which is worth doing, that is pleasant in itself and which should be done 'under such conditions as would make it neither over-wearisome or over-anxious'. Art, according to Morris, is made by people for people 'as a happiness to the maker and the user'.[19] While Morris's ideas might be criticized as utopian, universal and therefore suspect in this age of poststructuralist relativism, he attempted to theorize the position of worker and product so that both producer and consumer experienced benefits from a cycle of buying and selling. In addition, although pleasure as a reading or viewing position has been theorized (often psychoanalytically), production is rarely looked at as work which gives pleasure. This is not to posit a romanticization of the role of the creative artist in society as a free worker or to suggest that the artist characterizes the non-alienated worker; rather I suggest that certain nineteenth-century women artists lived ordinary lives as cultural workers supporting themselves in a capitalist economy by following a career that gave them pleasure as well as income.

Mary Cameron, for example, in an interview she gave to the *Westminster Gazette*, insisted that she always 'wished to paint' and made clear to readers that painting meant hard work and pleasure: ' "It means hard manual labour" [Cameron] answered, holding out a pair of hands, small, strong, muscular and sun-tanned. "It means pulling up your sleeves," she continued, and her brown eyes twinkled as she drew her slim figure up to full height, "and setting to work!" '[20]

This book is composed of two parts: the first part includes three essays concerned with education, exhibiting practices and organizations as they pertained to women artists; the second part includes three essays concerned with specific women, their experiences, and their representations. Education provides the starting point for this series of discreet but interlocked essays. Chapter 1, 'Sexual Economics and the Gendered Spaces of Art Education', highlights the historical moment when female artists entered the Board of Manufactures' School in Edinburgh for the first time and, in the process, examines the similarities and differences between the Edinburgh school and

the Glasgow School of Art. A detailed discussion of the two schools helps deconstruct the myth-like story associated with Laura Herford and her entrance into the Royal Academy Schools in London by examining the multi-layered nature of educational changes. The essay seeks to describe and analyse art education for women in general by emphasizing social history. Class and mobility enter into the discussion forming, in the process, the most overriding characteristic for success – a necessary component seems to have been membership in the broad-ranging and ill-defined category called the middle class. Sufficiently marginalized in academic studies – almost all secondary material regarding women's art education focuses on the canonical centres of London and Paris – the microcosm of Scotland shrinks further into the cities of Edinburgh and Glasgow. At first glance limiting, this encourages one to see the mobility of women within and between cities while, at the same time, providing the opportunity for a developed case-study of life, education and work for women artists who live outside the acknowledged 'centres' therefore opening up the possibilities for understanding the larger majority in the margins.

Chapter 2, 'Guild and venue', locates Christina Paterson Ross as an artist with a vested interest in maintaining associations with various art societies and clubs. While artists' groups did not label themselves 'guilds' in nineteenth-century Britain, the organizations performed the functions generally associated with guilds or trade unions. Sally Alexander, in her analysis of London trades, suggested that women's waged work was somewhat invisible in the early Victorian period largely because women had been excluded from the professions, the civil service, the scientific trades, as well as from the old guild crafts since the fifteenth century.[21] However, neither Alexander nor other labour historians have considered artists' groups as profession-specific guilds which promoted the interests and concerns of their members (artists). In Scotland, for example, the Glasgow Institute of the Fine Arts formed in 1861 to promote Scottish artists, to educate the public about art production and to provide a venue from which art could be sold.[22] The group was much better placed to further the interests of its members than the individual during a time when the 'solo' exhibition was a rarity. Women artists who wished to profit from sales and earn their living had to compete with these separate men's organizations and eventually they formed their own societies.[23] As an individual, Christina Paterson Ross joined the Scottish Society of Water Colour Painters, helped found the Edinburgh Ladies' Art Club and became one of the first members of the Society of Scottish Artists. She provides then, along with her friends and colleagues in Edinburgh, a case-study of a professional artist who used all the resources available to her to establish and maintain a career.

Chapter 3 relates a discussion of the Glasgow Society of Lady Artists to

an analysis of the first Charles Rennie Mackintosh exhibition to travel to North America in 1996. The emphasis in both chapters is upon women's friendships, and in both instances the main players, all of whom attended the Glasgow School of Art, belong to both stories. The Glasgow School of Art, with its concern for a co-operative relationship between industry and art and its interest in many of the ideals of the Arts and Crafts Movement, emphasized an integration of fine art and craft in the teaching of its students. Francis Newbery who became Principal of the School in 1885 brought with him from London an interest in William Morris's socialism as well as Morris's concern for 'art in craft' and 'craft in art'. Thus, many artists who studied at the School traversed the boundaries of fine art and craft and produced objects that fell into both categories. Agnes Raeburn, for example, exhibited watercolour pictures with the Scottish Society of Water Colour Painters, designed posters and exhibited embroidery. Jessie Newbery exhibited pictures in venues in Glasgow and Paisley, exhibited embroidery in national and international venues, designed metalwork and taught at the Glasgow School of Art. Ann Macbeth, like Newbery, taught and was most known for her embroidery, but she also did metalwork and bookbinding and, in addition, wrote extensively about teaching needlework. By the turn of the century, many of these women became political activists in support of women's rights and their art production must be viewed within the rise of the suffrage movement in Britain.

The second part concentrates upon a smaller number of artists, seeking to follow more closely their friendships, careers and experiences. It begins with chapter 4, 'Locality and pleasure in landscape' which provides a closer examination of one kind of painting, landscape, made by three women who had completed their formal or institutional training and had become professional artists: Kate Macaulay, Georgina Greenlees and Christina Paterson Ross. The story highlights the middle-class working woman, the land she represented, and the narrative woven into and through her representations of land. She functioned in several different ways: as a recorder of nostalgic identity, as an interpreter of 'her' land which, by the late nineteenth century, had been colonized by capital and tourism, as an entrepreneur who marketed her own production in exhibition venues and in private galleries, and as an intruder in a male-dominated art world. This intersection of the woman producer with her product represents an attempt on my part to enlarge the discussion of landscape painting and its ideologies to include the historical female worker/artist and to expose another side of so-called 'British' landscape – the representation of landscape within a particular Scottish experience. Integrated into this study is an exploration of the concept of pleasure as it is obtained from satisfaction in labour and delight in viewing

– that is, pleasure that was certainly obtained by both producer and consumer.

Chapter 5 moves away from a concern for larger groups to focus, instead, upon two friends, Florence Haig and Mary Rose Hill Burton, both of whom lived and worked in Edinburgh from about 1880 until near the end of the century. In addition to exploring their working relationship, their education and their careers, this chapter considers the representation of women by women, particularly the problems associated with the representation of what has been termed the 'other'. 'Other' has assumed a place within poststructural and postcolonial vocabulary as representing 'difference which stimulates desire' (the psychoanalytic definition) or as representing the colonized as described by the colonizer.[24] The term has assumed a common-usage status which indicates that the speaker, writer or artist depicts or discusses people who are not of the same class, gender, race or ethnicity. Haig, for example, made a painting of bondagers or female farm-labourers in the south-east part of Scotland; Burton made watercolour sketches of Japanese women when she visited her brother in Tokyo in the mid 1890s. While they do represent 'others' they also represent their own gender, and the conflation of this production and consumption provides an intriguing comment about difference and sameness amongst women.

Chapter 6, 'Energy to fearlessness', engages with pleasure and identity while highlighting the construction of the artist as taking place in the spaces between the artist's writing and picturing of herself, and the artist as she appears in the press. Mary Cameron, like Christina Paterson Ross, exhibited 'travelling' pictures in the Stirling Fine Art Association Exhibition of 1894 – *Scheveningen, Holland* and *On the Arno, France* – and like Ross and the other women in this story, she belonged to women artists' societies as well as to 'mixed' gender societies. Unlike any other women presented on these pages she dramatically inserted herself into a male-defined space and consequently was referred to as powerful, forceful and vigorous in the press. She constructed her own identity in interviews as a hard-working, dedicated artist who had studied intensely so she could follow a career as a painter. Cameron's engagement with the spectacle of Spanish bullfighting signals her status as a 'heroic' artist, destroys the boundaries between private and public, and raises questions about the meaning of work: how does the art historian discuss working-women artists who do not have to work? How is work defined when income is not necessary to maintain a middle-class lifestyle?

The women artists selected for this study emerge from a somewhat similar Scottish middle-class background and, as such, they cross or move through the designations available to the middle classes in general: that is, from the almost poor to the comfortably rich. As Stana Nenadic suggests in her work on the rise of the middle class in Scotland, 'classes are formed partly through

the dynamics of material accumulation, and partly through the self-conscious evolution of an intellectual identity'. They can be identified by 'common patterns of work, lifestyle, organization, thought and behaviour'.[25] The women artists in this study share these identifying features but, in addition, they share a Scottish identity which ranges from the nomadic Scottishness of Kate Macaulay to the wanting-to-escape Scottishness of Mary Cameron and, because of this, they provide a unified background which, in its turn, exposes all the falseness of this kind of unification. Nevertheless, and despite their many differences, they share a commitment to artistic training and professionalism, a dedication to the women artists' societies and a desire to succeed. It is their desire, their commitment and the pleasure they obtained from following their careers that informs the following collective stories.

Sexual economics and the gendered spaces of art education

The vicissitudes of art education for nineteenth-century women are woven through discussions of the life class and its availability or non-availability to female students. The Slade School of Art is often touted as the most 'advanced' of art institutions in Britain dedicated, as it was, to offering the best fine-art training to women and men in the late nineteenth century and offering its female students the opportunity to study from the nude model.[1] Scottish institutions, which provide the locus of study for this essay, had their own history of life-class study informed by religious and moral constraints – possibly to a greater extent than were institutions in the south. However, the life-class debate is not central to the following discussion. Suffice to say that since the publication of Linda Nochlin's influential essay of the 1970s, 'Why have there been no great women artists?',[2] histories of art education for women have necessarily centred upon a traditional description of art (painting, drawing and sculpture) as a precise three-dimensional description of the human body. Antithetical to this are the sophisticated debates of Deborah Cherry, Gen Doy, Griselda Pollock, Lisa Tickner or Lise Vogel which implicate the hierarchical structure of art history itself in the constructed nature of its own requirements.[3]

This essay seeks to describe and analyse art education for women in general (and not exclusively as it revolved around the life-class debate) by discussing education in Scotland beginning with the mid-nineteenth century and ending with the establishment of the Edinburgh College of Art in 1902.[4] Sufficiently marginalized in academic studies – almost all secondary material regarding women's art education focuses on the so-called centres, London and Paris – the microcosm of Scotland shrinks further into Edinburgh and Glasgow. An examination of the two cities encourages one to see the mobility of women while, at the same time, provides the opportunity for a developed case-study of life, education and work for women artists outside the centre,

therefore opening up the possibilities for understanding the larger majority in the margins.[5] The concerns expressed here are for a social history of art education for women as they aspired to establish careers in the art world or its related milieu. The most overriding characteristic for success was membership in the broad-ranging and ill-defined category called the middle class. Working-class or lower-middle-class women, if they were educated in art schools, often entered manufacturing rather than compete in the more financially precarious market of fine-art selling.

Art education in Edinburgh

Women's entrance into art classes in Edinburgh eschews the mythic fiction attached to Laura Herford's 1860 admission to the Royal Academy Schools in London. Herford's story probably originates in an article about the Royal Academy Schools published in 1888. This 'glimpse' into students' work and life at the Schools recounted the admission of female students as taking 'its rise in a rather curious incident': among drawings sent by candidates, one successful application 'bore only the initials of the candidate's Christian names.' Herford was admitted and it was then discovered 'nearly a hundred years after the foundation of the schools' that there was no rule against the admission of female students.[6] The narrative of Herford's breakthrough often casts her in the role of individual heroine[7] rather than accepting, as has Deborah Cherry, that her admission represented the culmination of an organized campaign to have women take their places in art classes. Cherry's pragmatic assessment suggests that women were admitted as the 'direct outcome of feminist pressure which was maintained as the [London] Academy restricted the numbers of women students and their access to curriculum'.[8] A close look at Edinburgh and Glasgow indicates that the opening up of classes to female students represents one success in the ongoing struggle for women's education in Scotland – this provides an instance of the 'local' offering suggestions and possibilities which then might enlarge a discussion of the 'general'.

Agitation for reform in art education in Edinburgh, in one instance, can be attributed to the actions of an individual although this undoubtedly was linked to more general societal movements and, unexpectedly in another instance, to institutionalized religion. Unlike England, the incursion of women into Edinburgh's art training school surprisingly had the sanction of religion, albeit the non-traditional Free Church of Scotland, and undoubtedly had the approval of a number of male advocates. The admission came very easily if one attends to the Minute Books of the Board of Trustees for Manufactures (the School of Art came under the auspices of this Board) but

the shadow of a debate that must have raged in closed chambers and within private conversations for quite some time before becoming an item on the agenda of a Board Meeting remains between the lines.[9] In addition, the reform in art education took place during a time when campaigns on women's issues, ranging from property laws to contagious diseases, flourished throughout Britain. According to Barbara Caine, the 1850s and 1860s saw 'a host of different campaigns aimed at the emancipation of women': these included expanding the range of employment open to women, improving secondary education, making higher education available to women and, finally, obtaining the vote.[10] Art schools in Edinburgh and Glasgow had to accept the challenge but changes, particularly in Edinburgh, resulted from economic concerns as much as from organized pressure – or more precisely, the organized pressure struck at the purse strings of the institution.

Individual rather than collective action can be examined almost 150 years after the event because archival material related to the operation of the art school in Edinburgh remains a highly documented part of the city's important and influential Board of Manufactures. The minutes of the Board meetings record the receipt of a letter, early in 1850, from Edinburgh-advo-cate-cum-university-professor Cosmo Innes 'requesting that his daughter might be accommodated with a private room in which to copy from the casts in the Statue Gallery'. Although ensuing discussion revolved around the request of one person, the Board obviously understood this debate to represent more wide-ranging concerns when it acknowledged 'that such applications might not be limited to one individual, and that it was highly expedient that every accommodation should be afforded to ladies desirous of studying'.[11] Innes placed his request on behalf of his twenty-two-year-old daughter Katherine but his dedication to the cause of women's education reached beyond the confines of his own home and would extend into the controversy surrounding the medical profession and prospective female practitioners. Writing years later about her father, Katherine Innes Burton proudly reiterated Innes's resolute support for the 'little band of female students in medicine in their contest with the University of Edinburgh'.[12] Katherine Innes, in a twist of circumstance, or perhaps in despair at the conservative entrenchment of fine art, abandoned her drawing of plaster-cast bodies for the more hands-on experience of working with Florence Nightingale in the Crimea.[13]

Certainly, the final motion of the Board to allow women to copy in the Statue Galleries represents an accommodating gallantry rather than serious intention: the Board 'resolved that the use of the Statue Galleries for copying, should be reserved exclusively for ladies from 10 to 12 every Monday morning'.[14] This limited access to public training, which would have sup-plemented the private lessons that middle-class women could receive from

tutors or from attendance in the studios of drawing 'masters', implied the erosion of the segregated areas that the male members of the Board and the male instructors at the School of Art had designated as their own. The Royal Scottish Academy, in place since 1826 and inextricably tied physically and psychologically to the School of Art, jealously guarded admission and approval. Like England's Royal Academy, membership in this elite group provided the necessary economic link to commissions and hence to the monetary success of the artist as well as to his social status.[15] Ironically, recognition in either Academy also guaranteed income from students, many of whom would have been female. Thus, the 'club', in its exclusions, monitored to whom success and thereby financial reward would accrue. Middle-class women having been designated 'not working' were refused acceptance – they did, after all, constitute a large and potentially threatening constituency: many of them had received art classes as part of their education and many of them, like their male colleagues, had the technical abilities to excel professionally. Competition from such a large group, wittingly or unwittingly, had to be controlled and fortunately for academics a patriarchal and capitalistic society provided them with the barricade: the much debated and highly complex ideologically organizing principle of two separate and distinctly different gendered spaces. That women like Katherine Innes moved through and around these constructed boundaries, both in their physical movements in the urban environment and in their daily lives, did not destroy the coded rigidity which could operate particularly well within the confines of 'private clubs' such as the various fine-art academies.

This is not to infer a total lack of empathy from club members. Sculptor James Gall, for instance, supported Innes's requests to the Board with a further amendment.[16] Gall 'called upon' the secretary of the Board 'and stated the advantage that would be derived to each lady attending in the Statue Galleries to study from the casts during the ladies' hours on Monday, were she able to continue her lessons there under the eye of the preceptor at whose recommendation she might have been induced to visit the gallery for study'.[17] Obviously Gall had private students and he wanted those students to benefit from further training but he was young and not yet a recognized and fully chartered member of the 'club'. He refused to put his request in writing and later wished 'to let the subject drop' not, however, until he had observed that the Commissioners, of course, would be 'most anxious' to encourage any development 'beneficial to Art'. Quite simply, encouraging women to further their art education would benefit art in general. The more powerful 'master' of the Ornamental Department in the Trustees' School, Alexander Christie, along with the highly influential Board member Alexander Maconochie (later Lord Meadowbane) adamantly opposed any inclusion of women. Within a few months of the Board's

decision, and on the occasion of an Edinburgh meeting of the British Association, Maconochie would object strongly to the Picture Galleries being used as a reception room for 'strangers and foreigners'. Apparently, his objection to difference extended beyond the descriptive category of biological sex and suggests, again, that restriction of women may be part of a broader and more intensive limitation that controls an economic market and, in the process, saves the 'best' for a limited number.

By the mid 1850s, then, art education in Edinburgh for women had expanded very little, making only a tiny incursion into the Galleries for two hours per week. Formal art classes in the capital city retained their exclusivity preparing their male students for male membership in the Academy but, given what appears on the surface to be a sudden policy shift four years later, the embers of change must have continued to glow. As mentioned earlier, agitation for the change in laws that oppressed married women, a growing concern for improved general education for women and debates around the issue of who had the right to vote permeated certain sectors of British society by the early 1850s, thereby undoubtedly adding to the criticisms directed toward the Board's restrictive policies. Although Katherine Innes chose not to attend institutional art classes, shortly before she boarded the ship that would take her to the Crimea, women did enter classes in the School of Art.

In 1854, David Octavius Hill, President of the Royal Scottish Academy[18] wrote to the Board commending the decision to admit women and complying with the subsequent request for additional space. 'It afforded the President and Council of the Academy', wrote Hill, 'much gratification to comply with this request, made for a purpose so important and desirable.'[19] Hill's recognition of the importance and desirability of educating women artists suggests the articulation of a debate that had been played out and negotiated for some time prior to the writing of this letter.[20] Only months earlier, in the spring of 1853, the Free Church of Scotland had requested that their teachers (male and female) be able to study drawing in the School of Art.[21] This request was followed about eight months later by a letter from one of the Free School teachers written on behalf of herself and seven other teachers. The letter's author, Agnes Hay, named herself one of the 'Female Teachers in the Northern District under Government Inspection' and requested admission to the School's art classes. Her letter was accompanied by letters from instructors Robert Scott Lauder and Alexander Christie (who, by this time, had modified his objections to women students) supporting the request and asking for additional space.[22] The two instructors asked for the end room next to the Library, but permission for use of that space had to be obtained from the Royal Scottish Academy, hence Hill's involvement. However, that particular area provided accommodation for twenty students and their

equipment, more than double the number of female students who were apparently seeking admission. According to Board Minutes, 'a class up to the number of twenty could be received and taught [and the] . . . fittings required for this would only consist of stools, a few additional examples and gas fittings, none of which would cost much'.[23]

In addition, the Board recognized that they must act or others would act in their place: there were rumours of a second art school being opened in Edinburgh to offer competition to the Board: 'There can be no doubt that the short and broken hours observed in the Board's School, and the absence of Female Classes, present a marked contrast to the system of continuous and long sustained study allowed and encouraged by the Department of Practical Art.'[24] Here the economics of women's education becomes blatant and the ideological arrangement of private and public space succumbs to the hint of profit to-be-obtained elsewhere if the conservative entrenchment did not open its doors to the 'domestic' sex. Board Minutes reported that at Marlborough House (London) attendance at classes lasted for eight hours and 'many of the Female students are so eager to protract the hours of study, that the Mistress has often to interfere and stop the work in order to force some relaxation'. The Board also recognized that the situation was character-istic not only in London but 'in some of the Provincial schools' (that Glasgow followed the more advanced schools in their attitude toward female students failed to receive mention) and recognized that it must change its policies – and this included charging small fees for studying – or another school would open and undercut their authority in the area of art education.[25] Clearly, Alexander Christie's changing opinion was related both to power and eco-nomics: if the School and with it the Academy was to maintain control then it must expand that control to include changes that were about to take place with or without them. The Board's secretary presented this report along with Agnes Hay's letter: the time had come for women to be admitted to art classes in Edinburgh.

The School's new session opened in October 1854 with women students in attendance. As would be expected, Agnes Hay was one of those students, but along with her appeared a number of women who were not teachers: altogether fourteen women were admitted as 'ordinary students' in the Female Class. The list included Isabella Scott Lauder (1839–1918), daughter of artist-teacher Robert Scott Lauder, who would become a founder-member of the Edinburgh Ladies' Art Club. Lauder was about fifteen years old[26] when she began following classes, however the winning of a prize for a 'shaded drawing' done during her first year of study suggests that she had been studying art prior to entering classes. By 1861, at twenty-two years of age, Lauder was exhibiting with both the Royal Scottish Academy and the Glasgow Institute of the Fine Arts on a regular basis. Her self-portrait

1 *Priscilla the Puritan Maid*, Isabella Scott Lauder, 1862

as *Priscilla the Puritan Maid* (1862) (Fig.1)[27] exhibited with the Royal Scottish Academy confirms Lauder's virtuosity and skill.

The picture depicts a scene in Henry Wadsworth Longfellow's 'The Courtship of Miles Standish' published just four years before Lauder exhibited the painting. Lauder selected to represent the moment when John Alden opened the door upon 'the loveliest maiden of Plymouth'; she was seated beside her spinning wheel with a psalm book open on her lap.[28] Lauder's picture attests to her understanding of contemporary literature and demonstrates her technical skills: she painted drapery, a human figure and an animal, as well as deep shadows and highlights caused from the light falling into the room through an open window. Thus, Lauder asserted her right to place work in an Academy exhibition. While this was not the only way to become an artist, Lauder's path certainly represents one of the most frequently followed: educated at an art school, in this case Edinburgh, then exhibiting with, although not becoming a member of, the established institutions. However, once the School opened its 'fine-art' doors to female students, young women added this option to the more restrictive but nevertheless enabling area of private learning, and once the so-called ladies' clubs formed,

they could include another venue as well as a support group to their options for learning and exhibiting.

In Edinburgh the women's classes fell under the auspices of the Architecture and Ornamental Department and they were taught by the 'master' of that Department, Alexander Christie, in five different classes: drawing from flat, drawing from outline, shaded drawing (chalk), watercolours and oils. However, within four years, and after the submission of a lengthy report written by Henry Cole of the National Government's Department of Science and Art in London, the structure of the School altered and it became one of the art schools operating under the auspices of the central government – the system of art education euphemistically called the South Kensington system.[29] Cole had also recommended the hiring of a female teacher:

We have to recommend the appointment of a Female Teacher to superintend the instruction of the Ladies' Classes . . . it is quite impossible that any proper supervision of them can be exercised unless someone is actually present in the rooms . . . It cannot be doubted too that a female school ought, if possible, to have a female superintendent.[30]

The London report suggested, or more accurately insisted, that the teacher have a certificate from the Department of Science and Art and that she be allowed to teach privately outside of the School to supplement her income. Almost immediately a competition for the position was advertized and subsequently filled by a highly recommended Lancashire-born, London-trained teacher, Susan Ashworth.[31] The twenty-nine-year-old Ashworth arrived in Edinburgh in time to start the autumn term (October 1858). By 1862, when the number of female students attending the School had grown to 110, the Board agreed that Ashworth should have an assistant teacher rather than two pupil teachers.[32]

Isabella Byres, a young Aberdonian woman who had been studying at the School under Ashworth as one of her 'pupil teachers', was promoted to the rank of assistant teacher and guaranteed a salary from the Board of £30 per annum for working ten hours per week.[33] Ashworth, by this time, was earning just over £125. The discrepancy in salary between Ashworth and her Edinburgh-trained assistant highlights a gap worth exploring. Ashworth's £125 put her at the bottom of the middle class if one accepts Dudley Baxter's estimates of incomes in Scotland (1867): 'middling' middle class incomes ranged from £100 to £1000 per year; the 'lower-small' middle class received incomes of up to £100; a highly-skilled labourer earned wages of over £50 while an unskilled male labourer earned under £40.[34] Ashworth, who probably lived in lodgings in an Edinburgh boarding house, could have maintained a hold (barely) on middle-class status. Unlike her colleagues in Glasgow who earned money by selling pictures, Ashworth rarely exhibited

although she undoubtedly earned additional income by teaching privately (the School accepted that she would take on additional private teaching).

Isabella Byres fared differently. She had not trained at a recognized London school; quite likely she could not afford to leave Scotland to further her education and, as a result, she remained an assistant teacher until her retirement in 1882, thus never earning much as a teacher. She did, at one point during her career, agitate for a substantial salary increase but did not receive one; the Board, in over twenty years, never raised her salary beyond £100. While Byres protested to the Board about her low salary and requested an increase in pay, her colleague, Mathilda Crichton resigned as pupil teacher 'in consequence of having been appointed Teacher of Drawing in the Forest Hill Academy, London, which was a much better situation'.[35] Crichton's example indicates that if a woman was willing to move she might obtain more lucrative employment, but if, like Byres, she did not or could not relocate, her financial position could be precarious. After Ashworth's resignation, Byres, with her years of experience, worked under another young London-trained teacher until her retirement, and then after twenty-three years of service was denied by the Board a 'retirement allowance'.[36] Although Byres was employed, for most of her career she earned less than a skilled labourer, was treated in a petty and mean way by her employers and, although as an art teacher she would have been (and still is) identified as middle class, her financial status speaks of dependency. Byres did not live on her own; she shared an eight-room house with her brother and sister-in-law and, upon her brother's death continued to share a small house with her sister-in-law in Aberdeen. The gap between Byres and Ashworth clearly signals the variety of situations inhabited by middle-class teachers of art which parallels, as shall be seen later, the range of possibilities available to practising artists.

Of the 234 women studying under Susan Ashworth in 1873, fifty-five worked in addition to attending classes. Thirty-seven of these were pupil teachers and teachers while the remaining occupations varied: embroideress, etcher, sewing machinist, wood engraver. The largest number of women, 179, had 'no stated profession'.[37] These middle-class students would have been studying art with the hope of working as artists and, obviously, were much more privileged than their fifty-five already working colleagues. As Deborah Cherry suggested in her study of Victorian women artists in England, ideologies of domesticity were neither static, monolithic or dominant: 'The discursive processes and social practices which preferred domestic femininity co-existed with contending constructions of femininity as independence and discourses on paid work, vocational training and professional status.'[38] While not all of the women studying art would become professional artists, it would be a mistake to assume that simply because they

were middle class or because they had private incomes, they did not take their classes seriously. Their colleagues in the male school would have shared with them family backgrounds, private incomes, and seriousness of intent and, in addition, not all the over four hundred male students succeeded as artists. For both sexes the success rate was extremely low.

During her tenure as teacher in the Female School, Ashworth promoted her students' work and supported the efforts of her students when she thought them unfairly thwarted. For example, in 1864 she protested against the Department of Science and Art, questioning the examiners' decision to award only one prize (a medallion) to the Female School while it awarded nine to the Male School; this was done, according to Ashworth, when at the local level the Female School had been much more successful than the Male School.[39] During her tenure at the School the number of female students continued to increase, the women did well in their local examinations and occasionally won prizes at the national level. However, there was 'very severe competition' for prizes: by the late 1860s there were 103 schools of art in Britain with nearly 19,000 students amongst whom were distributed 10 gold medals, 20 silver medals and 50 bronze medals.[40]

In the face of such competition, and eager to ensure that students received a good education, Ashworth encouraged the Edinburgh school to focus more attention on drawing skills: 'several useful and profitable occupations requiring only complete mastery of hand in technical drawing would be open for the benefit of women'. In her report to the Board, Ashworth insisted that a demand was 'springing up for the practical employment of skilled Draftswomen in works of Industrial manufacture': she cited decoration of fans, book illustration and painting or etching upon glass.[41] 'Doubtless' continued Ashworth, there were 'many other similar branches of industry, admirably adapted to females possessed of the requisite skill in Drawing.' For example, in 1869 the School had received a request from the glass engravers Hauptmann & Co. 'enquiring whether they could obtain from the Female School of Art, skilled students who would take employment in their establishment to etch upon glass with fluoric acid'.[42] Two years later, Agnes Boyd won a first prize for 'the best Design for a Porcelain Dessert Service' which went on to the 1871 International Exhibition in London thus representing 'the efficiency of the School in producing works of Industrial Design connected with some of the principal manufacturers of the Country'.[43] Boyd's success also attests to the versatility of many of the students: she studied both art and design.

Ashworth's Edinburgh career followed a circuitous path and in the traces that remain one can locate mementoes of the life of a nineteenth-century 'career woman' – the heights as well as the problems. Ashworth's professional life manoeuvred from accolades through complaints of mediocrity

and finally to resignation: she struck one of her students, tore up her drawing and refused to write a letter as conciliatory as the one demanded from her by the Board. The reasons for her action remain a mystery but the insult directed toward her young student precipitated her retirement and her move back to London.[44] Nevertheless, her salary by the time she left the School was £300 per year – more than adequate by 1874 standards. To commemorate the sixteen years she had spent teaching in Edinburgh 'some of her former students' presented Ashworth with 'a very handsome drawing room portfolio, mounted on a stand'.[45] She had moved to Edinburgh to assume her teaching position and, when her job ended, she left Edinburgh. In London, she lived first in a small accommodation in Hampstead's Haverstock Hill where, surrounded by other artists as well as by tradesmen and professionals, she filled her less-demanding days by painting more pictures and, possibly, by teaching privately. For the first time, in 1872, she exhibited with London's Society of Women Artists and, later in the decade, showed with the Dudley Galleries. Her landscape pictures reveal travels around England to Derbyshire, Bath and the Lake District as well as Wales, suggesting that she lived comfortably with enough money left over to make small trips.

About the time Ashworth was facing a crisis in the classroom and with the Board, the names of students who would later participate in the Edinburgh Ladies' Art Club began to appear on prize lists.[49] They would continue on with their training under Woon even though, by 1876, their classroom was full to capacity.[50] Some of the women who eventually formed the Ladies' Art Club probably first met in the classroom and, in addition to what they learned in the formal classroom setting, the friendships thus established

Although Isabella Byres taught the female class after Ashworth's 'retirement', the Board turned again to London for a permanent replacement.[46] In December they hired Rosa Woon who had been a student in the National Art Training School in London for ten years (1863–73). Woon was only twenty-four years old when she was hired and during the four years prior to her appointment she had received allowances from the Department of Science and Art to continue her training as an art teacher, attesting to the high regard accorded her abilities.[47] She proved to be a good choice: enrolment in the female class increased by 37 to 274 during her first year of teaching and 23 of her students passed their examinations at the national level – of these, 3 won Queen's prizes, one won a Free Studentship and one won a bronze medal. The year had been a particularly exciting year for the School: academician Sir Noël Paton commended the students and their instructors for their accomplishments when he addressed the annual meeting, and over 2000 people attended the exhibition of students' work which opened for two days in January at The Mound.[48]

would represent companionship as well as support for their mutual endeav-
ours. Such friendship ranged from intimate relationships to relationships
which offered 'utility value';[51] that is, female students willing to use their
time or their resources to help other female students meet their goals.
Students attending classes together and particularly those women who also
became members of the Edinburgh Ladies' Art Club quite likely formed
varying degrees of attachment and may have travelled together collecting
material for their pictures. This group, which over the course of ten years
included successful artists such as Mary Cameron, Agnes Cowieson and
Margaret Dempster, represented for the first time in the history of art edu-
cation in Edinburgh women who either would earn their living as artists or
supplement private incomes with the sales of pictures but, more importantly,
they would identify themselves as artists.

Woon became a highly effectual teacher who encouraged her students
toward the successful completion of examinations and the winning of
national prizes. To her credit, in 1881 a female student from Edinburgh won
a gold medal in the national competition for the first time in the history of
the School – Mary Helen Surenne won a medal for a chalk drawing of a
figure from the antique[52] and, in the same year, became Woon's assistant
teacher. Upon hiring Surenne, the Board regularized the duties of the
assistant teacher and increased her number of contact hours with the
students. Obviously necessitated by the continuing increase in enrolment in
the School, Surenne was to supervise students sixteen hours per week
during the busiest term, from February to April, and fourteen hours per
week over the whole instruction year.[53] Her predecessor, Isabella Byres, had
worked ten hours per week but this was no longer sufficient to provide the
female students with quality instruction.

During this time of expansion for the female school, the Head Master
Charles Hodder pressed the Board for approval to hire a male draped model
for the Male School thereby impinging upon the prerogative of the Royal
Scottish Academy. The RSA had assumed sole responsibility for life-classes
with its 1858 charter; male students had to turn to the RSA for their training
in drawing or painting from the model and their skills were tested only
amongst the small group at the RSA. Students in Edinburgh's School of Art,
because it was part of the South Kensington system, had to compete with
students from all over Britain thus their technical skills came under intense
scrutiny, a matter which according to Hodder, spoke well for their training.
The ensuing decade-long official debate revolved around the training of male
artists; women artists, however, entered into the argument in the press and,
undoubtedly, in private and not-so-private conversation.

The debate about women students can be traced in 'letters to the editor'
of various local newspapers. Newspapers could print divergent opinions in

this column without having to accept editorial responsibility for dissenting views and without having to devote press coverage to the issues. Thus divested of commitment to either side, the paper could still present the 'story'. The *Courant* printed the most persuasive and inducing plea for women's art education and women's right to study from the model like their male colleagues: 'Why is it', wrote one anonymous correspondent,

that every facility is given to our sons, in Edinburgh to become artists, while obstacles – which must prove in many cases insurmountable – are thrown in the way of our daughters? Why does the Scottish metropolis, which justly boasts of being one of the most enlightened cities of the age, fall so short of her sister one in England in this respect? Why does Scotland refuse with niggard hand to permit her daughters to share in the advantages which she lavishes upon her sons?

The lucid commentator insisted that if study at a life school is considered indispensable for those wishing to make art their profession, then it was a 'harsh, not to say cruel, restriction' that prevented women artists, with few exceptions, 'from getting beyond the amateur stage in Scotland'. Those who did succeed, according to the correspondent, had to travel south or abroad for their training (one of the reasons given later for forming the Edinburgh Ladies' Art Club); those whose parents could not afford to send them 'to board in a distant place' had to suffer the consequences. This could mean 'disappointment and disgust, and perchance a weary and wasted life'.[54]

Despite attempted reform and agitation for alternate venues for study, the traditional education obtained at Edinburgh's School of Art resulted in excellently trained artists. Professor Butcher from the University of Edinburgh, in his address to the students of the 1887–8 academic year, referred to the School as 'the meeting point between the fine arts and the useful arts', while he lamented the separation of art and handicraft. J. R. Findlay, a Commissioner of the Board of Manufactures who responded to Butcher's speech, supported Butcher's views particularly as they might apply to Celtic and Scottish ornamentation. In addition, and like Francis Newbery in Glasgow, Findlay insisted that Scottish students 'should not be slavish students of South Kensington or any other Home or Foreign schools'.[55]

Findlay and Butcher, along with the instructors from the School, had good reason to be proud when they awarded the prizes won by Edinburgh students in the National Competition. Hannah G. Preston MacGoun, who had been studying at the School since the mid 1880s, won a gold medal for her chalk study of an antique figure (as Surenne had in 1882) and, along with this, she was awarded a Princess of Wales scholarship 'as being one of the two female students taking the highest prizes in the national competition of 1888'. The Board's Annual Report commended MacGoun's 'exceptional success': 'This year was the first occasion on which either of the Princess of

Wales scholarships had found their way to Scotland, and it afforded the Board great satisfaction that a prominent student of the female school had been the first recipient of such an important award.' MacGoun had worked hard for her medal: she was a 'Student of the Head Master's figure class for ladies' every Tuesday and Thursday afternoon, and on Mondays, Wednesdays and Fridays she studied in the Statue Gallery.[56] This 'master' class, like its counterpart in London (Fig.2), drew from the fully dressed female figure not from the coveted and ostensibly more professional life or nude figure. MacGoun had been attending classes at the School of Art for at least four years when she won the medal and, although her background as the daughter of a Church of Scotland minister might suggest that she did not have to earn her living, she followed her career as a painter and an illustrator all her life.[57]

Hannah MacGoun's prestigious award arrived along with an escalating debate about life-drawing classes from the nude female model for female students. Students attending the South Kensington School in London were already able to draw from the female and the half-draped male model albeit under rigorously monitored conditions. But in Edinburgh women had to seek classes outside of the School if they were to include life drawing in their repertoire. Prior to 1889 many female students attended a life class of

2 The life class at the Academy, 1888

the Atelier Society in Queen Street where, according to the School of Art Committee's report to the Board, they could draw and paint from the model on certain days of the week. This instruction, however, had 'just come to an end, having been given up for want of funds'. It was 'therefore very opportune', continued the Committee's report, that the School should establish a life-class for female students.[58] While its regulations would have been every bit as strict as South Kensington's (the female student could not even attend without written consent from her parent or guardian), Edinburgh's situation was complicated by the prerogatives given to the Royal Scottish Academy in its 1858 charter: 'teaching of the Life should be under the control of the Academy ... instruction in the Board's School should not extend beyond the study of the Antique Instruction in Painting and Drawing'.[59] It was December of 1890 before the School of Art finally won its battle with the Scottish Academy and was able to offer its students, male and female, life classes. In the midst of the debate and largely motivated by it, the Edinburgh Ladies' Art Club formed in the autumn of 1889 drawing many of its members from the studios of the School of Art.

The Glasgow School of Art

Like the Edinburgh's Ladies' Art Club, Glasgow's earlier-formed and longer-lasting Society of Lady Artists had collected many of its members from classes in the city's prestigious School of Art. Here, however, most similarities between education for women in the two art schools end. Elizabeth Patrick, the Glasgow School's first female teacher, appears in the records of 1855: she was employed to teach the Ladies' Class, which met from noon until two in the afternoon three days per week. Patrick had studied at the School – her name appears in School records as early as 1848 – thus Glasgow unlike Edinburgh drew from its own ranks rather than turning to London.[60] By the autumn of 1861, 'in consideration of her long and valuable services', Patrick's salary was increased by £2 a year and she was appointed to teach the new 'special class for females'; she earned £20.[61] She was not 'imported' and perhaps because of this, her salary was far less than the London-trained Ashworth. By 1872 Georgina Greenlees, a daughter of the Head Master of the School and a frequent prize-winner at the local and national levels, had joined Patrick first as a pupil teacher, then later as a teacher.

The early employment by the Glasgow School of Art of one of its own students as a teacher in the female class signals the first of a number of differences from Edinburgh and it is a significant difference that continued well into the twentieth century: Glasgow consistently offered places to its former female students and, in addition, these students were successful

exhibiting artists as well as teachers. The turn of the century saw former students such as Ann Macbeth, Jessie King, Susan Crawford and Annie French all teaching at the GSA. Second, the relationship between the Glasgow School of Art and the Glasgow Society of Lady Artists was direct and consistent. The Edinburgh Ladies' Art Club was formed under the presidency of Christina Paterson Ross, a highly successful artist who never studied in the city's Art School and, in addition, a number of its most notable members had avoided Edinburgh's Art School. Third, and perhaps most important, Glasgow had always highlighted its role as an educator of designers for industry and consequently attracted a number of intensely serious female students who fully intended to work upon the completion of their courses or who were already working and followed their classes in order to improve their positions. Thus, the stories of Elizabeth Patrick and her assistant teacher Georgina Greenlees, which differ considerably from their Edinburgh counterparts, describe a different narrative of art education for the female art student.

Georgina Greenlees studied at the Glasgow School of Art during the early 1870s under her father Robert Greenlees who had taught at the School since the 1850s and had been Head Master since 1863.[62] While Greenlees would become most known as a painter, she studied design as well as drawing, winning one of the national Queen's prizes in 1870 for a design for a lace curtain. Greenlees began her career at a time when art students were following courses leading toward careers as artists rather than artisans, but many women studying in Glasgow and Edinburgh combined courses of study. Less than twenty years earlier, in 1852, the 152 female students at the GSA ranging in age from twelve to thirty years were teachers, governesses, designers, 'fancy' workers and students.[63] Prizes awarded to students record the variety of courses that they followed. Helen Walton, a colleague of Greenlees, won the Haldane prize for painting the figure from a copy in 1871, while another colleague and future member of the Glasgow Society of Lady Artists, Jane Nisbet, won a medal for her drawing of plants from nature. Greenlees won a Haldane prize the following year for a design for a scarf and damasks.[64] Within ten years another friend and colleague in the Glasgow Society of Lady Artists, Susan Crawford, would take prizes in geometry and in perspective.[65]

By the time Georgina Greenlees started learning her trade, women were not only studying a wide variety of subjects but they were becoming picture painters in ever greater numbers. Greenlees took this work as her career and established her reputation as a painter and as a spokesperson for women's art education and art practice. By 1872 Greenlees began to teach as well as study at the School, assisting Elizabeth Patrick with the Ladies' Classes, thus bringing to two the number of female teachers at the GSA.[66] Both Greenlees and Patrick combined teaching careers with exhibiting and selling pictures.

Greenlees exhibited with the Royal Scottish Academy and the Glasgow Institute of the Fine Arts for the first time in 1867 when she was an eighteen-year-old student.[67] Her career as a painter flourished while she was teaching and although the reasons are disguised by the polite language of bureaucracy, combining teaching with an energetic exhibiting career went against the policies of an art school whose prize-winning status was slipping.

The Glasgow School of Art, like its counterpart in Edinburgh, was one of a number of art and design schools in Britain that relied upon a national competition and prize system for a significant portion of its funding. Quite literally, the more prizes students won at the annual national competitions in London, the larger was the grant obtained by the school. The late 1870s found the GSA's reputation falling and, concomitantly, the Board of Governors wanted improvement. While the number of students increased, it was 'somewhat discouraging', reported the *Glasgow Herald*, to find that the school continued to be 'unsuccessful in gaining the higher prizes offered by the Science and Art Department', and that there was no increase in the number of passes.[68] In 1877 a sub-committee of the Board of Governors determined to discover why, for two years, the School had 'obtained no medals or Queen's prizes', and why passes were four times less than they had been. The Board turned to an inspector from the Science and Art Department to provide them with some answers and, in turn, were given a blunt reply: 'It is hardly possible to escape the conclusion that there must be some defect in the teaching', wrote the London official.[69] Students were apparently being shuttled into higher levels before they had mastered the elementary levels, few students had a sound knowledge of anatomy, there was very little shading from the cast, no study of historic styles, hardly any painting from groups or still life, and no training in design.[70] The inspector suspected that supervision was lax, particularly in the Ladies' Classes. 'I am inclined to think,' wrote the inspector, 'that too great a leniency is shown towards the student with regard to the course of study, and that for fear of losing attendance, the pupils are allowed to undertake often what is rather useless or beyond their powers.' More especially, according to the inspector, this was the case with the Ladies' Class: he claimed that at ten in the morning about seventy women assembled for the morning class and, to his horror, they almost monopolized the School.[71]

Two more years passed with Greenlees and his staff trying to implement a report that demanded an 'increased energy, vigour and attention on the part of the teaching staff' and a reorganization of the system of instruction.[72] Nevertheless, the unsatisfactory condition with regard to attendance and finances did not improve and, amid calls for a financial audit of the past ten years, the teaching staff was informed of a forthcoming reorganization: the teaching staff was, according to the Board, 'excessive'.[73] Although lack of

space (seventy students in cramped quarters for example) and inadequate facilities plagued the School, the Board determined to shake-up its staff rather than spend money on physical improvements. The outcome was a rash of resignations, most of which undoubtedly were angry and bitter.

Robert Greenlees stated his intention to retire in March 1881: he had been thinking about retirement for three years.[74] Georgina Greenlees had written to the Board in February telling them that she intended 'to accept offers of engagements in private tuition'.[75] Robert Brydell, who had been appointed as assistant master in 1863, had loyalties to Greenlees that extended beyond the workplace – he had married Greenlees' daughter Marion in 1867 – and had no intention of continuing to teach for the GSA. He tendered his resignation on 22 March 1881, almost immediately after his father-in-law.[76] Elizabeth Patrick had been teaching at the GSA since 1855 when she began as an assistant teacher in the 'ladies class'; she was paid £10 a year, and by the time she started negotiating with the Board in 1881 her salary had only increased to £40. She did not act as quickly as Brydell, but by July she had decided that she could not agree to the Board's terms. According to Patrick, she could teach privately only four hours per week, nine months of the year and earn the same salary that the School offered her: it was not, she wrote, in her interest to stay.[77] With her resignation the Board decided to hold off on making any other changes until they appointed a new Head Master who would be expected to give 'his whole time and attention to the School'.[78] The resignations suggest support for Robert Greenlees, objection to proposed curriculum changes, and protest against the promised sacking of all the teachers.

Greenlees, like his daughter Georgina, was a prolific and dedicated exhibiting artist in addition to being head master of a growing art school in an ambitiously expanding city. He was in his early sixties, had been teaching for over thirty years, and possibly he needed a change. When his friends and former students organized a dinner in his honour they presented him with his portrait painted by one of his former students, William McTaggart, and lauded his contribution to art education in the city: 'in addition to those who painted pictures' there were architects, designers of textile fabrics, carpets, furniture, decorators, modellers, stained glass and art metalworkers, all of whom 'had benefited by his teaching'.[79]

By September 1881 the *Herald* reported that the new session of the GSA was beginning 'under unusually suspicious circumstances'. The numbers of students were down and the teaching had moved in a direction different from that laid out by the Board. A new head master had been appointed, one chosen for his successes at the Derby School of Art, and he was to supervise the addition of new classes in the areas of tapestry, glass, the study of design as it applied to household decoration, and the study of ornamental

design as it applied to manufacturing.[80] It remained to Greenlees's successor, Thomas Simmonds, to put Glasgow back onto a prize-winning path; Robert Greenlees and Georgina Greenlees turned their attention to their own art production, and gave their energies to other kinds of art organizations particularly ones that would support female artists. Again, this situation is markedly different from the one in Edinburgh. Susan Ashworth did not exhibit extensively; she was a teacher rather than a practising artist. Her assistant teacher followed the same path. Rosa Woon, who was teaching in Edinburgh during the early 1870s followed Ashworth's example and rarely exhibited while she was teaching, although there is some evidence that she worked to commission.[81] That aside, neither Edinburgh's teachers nor their assistants built up very extensive exhibiting records.

Within about two years of tendering their resignations as teachers at the GSA, Georgina Greenlees and Elizabeth Patrick, along with friends such as Jane Nisbet and Helen Salmon, and students such as Jane Cowan Wyper, Margaret Macdonald[82] and Henrietta Smith Roberton joined together to form the Glasgow Society of Lady Artists. The women were well aware of London's Society of Female Artists which had organized in 1855; some exhibited with them.[83] Recognizing the disadvantages of training in an art school which then had no female teacher, and exhibiting with societies that excluded them from administrative responsibilities they may have decided that an organization of their own had become a necessity.

The group of eight women, all of whom were practising artists, met in the studios that Georgina Greenlees shared with her father at 136 Wellington Street. Conceptualized as an association that would provide support and education for women artists, the members organized their first exhibition as a 'private one' during the first week of January 1884 in 'their rooms', a small studio space in 136 Wellington Street. In addition to a number of offices, 136 Wellington Street housed six artists' studios rented out from £10 to £25 per year. Even though the exhibition was private, a number of visitors wandered round the studios looking at the pictures, and the *Herald* critic wrote a short review for the Glasgow paper commending the work but lamenting the 'lack of variety'. The anonymous reviewer seemed somewhat dismayed at the 'total absence of domestic subjects' which, ostensibly because the art had been produced by women, 'might naturally be expected in such an exhibition'. In fact, the work reflected the studies and aptitudes of the women all of whom had studied or were still studying at the Glasgow School of Art: Helen Salmon, who had won a book prize as a student for figure drawing, exhibited a figure in oils; Jane Nisbet, who had won a Haldane prize for an analysis of plants from nature, exhibited an 'artistic drawing of poppies'; and Henrietta Smith Roberton, who had won a 'highest grade prize' at the national level for still life in oils, exhibited a picture of painted

vases. Georgina Greenlees contributed 'a well-painted figure subject' and Jane Cowan Wyper contributed a 'landscape study': both women would paint these subjects throughout their careers.[84]

The bond weaving together the early organizers and members of the Glasgow Society of Lady Artists was forged by their friendships, their interests, and their shared educational and familial backgrounds. In the hazy and shifting milieu of the latter part of the nineteenth century, when women were entering a workplace that did not yet acknowledge their existence as viable and economically productive members of a moneyed economy, these artists lived and worked in a peculiar and almost invisible institution. Earning one's living in such a trade was precarious: successful artists consistently related the dangers to students during the annual award-giving ceremonies in Glasgow and Edinburgh. In his 1885 address to Edinburgh students, Sir William Fettes Douglas warned that a decision to commit to art as a profession was 'peculiarly dangerous' because so few 'even when glaringly unsuccessful' have the courage necessary to change and follow a different career.[85] Nevertheless, many women artists did earn their living by combining teaching (often private tuition) with selling work at exhibitions, and Georgina Greenlees's income was probably higher after she left the GSA, than while she was teaching.

During the early years of the Glasgow Society of Lady Artists, Greenlees also exhibited pictures with the Royal Scottish Academy, the Glasgow Institute of the Fine Arts, the Scottish Society of Water Colour Painters, the Dumbarton Fine Art Exhibition, and the Kirkcaldy Fine Art Exhibition among others. During one six-month period between October 1882 and April 1883, she sold *The Village Belle* for £15 15s (Dumbarton),[86] *The Favourite Air* for £30 (Glasgow),[87] and *After the Dance* for £25 (Glasgow).[88] This represents only the portion of her sales that can be tracked in the erratically reported sales lists in the *Glasgow Herald* and the *Scotsman*, making it fair to assume that her income was greater than these three sales indicate. Nevertheless these sales alone represent an income of just over £65 for a six month period while her annual salary as a teacher at the Glasgow School of Art had been only £40; in 1878 Greenlees sold *A Bay at Rowardennan* for £40: one painting for as much as she earned in a year teaching.[89] Assuming she was accepting 'private tuition' as her letter to the GSA's Board of Governors indicated, then she also supplemented sales of pictures with an income from private art classes. She was, by any standards, a successful, independently-employed working woman.

Greenlees was educated in the Glasgow School of Art, taught at the School, then helped to form and worked within the Glasgow Society of Lady Artists. Like many other Scottish women following careers in art she was sensitive to the needs of up-and-coming artists and while after leaving the GSA she

never again taught in an institution, she did offer private classes and she helped women continue their training within a professional organization – the Glasgow Society of Lady Artists. When Greenlees and Patrick left the Glasgow School of Art, there was no female teacher to replace them. Although the School continued to attract numbers of female students, they were taught by male teachers until 1892 when C. A. Dunlop was appointed by the Board, followed in 1894 by Jessie Newbery.

The intervening years without female teachers found the School expanding its curriculum to include new classes on china, tapestry and glass as well as the study of design as applied to household decoration and the study of ornamental design as applied to all manufacturing purposes.[90] Female students continued to attend the GSA and to support the Glasgow Society of Lady Artists thereby maintaining a close relationship between the system of education and the supportive artists' organization. Turn-of-the-century Glasgow could boast a large number of highly successful female artists undoubtedly due to the combination of excellent training and a supportive infrastructure of female colleagues; concomitantly the number of women teaching at the Glasgow School of Art increased. 'In fact,' wrote art critic Clare Henry in her review of the 1990 exhibition *'Glasgow Girls': Women in Art and Design 1880–1920*, 'when it comes to female teachers, Glasgow was better off in 1908 than today.'[91] In 1994, one hundred years after Jessie Newbery initiated the embroidery classes at the School, the 'gender ratio of Glasgow School of Art staff was 82 per cent male and 17 per cent female'.[92]

Edinburgh also produced its fair share of outstanding female artists but could not boast so many artist-teachers: education for women artists in the east of Scotland always became intertwined with the conservative bastion, the Royal Scottish Academy. In addition, by the turn of the century Glasgow clearly was recognized as the place to study design or the so-called decorative arts. For example, in 1899 the *Studio* commended the annual exhibition of the Glasgow School of Art Club for 'the boldness of its innovations and the certainty of the appearance of some novelty'[93] and, by this time, the 'Glasgow Style' had attracted the attention of critics in Britain as well as on the Continent. Jessie Newbery and Ann Macbeth, both featured in the *Studio*'s review, had studied in the GSA, taught in the School and were active members of the Glasgow Society of Lady Artists.

In Edinburgh, by 1899, the Ladies' Art Club had disappeared and former students certainly were not teaching in the Art School. To the contrary, when the Board made its decision to amalgamate their School of Art with the School of Applied Art, all the teachers including Art Mistress Rosa Woon and Assistant Mistress Mary Helen Surenne were asked to resign: it was essential, insisted the Board, that the School of Art 'should be completely reorganized and conducted in the future under an entirely new staff of

teachers'.[94] The new staff was composed of five male teachers.[95] Like Ashworth before her, Woon returned to London, settling back into her family's Chelsea neighbourhood. Surenne remained in Edinburgh, sharing the family home with her older sister.[96]

While art education for women followed a course somewhat similar to women's incursions into other areas of study, it did not suffer the extreme derision attached to women attempting to study medicine while, at the same time, it provided more independence for the successful student than did, for example, working as a governess. A successful woman artist while struggling to convince her male colleagues that she did have a right to enter their segregated societies and vie for membership in the Royal Scottish Academy, was able to work, travel, exhibit and earn a reasonable amount of money as an independently employed worker. Thus, the entry of women into art schools signals a success tinged with the possibility for independence that few other occupations could offer – and therefore would have lured the hard-working and talented artist to the challenge. And while different schools opened their doors in different ways to different kinds of women, they all announced possibilities for the interested and challenges for the willing.

Guild and venue: women artists, exhibition spaces, and 'separate' societies

Guild, a term most often associated with medieval craftspeople, designates an 'association of people for mutual aid or the pursuit of a common goal'.[1] As such, although not often thought of in these terms, it aptly describes the function of late-nineteenth-century artists' societies like the Royal Scottish Academy, the Glasgow Institute of the Fine Arts, the Scottish Society of Water Colour Painters, the Society of Scottish Artists and the 'lady' artists' societies. Appropriately, a nineteenth-century 'gild' history considered the associations as composed of 'those living in the same neighbourhood' and sharing 'common obligations' to regulate their trade.[2] The history of guilds in Britain dates back at least until the late fourteenth century when the Crown 'obliged all gilds to set down their rules and other information' and the most numerous of the guilds were termed 'social' or 'parish gilds'.[3] Members of such organizations banded together 'for mutual security against poverty and misfortune or better to meet demands made on them by the local overlord of manor or monastery'. According to guild historian R. A. Leeson, both 'bretheren and sisteren' took part in the early organizations although, by the sixteenth century, restrictions began to be enforced against female membership in many organizations.[4] Leeson traces the development of the medieval 'craft fraternities' through to the trade unionism of the nineteenth century, attempting to establish links between the pre-industrial organizations and the later trade-oriented movements. However, another branch of development might be found not in trade unions per se, but in the numerous societies that formed in the late eighteenth and early nineteenth centuries within the culture industry. Societies for artists formed in Britain as early as the seventeenth century, becoming institutionalized by the late eighteenth century in England's Royal Academy and Society of Artists.[5] These societies, which would include the Royal Scottish Academy by 1826, gave artists a space which could be shared with colleagues and from which

they might sell their work. The later-formed organizations such as the water-colour societies[6] and the 'lady' artists' societies provided a much-needed space for women artists who could not act as members in the traditional bastion of conservatism, such as the Royal Academy or the Royal Scottish Academy, even though they could and did participate in the Academies as exhibiting venues. Thus, while organizations such as the Edinburgh Ladies' Art Club conflated the space of guild and venue, other associations such as the RSA controlled both membership and exhibitions with a policy of exclusion reinforced and protected by allowing minor inclusions: that is, by letting some women exhibit.

Critics confirmed the hierarchies in their reviews of major exhibitions. For example, the *Scotsman* in its 1889 review of the sixty-third exhibition of the Royal Scottish Academy acknowledged the 'fraternity of artists' which was, 'of course, largely represented' thereby attesting to the large number of exhibits by male members. The exhibition had opened at nine o'clock in the morning on a blustering, rainy February day but by one in the afternoon the weather improved and the crowd became so huge 'that seeing the pictures was out of the question',[7] assuring a large audience which might, in turn, purchase works or, at least, become aware of the names of the members of the 'fraternity'. Before the day was out, officials for the Royal Association for the Promotion of Fine Arts in Scotland had purchased a number of pictures on behalf of the Association. They bought two pictures by Edinburgh artist Jessie Dixon Gray: *The Old Casket* (selling for £10 10s) and *The Broken Jug* (selling for £8 8s).[8] Christina Paterson Ross exhibited two pictures, one of which was a 'strongly-drawn head',[9] but there is no indication of any sales. Another colleague of Gray's and Ross's, Margaret Dempster, exhibited a 'refined' portrait of a woman 'in dark hat and costume' which, according to the *Scotsman*'s critic, had been 'hung too high to see the first-rate work which apparently has been put upon it',[10] thereby confirming one of the disadvantages of being a non-member or an outsider and suggesting one reason, among many, for seeking out alternative organizations. All three women were founder members of the Edinburgh Ladies' Art Club which was to open its first exhibition eight months after the sixty-third RSA exhibition; the three women also would become 'equal' members of the soon-to-be-formed Society of Scottish Artists.

Early reports in the press recognized the 1889 RSA exhibition as 'a genuine harvest of Scottish art' that represented 'a number of workers in the West of Scotland' as well as Edinburgh artists.[11] Nevertheless, while the Academy claimed to uphold the 'national' claims of its charter by representing the whole of Scotland, the decade of the 1880s had signalled dissatisfactions on the part of artists and viewers. These grumblings recurrently became public in the letters-to-the-editor sections of local newspapers. A viewer with the

pseudonym of 'Outsider', after questioning by whom and for what purpose the Academy had been founded as well as asking how it was supported, painstakingly calculated a set of statistics that proved Edinburgh hegemony: in 1881 22 of the 30 academicians resided in Edinburgh and 267 of its 514 exhibitors were from Edinburgh or its suburbs. Of the remaining contributors 52 were Glaswegian, 84 from other parts of Scotland and 111 from England.[12] Not content to rely on only one exhibition, 'Outsider' quickly submitted another letter to the *Glasgow Herald* in which 1882 statistics showed an even 'more marked divergence from the principles of fair play': 270 of 478 or 56 per cent of the exhibitors were from the east of Scotland. 'Outsider' pointed out that the Academy's charter claimed 'the advancement of the fine arts in Scotland' and therefore its undue partiality should outrage the public. If the Glasgow Institute of the Fine Arts dealt with Edinburgh artists this way, claimed 'Outsider', 'we should be looked upon as utter barbarians'. Glasgow artists were expected 'to stand patiently in the cold while the academicians, their friends, their friends' friends, and the whole tribe of sisters, cousins, and aunts take up the wall space' which should be assigned to 'the most worthy'.[13]

While comments about the disparity between numbers of works by Edinburgh artists versus other artists might have been accurate, the disparaging reference to sisters, cousins and aunts was both a truth and an untruth. Many women like Jessie Dixon Gray were from families with more than one artist but hers was not a family of academicians. Unlike many generalizations made about women artists, most of the ninety-five women (with a total of 153 exhibits) in the 1889 RSA exhibition were working middle-class women who exhibited regularly with the Scottish Academy and with the Glasgow Institute of the Fine Arts. For example, in 1887, Christina Paterson Ross had exhibited *Chez Nous* in the watercolour room of the Royal Scottish Academy. The untraced picture, 'a triptych representing the interiors of three studios with artists working in them',[14] was not for sale, undoubtedly because it depicted friends and colleagues of Ross's and, perhaps, even included the artist herself. If the picture showed women working, Ross's painting would be one of many in the tradition of western art to make a statement about women and their chosen profession.[15]

Ross's picture, whether it represented men or women (and given Ross's tendency to depict women in her pictures, it was probably of women), bridged a gap between the studio and the venue, and thus, particularly for women artists, brought together the perceived private space of a woman's studio with the definitely public space of the exhibiting venue. That a woman's studio was considered a private space has to do with a lack of recognition of her work as professional and the tendency, on the part of critics, to conflate the professional with the so-called amateur. Given that

fine art itself was perceived as part of a cultural sphere rather than part of an economic sphere, it was easy for critics and public alike to relegate the artistic profession to the realm of the 'less serious'. When the artist was female, this became all the more part of the domestic mystique around her and she was seldom seen as part of a coterie that made art its means of earning a living. Jayne Stephenson and Callum Brown, in an essay that examined women's memories of work in early twentieth-century Scotland, suggested that 'there tends to be little consideration of working-class women enjoying their work, gaining from it a sense of independence from domesticity, an opportunity for self-development, and a popular culture of personal friendships, peer-companionship and leisure pastimes'.[16] The same kind of satisfaction undoubtedly was experienced by middle-class women workers like Christina Paterson Ross and Jessie Dixon Gray.

Christina Paterson Ross earned her living and negotiated her status as an artist within and without artists' organizations. She belonged to the Scottish Society of Water Colour Painters, the Edinburgh Ladies' Art Club, the Society of Scottish Artists and the Paris Club for International Women Artists. Although she was denied membership in the Royal Scottish Academy, she exhibited regularly with them beginning in 1868. In addition, she worked to have pictures for sale in venues across Scotland and in England. In the late 1870s and early 1880s, for example, she was exhibiting in the Dundee Fine Art Exhibition, the Kilmarnock Fine Art Exhibition, the Kirkcaldy Fine Art Exhibition, the Stirling Fine Art Association, the Royal Manchester Institution and, most importantly, the Glasgow Institute of the Fine Arts.

The Institute had formed in 1861 specifically to support and promote Scottish artists; unfortunately it sought to establish itself when the west of Scotland was on the brink of economic disaster. In 1863 when the fledgling organization mounted its second exhibition many exhibitions in Scotland had been cancelled because of the 'distress caused by the cotton famine'.[17] Unemployment was high and trade was slow but the Institute persevered in its attempts to provide a venue and a market for struggling artists and, although women artists were not amongst the subscribing members,[18] their pictures appeared in Institute exhibitions regularly and in ever-increasing numbers. Both Christina Paterson Ross and Georgina Greenlees were exhibiting with the Institute by the 1870s and both women along with many of their colleagues from the women artists' societies used the Institute as a venue. For Glasgow women like Greenlees, the logistics of exhibiting with the Institute were simple and uncomplicated; her Wellington Street studio was a short walk away and although her pictures were too large to carry – for example, *A Hayfield at Luss* (1878) measured thirty-six inches by twenty-four inches – arranging for transportation would have been a relatively easy task. Similarly, Laura Chapman and Elizabeth Patrick, Greenlees's friends

and colleagues in Glasgow who, along with her, were singled out for praise in the *Glasgow Herald*'s 'Studio Notes', an exhibition 'preview' column, shared the ease of transporting their pictures the short distance from their studios.[19] 'Studio Notes' assured selected artists of viewer recognition – having their 'products' advertised weeks before the exhibition opened meant that their names were familiar even before their pictures were seen. Reading about Greenlees's 'remarkable' hayfield from Luss or about Chapman's 'very truthful studies of bracken and heather' ensured the artists an audience already prepared to see their work – perhaps even to seek out their work – and, ultimately, to purchase what they saw. The Glasgow press tended to comment on Glaswegian artists making it easier for artists to be known in their own city just as it was easier for them to exhibit in their own city.

Such ease would not have characterized Christina Paterson Ross's participation in Glasgow Institute exhibitions. In addition to the inconvenience and work involved in getting pictures from her Edinburgh studio to Glasgow, she had to factor in additional expenses – the cost of either her train trip between the two cities if she carried the works herself or the cost of shipping if she did not accompany her pictures. Invited artists, those who received the 'Circular of the Institute', could submit up to six works. The additional perk attached to an invitation to participate was a promise, on the part of the Institute, to cover the cost of sending pictures: invited artists could send their pieces to the Institute by 'carriage at ordinary rates' at the Institute's expense. During the 1870s, few artists were invited and those tended to be academicians from either Scotland or England.[20] Uninvited artists could submit a maximum of two works, the shipping of which was their responsibility. Thus, when Ross sold her picture *Washing Day* in 1877 for £8 8s,[21] in addition to incorporating the costs of mounting and framing into her profit she also had to include the costs of packing and shipping or her own transportation. Fortuitously Ross's brother and her father often exhibited pictures in Institute exhibitions as well and, because the artists located their studios in the same block of flats, one person could have accompanied all the pictures. Such co-operative efforts undoubtedly made preparations for exhibiting much less arduous as well as less expensive.[22]

While the Institute served as a venue for Ross for many years – she exhibited frequently from 1870 until her death in 1906 – she never had 'insider' status and therefore always was restricted to showing only one or two pieces a year. Membership in an organization or 'guild' would expand her opportunities for selling work, increase her visibility and enhance her status. For Ross, and her Glaswegian colleague Georgina Greenlees, this cachet became theirs with the formation of the Scottish Society of Water Colour Painters in 1878.

The Scottish Society of Painters in Water Colours (see chapter 4) formed

'on a similar basis to the water-colour societies of England' intended to provide a space that enabled artists to exchange ideas and concerns about their careers as well as giving them a place from which they could offer pictures for sale to a growing middle-class and consumer-oriented public. Critically, the 'joint co-operation' between the two largest Scottish cities, Glasgow and Edinburgh, was acclaimed and while 'the cultivation of water-colour' promised 'to improve public taste',[23] it also meant that artists from the two cities could work more closely together. This was undoubtedly significant for women artists. For example, Georgina Greenlees, who was accepted as an associate member when the Society organized, was the first president of the Glasgow Society of Lady Artists which formed about three years after the SSW. Membership in the Water Colour Society gave Christina Paterson Ross and Greenlees contact with women artists from other Scottish towns and cities. Certainly, Ross's contact with Greenlees would have proved advantageous when Ross organized the Edinburgh Ladies' Art Club in 1889.

Equally important for the women was a new venue which provided a market for their pictures. Without over-emphasizing the commercial nature of the venture, the artists certainly understood and intended the Society to promote sales. Francis Powell, who chaired the early meetings and would become the first President of the new Society, declared that 'water-colour paintings in Scotland had been quite in the shade, as they were generally exhibited along with oil paintings and in rooms of the worst possible light'. 'If cultivated', insisted Powell, 'a love of water-colour paintings would grow; and if properly exhibited people would purchase them'.[24] The key phrase here is that watercolours, 'if properly exhibited' would be purchased: all these artists, male and female, needed to sell their work, and competing against large oil paintings in RSA exhibitions was difficult. A watercolour was smaller in scale, not as bold in colour, and not as elaborate in design, often, for example, depicting landscape or genre, 'ordinary' scenes rather than the mythical or historical extravaganzas familiar to viewers of oil pictures. These smaller and less expensive pictures found buyers amongst the middle classes: a small watercolour could sell for as little as £2 therefore was well within the financial reach of a middle-class family with an annual income of £200 or £300 pounds. An oil painting could sell for much larger amounts: Robert Thornburn Ross, Christina Paterson Ross's academician father sold his oil painting, *The Spinning Wheel* from a Glasgow Institute Exhibition in 1876 for £200; he sold a watercolour picture from the same exhibition for £50 – still expensive but much less than what an academician would charge for an oil picture.

Belonging to such an organization provided Christina Paterson Ross with a venue from which to sell her work and, although the early reviews of the first exhibition of the newly formed SSW in the autumn of 1878 emphasized

'taste' and played down commercialism, the *Glasgow Herald* did acknowledge the importance of sales: 'All the exhibition is in want of is the patronage of picture-buyers who really have a knowledge of art.'[25] About a month later, the *Herald* reported on the large evening attendance and the satisfactory level of sales, while it chastised visitors to the exhibition for not being more liberal in their patronage of the artists.[26] Glasgow collectors, in particular, were criticized frequently by the press for purchasing too many foreign pictures or copies of foreign pictures, and not supporting Scottish artists. When the watercolour exhibition closed in January the *Herald* lamented the attendance statistics insisting that it had 'fallen much short of what the excellence of the collection deserved' and that most appreciative visitors had come from England rather than from Scotland: the exhibition was spoken of with enthusiasm 'in London among artistic people'. 'English artists', wrote the *Herald*, 'have expressed much surprise to find water colour painting has made such progress in Scotland, an opinion all the more complimentary since water colour artists receive no adequate support from Glasgow picture collectors'. While sales amounted to nearly £600, once expenses had been deducted 'the society's first exhibition, from the selling point of view' had not proved a success. The *Herald*, not surprisingly, conflated sales with artistic reputation and condemned Glasgow for not upholding the 'artistic reputation of the city'.[27]

While fine arts as culture often dismisses as crass monetary gain and materialism, a working artist had to sell her product; the SSW, prestigious as an exhibiting venue, remained a firm advocate of sales and cash income for its members. Although by 1881 there were only four female members, the women were highly visible in the exhibition venue and in the reviews of the exhibition. Membership in the Society validated their position as producers for the art market and, in so doing, established their credibility as working artists. This kind of acceptance improved their own marketability, while at the same time paving the way for other women artists who wanted to work in fine art. Thus, their professionalism as well as their chances for earning money were enhanced. The Society allowed each member to exhibit up to eight pictures – thereby giving the women substantially greater opportunity to gain income and to become known as artists than did their status as non-invited participants in the Institute or non-members of the RSA.[28]

Critics more often than not gave the female members good reviews. For example, in 1881 the *Glasgow Herald* acknowledged Christina Paterson Ross as 'a powerful addition to the society': she had recently been accepted for membership. Her genre picture, *An Old Closet* demonstrated her exceptional talent for design and colour; her landscape *Old Houses* demonstrated her success with representing the picturesque. A space existed for women in the exhibition venue and in the critical reviews which, in turn, opened up

the more private space of their studios. The income the artists derived from these exhibitions remains difficult to piece together, but occasionally the Scottish newspapers printed sales reports listing the titles of the pictures sold, the artist's name and the amount. For example, in 1881 Christina Paterson Ross sold *In the Hall at Cairndhu* for £12 12s;[29] the purchaser is not listed but it may well have been bought by Cairndhu's owner, Glaswegian merchant John Ure.[30] However, it is the price of the picture or the amount earned by the artist that I should like to consider first. As with wages, women artists sold their pictures for less than men artists: J. Denovan Adam, for example, sold *The Village Common* from the same exhibition for almost exactly twice the amount, £25.[31] This discrepancy in selling price supports studies done on women and work in the nineteenth century. According to Tracy Davis in her study, *Actresses as Working Women*, actors inevitably earned more than actresses although the highly successful actress might earn as much as her male lead – in the theatre a leading comedy actress might earn as much as £40 per week when she worked; a touring actress might earn as little as £2 per week.[32] Cyril Ehrlich in his social history of the music profession in Britain alludes to a similar pattern for female musicians and, like artists, most musicians had to teach to supplement their income; he assumes (based on that unreliable but ever-useful indicator, the census) that 'the great majority of female musicians' were teachers rather than performers.[33]

Artists' incomes, like actors, reflect a similar situation with an odd but explainable twist: the women priced their own pictures when they placed them in exhibiting venues. Thus, even when they determined the value of their work themselves, they subscribed to the dominant ideology to such an extent that rarely did a woman artist sell her work for as much as her male colleague. While, as I argue throughout this text, artists are independently-employed working women, they continue to work for less and, in the process, provide a viable example to support Antonio Gramsci's theoretical concept of hegemony. Working women artists quite consistently participate in society as a subordinate class, kept in place 'by means of a combination of coercion and persuasion' that has been called an 'organization of consent'.[34] Thus, although their working conditions and expenses may mirror those of their male colleagues, their income remains less.

Christina Paterson Ross's *In the Hall at Cairndhu* provides more than an economic insight into a woman's career in the 1880s. The house had been built in Helensburgh in 1871 for Glasgow merchant, John Ure. William Leiper designed the imposing château-like exterior and, together with stained-glass artist Daniel Cotter, designed the impressive interior. Ure's daughter Isabella was an artist and founder-member of the Glasgow Society of Lady Artists. That Ross painted a picture of the interior of the house suggests that she visited Cairndhu and, because it is unlikely she made the train trip from

Edinburgh to Glasgow and then on to Helensburgh without staying the night, she may have remained for a few days or visited more than once. Because Isabella Ure was also an artist, Ross may have been visiting her or, fellow-member of the SSW, Lily Blatherwick who also lived in Helensburgh. Because Ross rarely painted the west of Scotland, this picture represents an unusual excursion for her into the countryside north of Glasgow and suggests that the trip was made specifically to visit Cairndhu.

Her picture of Cairndhu contrasts with her 1878 picture of laundry-women at work, *Mangling Done Here*, which was exhibited with the Royal Scottish Academy during the year that the SSW formed. The thumbnail sketch done for the Academy's illustrated catalogue (Fig.3) portrays 'a humble interior, in which two servant girls wait for the clothes which an old woman laboriously mangles for them'[35] and, given the titles of many of her pictures, represents frequently painted subject matter. Certainly, as John Barrell has suggested, pictures of labourers became popular in eighteenth-century England and remained popular well into the nineteenth century. Barrell's observation that the paintings he discussed were made by the rich, 'at least from the perspective of the poor', and were sold for display in the 'drawing rooms of

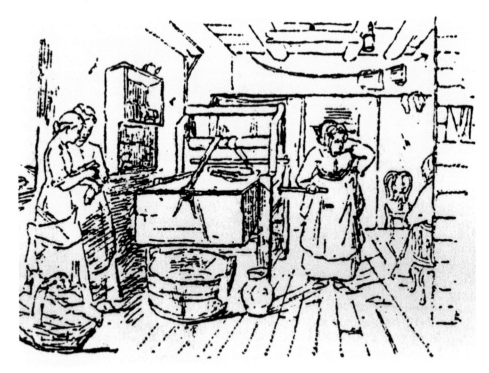

3 *Mangling Done Here*, Christina Paterson Ross, 1878

the polite'[36] aptly applies to Scotland as well as England. However, class distinctions such as these require gender modifications and are never as simplistically organized as they first appear. While Ross may well appear 'rich' to the laundress sweating over the clothes of her clients and to the domestics waiting to collect their employers' belongings, she struggled to earn her living. Nevertheless, class and income separate Ross from the three female labourers. Ross's father, as a moderately successful painter of portraits and landscapes, was able to support himself, his wife and his children thereby enabling his family to participate in society as middle class; Christina Paterson Ross, because she received training (fortunately) as an artist was able to sell pictures and teach privately. Although she had to manage her activities and paint in order to make a profit, she was independently employed. While her income was always unpredictable, fluctuating according to demand, she took pleasure in her activities and undoubtedly obtained pride and a sense of achievement from her endeavours. But to earn her living, she had to paint pictures that would sell.

Judging from the titles of many of Ross's pictures, she tended to paint scenes like *Mangling Done Here* which reproduced images of labouring women or men, or the poor. The critically acclaimed 'strong drawing of a beggar woman' reproduced in the illustrated catalogue which accompanied the 1884 RSA exhibition (Fig.4),[37] for example, shares the distanced-empathy found in *Mangling Done Here* and is quite likely characteristic of many of Ross's pictures. A picture of sailmakers (Fig.5) made over twenty years later (shortly before her death in 1906) also celebrates work, in this instance representing men associated with the fishing industry; its sombre colour and deep shadows persuasively captured the dignity of labourers associated with such representations at this time.[38]

Ross's Water Colour Society colleague, Georgina Greenlees, painted genre scenes as well but, rather than focusing upon those who would be considered from a lower class, she favoured images of women who shared experiences somewhat similar to her own. The violinist Greenlees painted in *An Itinerant Musician* (exhibited with the SSW, 1883) (Fig.6) would have worked extremely hard, as did Greenlees herself, to obtain a level of expertise that would have enabled her to survive as a cultural worker. The musician could have studied at the Royal Academy of Music in London because, unlike the Royal Academy of Art, males and females had been admitted together since its inception in 1822; however women pianists (Clara Schumann being the most famous) appeared before audiences much more often than violinists. It was not until later in the century, encouraged by the Royal College of Music (established 1882) that female violinists began to perform more frequently. Even then, only 16 women applied for violin scholarships, 185 applied to study the piano; of the 16 aspiring violinists, one was successful.[39] More

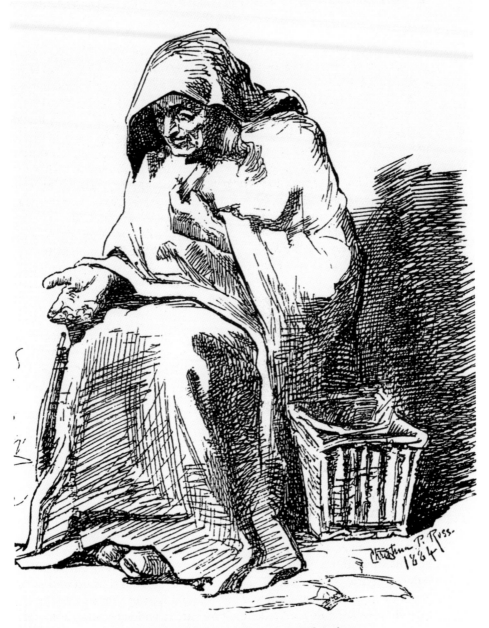

912 'And the woman was old, and ragged, and grey,
And bent with the chill of the winter's day.'

CHRISTINA P. ROSS.

4 'And the woman was old, and ragged, and grey', Christina Paterson Ross, 1884

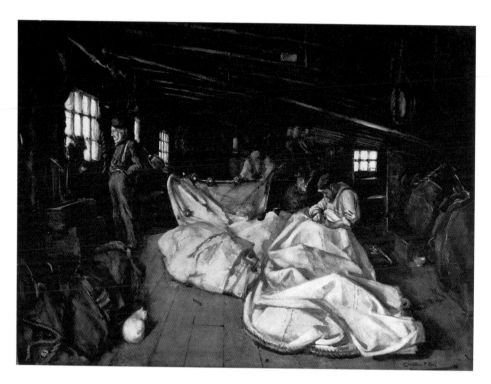

5 *Sailmaking*, Christina Paterson Ross, 1905

significant, and damaging, for professional musicians was the barring of women from major organizations which formed during the late nineteenth century in Scotland and England. Musicians, like actors, were strident in their attempts to organize along the lines of trade unions in order to obtain respectable salaries and conditions from theatres, determined to protect their members even if it meant going on strike or boycotting certain venues.[40] Allowing women to study and perform but forbidding their membership in protective groups effectively limited their activities and curtailed full participation in their profession. Thus, while musicians were willing to organize unions (although many felt they were 'men in a profession and not a trade')[41] artists continued joining together in associations which provided them a place to sell their work but did not attempt to address issues of working conditions or security; both groups excluded female artists even though women contributed to the professions and earned their livings by working with the skills they had learned.

For example, Marie Schumann, an American violinist and music teacher, performed in Glasgow in the autumn of 1882, just months before Greenlees exhibited her picture.[42] While Greenlees's picture may be a portrait of the

6 *An Itinerant Musician*, Georgina Greenlees, 1883

solo violinist, it also captures the moment when women began to perform as violinists in public concerts. Cyril Ehrlich cites this moment as beginning with amateurs – for example, the Dundee ladies' string orchestra began playing publically in 1882[43] – but quickly shifting to professional performers such as Marie Schumann. When Lucy Green discusses the affirmation and the interruption of femininity in her study of gender and music, she organizes the relationship between different kinds of female performers and various 'display delineations'. According to Green, 'the musical sound-source of the woman singer is her body itself' thereby creating a 'self-referring cycle from body to femininity and back again'. A female instrumentalist, even though her body is on display, 'mediates the whole scenario through a piece of technology'. The violinist, according to Green, appears less locked into her body than the singer and therefore is less available sexually: her femininity is interrupted rather than affirmed.[44] Earlier, I suggested that women artists, when they displayed their pictures, became visible to the market economy in which they worked – this display provides the opportunity for historical research to reconstruct or narrativize the artist. However, following Green, because their bodies are invisible in the cultural product, female artists became more 'acceptable' in a middle-class world than were performers. Actresses, like singers, are inextricably visualized as 'body'; Greenlees's violinist interrupts the sexuality of the body; Greenlees's body is invisible in her art. This, in part, may explain why female artists were designated securely middle class (as were writers) when other women working in the field of culture were frequently placed outside the boundaries of respectability. Greenlees's decision to paint a musician, one who shared with her the tribulations of a long, arduous training, establishes a link between two careers and reiterates a visualization of professionalism.

Coinciding with Greenlees's representation of a professional woman musician, Greenlees along with a number of her Glaswegian colleagues established the Glasgow Society of Lady Artists as the first society in Scotland devoted specifically to the professional status of women artists. A few years later, Christina Paterson Ross became the first president of the Edinburgh Ladies' Art Club. Edinburgh as an urban space provided women artists a place to work, sell pictures and live despite a dearth of professional clubs or organizations which supported their activity. This lack of support led the women to organize the Edinburgh Ladies' Art Club in 1889, seven years after the founding of Glasgow's Society. However, unlike the Glasgow women who elected to expand their membership so as to include community support, the Edinburgh Club restricted its membership to professional artists.[45] As the *Scotsman* eloquently suggested, 'Acting on the sound principle that Providence helps those who help themselves, the ladies have organized this Art Club, which includes the bulk of those whose names are

familiar in the catalogues of the Royal Scottish Academy.'[46] Certainly the women needed to 'help themselves'; such alliances with one another provided them with a support group defined by occupation. Friendship in this instance represented 'both a personal attachment and a socially constructed and culturally articulated form of relationship',[47] and became institutionalized within organizations such as London's Society of Lady Artists, the Glasgow Society of Lady Artists and the Edinburgh Ladies' Art Club. Locating a place where a self-identified group could meet, as well as a space in which they could interact and discuss their work, provided members with a position which, in turn, identified them as artists. The single, isolated artist could not challenge a dominant, controlling group but an assembly of women working together could become visible by exhibiting in established venues while, at the same time, exhibiting in their own organization; their voices were heard when their pictures were seen.

The formation of the Edinburgh Ladies' Art Club was inextricably linked to problems in the art school. Unlike the Glasgow Society of Lady Artists which worked with the art school, the Edinburgh Club was from the start an oppositional group. Their first exhibition attracted press comments which both supported and detracted from their programme but, whatever the criticism or praise, the women were acknowledged as participants in the art market. According to the *Scotsman*, the Royal Scottish Academy, unlike London's Royal Academy, had not yet seen fit to offer 'tuition in art to lady students', so that when female students completed their work at the Board of Manufactures' School, they had to continue their art education 'in a somewhat desultory way'.[48] Several of the women opted for attending classes in Parisian studios (these women would later participate in the founding of the Paris Club for International Women Artists).[49]

Frustrated with this situation, Edinburgh women had organized a life class of their own in the winter of 1888,[50] soon to be followed by the organization of the Ladies' Art Club. However, the women did not move to establish their own spaces until after petitions asking the Academy to change its rules had been discussed, circulated and publicized. The problem of access to classes had been recognized as early as 1882, that is, seven years before the Club opened its first exhibition. A letter to the editor published in the *Courant* in the spring of 1882 criticized art education in Edinburgh (see chapter 1); it was time, insisted the letter-writer, that similar opportunities were offered to both sexes, that if 'a course of study at the life school' was deemed indispensable to those who intended making art their profession, then this study must be available for females as well as males.[51] A less passionate but obviously more well-informed analysis of the state of art education for women appeared in the *Scotsman* within days: 'What is really needed,' wrote a student, 'is that our existing School of Art should be put into a state of

efficiency instead of remaining, as it is at present, all but useless. Hundreds of female students annually enter the classes held in the Royal Institution building. Many of these go away disgusted at the end of a few months … many remain for the sake of the rooms, models, &c., enduring the teachers as a necessary evil.' The problems listed were serious: mixed messages about enrolments, scheduled classes being cancelled at the last minute (this was a major problem for students who commuted from the country), the poor quality of the library and, finally, mediocre instruction.[52] Another letter, again from a student and again published in the *Scotsman*, insisted that women must be allowed to study at the Royal Scottish Academy with their male colleagues. Academician William Hole responded, promising changes;[53] seven years later, when the Edinburgh Ladies' Art Club opened its first exhibition, the changes remained fictive.

Shortly before the Club's first exhibition in 1889, the women made another plea for classes but this time did not even receive a reply from the Academy. Despite this, according to the *Scotsman*, they remained optimistic particularly because the Academy was organizing a new charter: 'the ladies are in hopes that they may not be altogether excluded from the educational benefits that are promised under the new charter'.[54] Certainly, as the *Scotsman* was quick to point out, there was work to be done in connection with education of women artists in Edinburgh, and this newly formed Club was perceived as being able to accomplish this 'better than any other body'. The Club, hoped the *Scotsman*, would receive the attention and recognition that its aims and aspirations merit.

However, a glance at the press reviews of the Edinburgh Ladies' Art Club's first exhibition and reviews of the annual exhibition of the Royal Scottish Academy which opened only three months later (early 1890), elucidated the problems faced by the women. A comparison of the press reviews of the two exhibitions demonstrates that a change of venue for the same picture (by a woman artist) also changed the critical commentaries associated with the picture. Critics embellished and strengthened their reviews when the picture appeared on the walls of the RSA. When a woman artist exhibited her picture with the Ladies' Art Club, reviewers' comments were short and rather grudgingly given. When, however, she exhibited the same picture with an established and more prestigious venue, the reviews became more precise and expansive. Mary Cameron's 'clever' picture of French soldiers, when shown with the Academy, became a 'spiritedly painted picture' of French soldiers 'skirmishing in a leafless wood'; the figures showed 'excellent draftsmanship', the colour was good and the style, 'military'. Christina Paterson Ross's pictures were 'full of beautiful workmanship' and Isabella Scott Lauder's painting, *Henwife*, was 'strongly modelled', its representation of costumes and accessories carefully treated.[55]

This review, which appeared so soon after the women's own exhibition, was more effusive about women's art production and the critic also took the opportunity to highlight the artists' concerns: women, unable to obtain 'adequate tuition in the higher departments of art' and, unable to attend proper classes at the Academy, painted one week from a model in one studio, another week from a model in a different studio. This kind of training, according to the *Scotsman*, lacked the 'steady-going, systematized purpose' which characterized the training received by male students. In addition, the critic pointed out, the Royal Academy in London had made 'ample provision for the art education of ladies' and this education justified 'the wisdom of the Academy' when the female students carried off a number of the main prizes of the 1889 academic year. 'Perhaps', suggested the *Scotsman*, 'something of this may yet be seen at a not distant period in connection with the Scottish Academy'.[56] Clearly, women had no entrée to the solidarity and bonhomie provided by membership in the Academy and absolutely no access to decision-making processes.

When, in 1890, over fifty women had work admitted to the RSA exhibition, the *Scotsman* sardonically insisted that the Hanging Committee must have had to exercise a 'considerable amount of ingenuity' in order to sky almost every work by a woman, while those not skied were 'put into an odd corner, or under an arch', where the pictures were almost impossible to see. 'The ladies,' wrote the critic, 'certainly have cause to grumble at the ungallant way in which their works have been treated by the Academicians.' Apparently 'ungallantry' did not extend to the watercolour room where, according to the *Scotsman*, 'more justice' had been done to the women's pictures. Quite likely this had less to do with gallantry than with a more ready acceptance of women as watercolour artists and, possibly, with the recognition of their activity in the Royal Scottish Society of Painters in Water Colours. Edinburgh Ladies' Art Club members, Margaret Dempster, Jessie Dixon Gray, Florence Haig, Barbara Peddie and Rosa Woon (among others) were singled out for commendation. Christina Paterson Ross as President of the Ladies' Art Club and as a member of the Royal Scottish Society of Painters in Water Colours was given a stellar review for her picture *Russian Tea*, a portrait of a woman in an interior and for *Sand Carriers*, her 'study on the French coast'; as always the critic complimented her skilled use of the medium and her 'workmanship'.[57]

The following year, the critic again singled out a number of women artists who exhibited regularly with the RSA all of whom were active members of the Ladies' Art Club: Meg Wright's half-length portrait of a woman was her 'best work yet'; Margaret Dempster's pictures were meritorious; Mary Cameron's portraits, one of a woman in a walking costume, another of a well-known politician, were excellent – the critic lauded her draughtsmanship, her

ability to represent textures and her accomplishment in the painting of hands; and, Mary Rose Hill Burton's Irish landscape was described in detail, then praised for its 'careful workmanship'.[58] The women received good reviews but the conditions under which they exhibited were not highlighted as they had been earlier.

When the Ladies' Art Club opened its second exhibition, the ideologies surrounding woman's art production became clearly evident: the *Scotsman*'s review insisted that the exhibition, 'on the whole' was rather disappointing.[59] The critic accepted and reinscribed the frequently made association of middle-class women with frivolity by suggesting that the artists 'could do a great deal better if they were in earnest with art, and did not make it merely a side interest'. Certainly, many of the women with work in the exhibition took their art very seriously indeed; some, like Christina Paterson Ross, earned their living by making art and teaching art. Isabella Scott Lauder (Fig.7) exhibited, taught art and lectured about art. After her father's death in 1869, Isabella Lauder moved to Tayport, teaching in and near Dundee until she married James Thomson in the mid 1870s. Although she gave up teaching for a period of time when she and her husband lived in London, she went back to her career of painting and teaching when they returned to Edinburgh around 1880. By 1895 she had added lecturing on art to her repertoire: she offered courses in Edinburgh, Dundee and Glasgow. The series of lectures went under the title 'A personally conducted tour in Italy (by lime-light) among the Painters, Sculptors, and Architects of the Early Centuries' and included individual lectures such as 'An Afternoon in Florence'. The *Scots Pictorial*, commenting on Lauder's lectures, wrote that 'in the respect of education and personal study abroad, none can be imagined better equipped to deal with Italian art'.[60] She gave birth to two sons, one in 1878 in London and the other in 1880 in Scotland. However, neither her marriage, nor motherhood, nor her husband's independent income prevented her from following a career in the arts.

Despite the significance the women attached to their careers as artists, the *Scotsman*'s critic insisted that there was little 'evidence of an intention to grapple with a serious subject; in portraiture the results obtained [were] not altogether satisfactory; and even in landscape the works shown have in them more of promise than of performance'.[61] However, the 1890 exhibition apparently 'had its good points' when the artists rose 'above an amateur standard'. Not only did this kind of review 'section off' the women's art from art in mainstream venues but it left behind a text that, if not questioned and deconstructed, gives twentieth-century readers a very specific and ideologically constructed vision of the late-nineteenth-century woman artist that, as can be seen from the examples of Christina Paterson Ross, Georgina Greenlees, Isabella Scott Lauder, Mary Cameron and many others, is histori-

7 Isabella Scott Lauder in the *Scots Pictorial*, 1897

cally suspect. In addition, rather than acknowledging the women's artists' societies as professional organizations performing exactly the same functions for their members as, for example, the Scottish Arts Club, the press encouraged the marginalization of such societies and reinforced their difference.

The Scottish Arts Club was a traditional and infinitely more established organization than the Edinburgh Ladies' Art Club. It formed in 1872 as the Scottish Artists' Club. Its move into new quarters in Edinburgh's 24 Rutland Square closely coincided with its name change which, in turn, signalled the admission of interested laymen as well as artists: the Club 'opened the door for the admission of men who, though not artists, are in close sympathy and association with art'. This apparently judicious 'admission of an outer element' was meant to 'freshen the atmosphere without in any way quenching the enthusiasm and the spirit of comradeship that belongs to the pursuits of the painter and the sculptor' and, in addition, it promised to 'bring Scottish art into closer touch with the Scottish public'.[62] This aside in my text has three purposes: first, it demonstrates the 'spirit of comradeship' nurtured by all art clubs; second, it clarifies the exclusions common to most of the clubs, this one being open only to male painters and sculptors; and third, it highlights the nationalism fostered by many of the clubs. The Scottish Arts Club represented and perpetuated a specifically late-nineteenth-century male ambience which was then readily transcribed into pictures and sculptures. Moving into new quarters provided an opportunity to reminisce upon the old: 'the men who have sat and laughed and talked and smoked with the goodly company who have gone may be excused for fearing that the later times can bring no such meetings of choice spirits, genial and gentle, as in the days that are no more'. Concomitantly, moving into new quarters provided the excitement of change and a chance for new adventures of the brush and hammer: the Scottish Arts Club 'has done wisely in setting the sail to a breeze of change and venturing out into more open waters'.[63]

The envisioned role of the Club was a mediating one, 'between artists and the world, to the benefit of both', and as such committed itself to putting aside the 'feud between art, which was sent to be the benefactor of mankind, and the great public from whom, in these democratic days at least, art must look for its great rewards and encouragements!'[64] The public, in this instance, was specifically and uniquely Scottish – it was served spiritually by the 'growth of the long and brilliant line of Scottish artists', and socially by Scottish art:

We should have among us an art and a literature recognizable, as are the works of the great national spirits, Burns, and Scott, and Raeburn, not simply or chiefly because the theme or the scope is Scottish, but because it possesses the Scottish depth, the Scottish strength and grip of life, the perfervid earnestness and the geniality

that are born in the blood and are racy of the soil. We should have, together with a famous school of art, a great Scottish manner.[65]

These rousing remarks came from Victorian author Hall Caine who declared the Club 'open' at a ceremony to which women had been invited. George Reid, the Club's President, congratulated the committee on 'the wisdom they had shown in inviting ladies to be present that day'. After receiving applause for this acknowledgement, Reid caused laughter when he suggested that the women 'would be able to satisfy a pardonable curiosity as to what a club confined to members of the opposite sex was like'. Reid did not remember that any such opportunity 'had ever been given by a committee of a ladies club' (his audience laughed again) but he hoped the present event 'would not be the last occasion on which those rooms would be graced and brightened by the presence of ladies'.[66] Unlike late twentieth-century reporting, nineteenth-century writers often included, in brackets, various forms of audience response – clapping, applause, laughter, cheering, jeering and so on thereby sprinkling written accounts of historical events with some indication of an audience's activity during speeches or lectures. Jokes, during events like the opening of the Scottish Arts Club were frequently at the expense of women.

In his lengthy speech, Reid expounded further upon the greatness of artists, their heroism and their sense of exploration which he fancifully compared with the rollicking adventures of Raleigh and Drake. 'It must have been a glorious thing,' said Reid, 'to live in those days, but though they are now gone, never to come back again, we have something equivalent in the very different enterprises of art.' Artists in England and Scotland had become 'another race of explorers . . . who go out to seek treasure in the fastnesses of Nature, in the Highlands, among the mountains, in the villages, on the sea, under the coast – treasure of flower and heather, and rock and cloud – bring it back to us in the city in the pictures they hang on our walls'.[67] Later in the evening, reverting to their Club atmosphere (that is, without women), 'a company of 150 gentlemen' sat down to a dinner.[68]

Caine spoke again, this time proposing the toast of the evening commending the Club for extending its membership while he criticized artists who drew away from the world as if they belonged 'to another race', showing nothing but contempt for the 'opinion of the public'. According to Caine, there was 'a great public of limited intelligence and inferior education' that must be reckoned with:

At the Manchester Exhibition two factory girls from Bolton stood before Millais' 'Huguenots'. They knew nothing of the Massacre of St. Bartholomew, and they didn't know what the picture was about. But the expression of pain on the face of the lady affected them to tears, and they were wiping their eyes. It puzzled them, however, that the lady should look so sad, being evidently on such excellent terms

with her sweetheart. And then there was the handkerchief. What *did* it mean? At length one of the girls hit on a bright idea. 'I know what's up,' she said. 'They've been having a stolen meetin in the garden so as the old folks wouldn't know, and the garden gate has blown to unexpected and clipped the young woman's hand'.[69]

Caine observed that it is was well-worth an artist's time 'to make a reckoning with' the public represented by the two young factory-workers, that art was not above educating such a public, and that while too much submission to 'public taste' could be dangerous, he felt that if he had 'anything to say', he must not despise those to whom he addressed his work: 'let me make myself intelligible to them, let me speak in their language, even if I have to sacrifice some of the quality of my own'. But before a reader of this text subscribes to a conviction of class consciousness amongst the artists, it must be noted that the speaker quickly moved to commendations of men of great achievements, men of great character and men of genius.

The Scottish Arts Club represented the traditional bastion of culture while the Edinburgh Ladies' Art Club subsisted on the fringes even though many of its members were recognized as 'regulars' in the large, established venues. A new organization, the Society of Scottish Artists was the first organization in Scotland to attempt to bridge the gap between the separate and exclusive traditional societies and the growing need to recognize women within the profession. The formation of the Society of Scottish Artists in the autumn of 1891 brought artists together with such diverse personalities as Gerald Baldwin Brown, Professor of Ancient History and the first incumbent of the Watson Gordon Chair of Fine Art at the University of Edinburgh; David Masson, Professor of English Literature at the University of Edinburgh and an active supporter of the Edinburgh Association for the University Education of Women; Flora Stevenson, a staunch campaigner for women's rights and a member of the Edinburgh National Society for Women's Suffrage; and, Patrick Geddes, Edinburgh's 'renaissance man', biologist and urban planner. 'There was a good attendance of ladies and gentlemen', reported the *Scotsman*, 'the younger branch of the artistic profession being well represented.' The Marquis of Huntly, the President of the Society of Scottish Artists, used the organization's first meeting to explain 'objects and aims' and to express great regret 'at the absence on this occasion of the President of the Royal Scottish Academy'.[70]

The public meeting, to coincide with the inauguration of the new Society, took place in Edinburgh and although artists from across Scotland took part, most lived and worked in Edinburgh. This signalled, then, the first serious threat to the Royal Scottish Academy's hegemonic control over art production in the east of Scotland and, in addition, confirmed the role of women as professional artists. Nevertheless, words were carefully chosen so as not to offend the Academy nor those academicians who did not join the new

Society: 'Do not let any one suppose', said the Marquis of Huntly, 'that there is any desire or intention on the part of the Society to weaken or derogate from the supremacy of our leading national institution for the promotion of art in Scotland.'[71]

The Academy was, according to the new Society, bound by the nature of its constitution and by a tightly controlled admissions policy precisely at a time when the number of artists had increased. Justifications for the formation of a new Society continued as attempts were made to contain any notion of rivalry between the two organizations, the one of which obviously attracted younger, more innovative artists and the other which represented the establishment. This debate followed closely those being held in many parts of Europe about the same time and, while interesting, the Scottish story does not significantly differ from narratives of power shifts and reorganizations in art-centres in London, Berlin, Vienna or Paris.[72] However, the afternoon business meeting which took place after the large public meeting 'agreed to admit ladies on the same conditions as men'[73] and, for the first time in Scotland, women obtained entry to an artists' guild as professional members.

The Society of Scottish Artists traversed the segregated areas of men's art clubs and women's art clubs, providing a forum that at least began a reintegration of gendered spaces – to whose advantage remains an open-ended question. Christina Paterson Ross, Jessie Dixon Gray and Margaret Dempster took their places as full members of the Society of Scottish Artists and became active supporters of the organization as well as regular exhibitors. What they exhibited and where they worked linked the women together within the community of artists in Edinburgh. As mentioned above, Christina Paterson Ross lived in a flat at the west end of Queen Street with her family (Fig.8). After the death of both parents, Christina along with her artist-brother Joseph Thornburn Ross and their sister Jane Ross, moved into a flat in Atholl Crescent, remarkably close to the artist-centre of Shandwick Place. The flat was long and narrow but spacious with north windows facing out onto Atholl Crescent and south windows facing out onto Atholl Crescent Lane. Joseph Thornburn Ross kept a studio (formerly the stable) with a separate entrance on Atholl Crescent Lane as well as a direct entrance into the house; Christina Paterson Ross presumably kept her studio in the front of the house.[74] Like many middle-class households the Ross's kept servants (two according to press accounts) and it appears that the younger sister attended to the running of the house, freeing both her sister and brother to paint and instruct students.

Jessie Dixon Gray's family resembles Christina Paterson Ross's in almost every way. She lived with her family until she married and her father and sister Isabella were both painters. In addition, during the 1890s an English

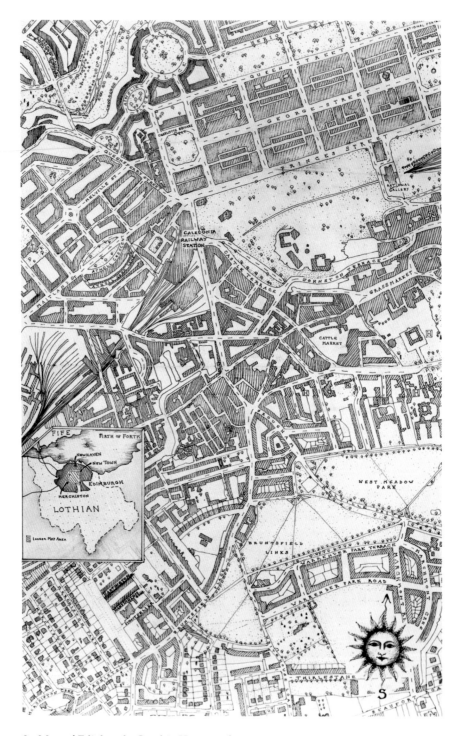

8 Map of Edinburgh, Cynthia Hammond

woman artist, a flower painter, boarded with the family in their large War-
render Park Crescent flat. Like Christina Paterson Ross, Gray's studio was
in the flat possibly because, in both instances, the families were intimately
involved with art production and living space would have been inextricably
interwoven with professional space. While not as close to the galleries and
supply shops as the Ross family, the artists were within walking distance of
Shandwick Place where so many of their colleagues worked, including
Margaret Dempster.

Dempster, although she lived almost around the corner from Ross's Queen
Street flat, was far wealthier than either Ross or Gray and did not live
amongst other artists. Her father was a sugar refiner and his income provided
his family with a sixteen-room house in Glenfinlas Street at the west end of
Edinburgh New Town's Charlotte Square. While Margaret Dempster was
attending art classes in the Board of Manufactures' School (she won a
Queen's medal when she was only seventeen),[75] her younger sisters were
being educated by a governess, a privileged kind of education she would
have also received. In addition, while most middle-class families had one
domestic servant working for them in the late nineteenth century, the
Dempster family employed a cook, a tablemaid, a housemaid and a kitchen-
maid thus attesting to the wealth of the household. However much
Dempster's wealth may have set her apart from her colleagues, she shared
their interests: she was a founder-member of the Edinburgh Ladies' Art Club
even serving as its secretary in the mid 1890s and she also joined the Glasgow
Society of Lady Artists. Before her marriage to landscape painter Robert
Buchan Nisbet in 1895 she appears to have kept her studio in the family
home; after her marriage she shared a studio with her husband in Shandwick
Place. In 1891, when the Society of Scottish Artists was forming, she was a
young, promising artist already recognized in the Edinburgh art community
as one of the top students of the city's art school and as an active member
of the women's professional organization.

Dempster placed a 'Sketch' of a 'young veiled lady', commended for its
excellent brushwork, in the first exhibition of the new Society which opened
in April 1892 in the galleries on the Mound (Fig.9).[76] These galleries,
according to the *Glasgow Herald*, although used by the Royal Scottish
Academy, did not belong to 'that august body, but are vested in the Board
of Manufactures, who granted the use of them' to the Society of Scottish
Artists. The new Society not only used the galleries but changed the 'look'
of them, making them more comfortable for the public and 'brighter'.[77] The
walls of the rooms, with one exception, were 'hung with rough grey canvas,
having overhead a low-toned sage green valance'; the central room was
covered with maroon coloured canvas. In addition, the pictures were hung

9 *The Motoring Veil* (nd), Margaret Dempster

'with large blank spaces between them' thus they were easy to view and not as crowded as during RSA exhibitions.[78]

Although Dempster, Ross and Gray exhibited with the SSA as members of the society, many of their colleagues from the Edinburgh Ladies' Art Club participated – Meg Wright and Mary Cameron, for example, had their pictures praised by the press. However, in the early years of the Society the women, while they obtained equal membership, did not achieve the kind of representation that they had in their own societies, and female membership of the SSA did nothing to alter their status with the RSA.

In 1901 Christina Paterson Ross, Mary Cameron and Meg Wright were nominated as Associate members of the Royal Scottish Academy (ARSA). However, as the *Pall Mall Gazette* noted, the infamous RSA charter was silent on the admission of women to the ranks of the Academy, and the silence 'would be used as an argument both ways'. According to the *Gazette*, 'the champions of the ladies' contended that not being excluded from being nominated as members meant that they could become members: if they could be nominated, then they could also be members. However, the 'other side' insisted that because they were not mentioned in the charter, clearly the charter never meant to include them; therefore, they could not become members.[79] The *Scots Pictorial* reported that the members of the Royal Scottish Academy were 'so divided in their opinion as to the eligibility of the gentle sex that legal advice had to be taken on the subject'.[80] Later, when the decision against the women had been made, the *Studio* reported that 'considering Academic tradition it is perhaps needless to say that no woman was elected'.[81] The Academies in Edinburgh and London would refuse women as members until the 1930s by which time their own power had been contested and often replaced by numerous new organizations like the Society of Scottish Artists; all the organizations vied for visibility in attempts to promote the work and the abilities of their members.

The exhibition venue, in addition to representing the site of the culmination of an artist's labour, also stands for or represents the validation of the artist's labour. Thus, while it provides a space in which the artist might proffer work for sale or garner interest in her or his talents as a teacher (hence gaining income by 'selling' knowledge), its most important function is to publicly validate the relationship between artist and public. Exhibition causes the art product to leave the private studio for the realm of the public forum and in doing so, draws attention to the artist in tandem with her society and culture. Organizations attached to venues, such as the Royal Scottish Academy and its own exhibition, control and regulate the negotiation between the initiated artist and the observing (and often buying) public. Keeping women out of such organizations hindered their ability to function successfully within the market-place. Thus, it is to the women's own societies

that historians must turn to better understand nineteenth-century women's attempts to establish their professionalism as cultural workers – it is the so-called 'separate societies' that provided a space for validation amongst these middle-class women workers and ensured their identity as 'artists'. Far from highlighting difference, the societies prompted the kind of union and organization women needed to establish a place in the artistic economy – the societies were the women's nineteenth-century guilds. If organizations like the Edinburgh Ladies' Art Club can be discussed in this context we might be able to expand or open up the rather restricted space to which such organizations are assigned. Giving them space allows recognition and may render visible those who have become invisible.

An earnest band of workers in the field of art

Nineteenth-century artists in Scotland worked to exhibit in numbers of British and Continental venues while, at the same time, recognizing the importance of establishing themselves in their own communities. Visibility gave them opportunity; display promised success. Little has changed: today's artists as well as yesterday's must be seen before they can be remembered, and memory is enhanced by the spectacle. In the late twentieth century, the memory of Scottish art has been dramatically reified by two large and somewhat related exhibitions: *'Glasgow Girls': Women in Art and Design, 1880–1920* (1991) and *Charles Rennie Mackintosh* (1996). Both exhibitions were organized under the auspices of Glasgow Museums, both celebrated Glaswegian artists, both attracted huge audiences and both helped define 'Scottishness' in art, now ubiquitously identified with 'The Glasgow Style'.

What follows is a narrative about the 1890s and the 1990s; the protagonists are women artists who lived in the 1890s and who, because their work was displayed in the 1990s, live again. *'Glasgow Girls': Women in Art and Design 1880–1920* opened in Glasgow Museums' Kelvingrove Art Gallery in August 1990. Its original closing date of 21 October 1990 was extended to 6 January 1991 only after controversial animosities between the reluctant venue administrator and the exhibition curator (an independent curator) were splashed across the pages of Scottish newspapers. The exhibition had been mounted despite Glasgow Museums' initial unwillingness to provide the venue. As Julian Spalding, the Director of Glasgow Museums and Art Galleries admitted, he had reservations about 'the concept of the show . . . but these misgivings did not prevent me and my organization giving all the help we could to realize the show, which within its limitations, is important, well done and popular'.[1] In fact, Spalding did almost everything he could to prevent the exhibition from ever taking place and it opened only because of curator Jude Burkhauser's strength, independence and fortitude.[2]

While the behind-the-scenes stories about this exhibition are already legendary in proportion and viciousness, the popularity of the show was enormous: 20,000 visitors saw the exhibition during its opening week and, altogether during its four-month existence, 400,000 viewers came to look at and enjoy the work of Glaswegian women, most of whom had studied at the Glasgow School of Art and most of whom were members of the Glasgow Society of Lady Artists. Numbers of women were included but the women associated with the 'Glasgow Four' were highlighted. These included Frances Macdonald, Margaret Macdonald, Jessie Newbery and their friends and colleagues in the so-called 'Mackintosh circle'. Thus the exhibition and the accompanying book challenged the hierarchies while at the same time perpetuating them and, in keeping with this, it was a detail from Margaret Macdonald's *The Opera of the Sea* (c.1905) which graced the book cover, the poster and the private view invitation. As Lynne Walker suggested in her review of *'Glasgow Girls'*, it did 'not even attempt to deconstruct the myth of Charles Rennie Mackintosh, the architect, designer and partner (in both senses of the word) of Margaret Macdonald'.[3]

Near the end of May 1996 a large exhibition devoted to the architectural and decorative work of Charles Rennie Mackintosh opened, as had *'Glasgow Girls'*, amidst furore and fanfare. The exhibition travelled from Glasgow's McLellan Galleries to New York's Metropolitan Museum in November and from there on to the Chicago Fine Art Institute and the Los Angeles County Museum, marking the first time American viewers were able to see such an accumulation of work done by the acclaimed turn-of-the-century Scottish architect. While feminist art historians and so-called 'new' art historians vigorously have attempted to displace the celebrated individual genius artmaker, museums continue to mount the spectacles which attract thousands of viewers, thus bringing badly needed dollars to the coffers of financially insecure public institutions.[4] During the eighteen weeks of Glasgow Museums' Mackintosh exhibition over 200,000 visitors made their ways through the wondrously designed Sauchiehall Street Gallery. That the exhibition reproduced almost precisely, albeit on a much larger scale, the ideology of the 1933 Mackintosh retrospective exhibition which had been held in the same location, slipped by unnoticed.[5] However, Martin Filler, in his review of the exhibition in its first American venue, did comment on the exclusions: 'That the show seen in New York is about 20 per cent smaller both in floor space and number of objects displayed is not as disturbing as the fact that almost all of the rejected artifacts were by the least famous three of the Four'.[6]

The historical women I wish to discuss – Janet Macdonald Aitken, Katherine Cameron, Jessie Keppie, Jessie Newbery, Ann Macbeth and Agnes Raeburn – played a role in the *'Glasgow Girls'* exhibition and are mentioned

briefly in the material which accompanied the Mackintosh exhibition. However, my concern is to elaborate upon the work and lives of the women who have come to be associated with the so-called 'Mackintosh circle', the aphorism that now dominates discussions of the turn-of-the-century Glaswegian art world. As Fiona MacCarthy suggested in her review of the Mackintosh exhibition, Mackintosh's 'new surge of popularity is not unconnected with his usefulness as focus' as Glasgow's 'heritage hero' during 1996, the city's 'Year of the Visual Arts' and as a promoter for Glasgow as Europe's 'City of Architecture and Design' in 1999.[7] The discussion that follows is not engaged in the making of an icon but rather seeks for a commentary about groups and friends – for artists in relation to other artists, for those who worked around the artist who years after his death has been constucted as 'hero'. My major concern is friendship amongst female artists and the identity of a particular coterie as middle-class working women; the second concern is layered upon the first and accepts that the information I have gathered about these women probably would have disappeared had it not been for intense Mackintosh-mania.

Six photographs were found recently by George Rawson, Fine Art Librarian at the Glasgow School of Art, and published by him in the *Charles Rennie Mackintosh Newsletter* (Summer 1993). The photographs depict a group of friends enjoying each other's company during a summer working holiday near Dunure south of Glasgow on Scotland's magnificent west coast. Subsequently, selected photos have been reproduced in at least four books[8] and they were included in the Mackintosh exhibition as a rare bit of archival material showing Mackintosh with his future wife and partner, Margaret Macdonald, her sister Frances Macdonald, Mackintosh's friend and colleague James Herbert McNair, along with other friends from the Glasgow School of Art (Fig.10): Janet Macdonald Aitken (1873–1941), Katherine Cameron (1874–1965), Jessie Keppie (1868–1951) and Agnes Raeburn (1872–1955).

Alan Crawford, in his recently published *Charles Rennie Mackintosh* (1995) has labelled the first of the photographs and the only one he reproduced in his book, 'The Immortals at play'.[9] The 'Immortals' seems to have been the name this lively group took for themselves and while Crawford suggests that being a member of the 'Immortals' freed Mackintosh socially and personally,[10] he does not comment upon how the group might have freed the women and, in addition, how it might have provided support for like-minded women from similar backgrounds with similar aims and aspirations. Crawford interestingly, and perhaps ironically, chose to include the one photograph from the group that most accurately represents Mackintosh as he has been created by art historians and critics: a lone, adulated man amongst his intelligent, creative supporters – in this instance, all of whom are women. Rather than encouraging the exploration of relationship or com-

10 The 'Immortals' at Dunure

munity, the practice has been to remove one artist from the others who
contributed to the conditions of production.

However, friendship is a material and visible point of connection for all
artists, female and male, and collaboration occurs much more frequently
than is generally recognized. The relationships amongst the Glaswegian
women developed in and around 'like-mindedness', camaraderie – what
today would be called networking – and allowed the artists to share knowl-
edge and understanding as it related to their careers as well as to provide
support for each other's forays into the highly visible world of the exhibiting
venue. Class and gender were woven into every aspect of the friendships.
In addition, the friendships were embedded in an economic structure that
ensured the women a coveted existence in the wondrously flexible middle
class, an existence which remained at least one step removed from, for
example, waged female labourers in Scotland's textile industry.

While the photographs document the presence of the women together,
thereby providing a visual record of their association, their connection to

one another is confirmed also by their attendance at the Glasgow School of Art, their involvement with a student publication, the *Magazine*, their membership in the Glasgow Society of Lady Artists and by their wills. As legal documents, wills give insight into the organization and dissemination of material culture.[11] Wills also enable a reader to establish connections that might otherwise go undetected. Although I assumed the four women in the Dunure photographs were friends, I could not establish definitive relationships until recognizing the circulation of material belongings and money amongst themselves. Janet Macdonald Aitken, the first of the friends to die, left jewellery to Raeburn and Keppie, and left money to Agnes Raeburn who, of the group of friends, was the least well off. Jessie Keppie, the wealthiest of the women, left £1000 pounds each to the Glasgow University Queen Margaret Settlement, the Glasgow Society of Lady Artists and the Redlands Hospital for Women; she left Agnes Raeburn £500. Even Raeburn left £50 to the Queen Margaret College Settlement. Wills, then, can establish and confirm interpersonal relationships amongst a group of women while, at the same time, denoting loyalties to women's professional organizations and support groups. For example, the relationship between Queen Margaret College, which had been founded in 1883 as a women's college associated with Glasgow University, and women artists attests to the support professional women provided for one another.[12] By the 1890s Queen Margaret College 'became unique in Scotland as a women's college that offered university-level teaching in both arts and medicine' and the Settlement Association undertook projects, for example, that established 'pioneering work on infant care, including the distribution of free milk to pregnant mothers'. In addition, and in keeping with the College's concern for women's rights, it was closely affiliated with the suffrage movement.[13] Affiliation with the College and the Settlement, like membership in the Glasgow Society of Lady Artists, confirms an ongoing support for groups that promoted women's rights and activities.

The four women artists, Aitken, Cameron, Keppie and Raeburn, like many of their nineteenth-century counterparts in England and other European countries as well as in North America, were middle-class, ranging from upper-middle class with small private incomes to middle- or lower-middle class which meant the woman must earn her own income. Because of this designation, their work as labour has become invisible even though, in some instances, their product remains on the market or in public and private collections. Artists' labour is seldom, if ever, discussed although art historians readily designate the product of their labour as 'a work', thereby changing the active verb (work) into a noun (an economic product or work of art). This kind of discussion combines with ideologies of the family, the domestic and the private or 'separate sphere' and, together, colludes to hide the work space and work place of the nineteenth-century middle-class woman,

whether that work space/place was within or without her home. Thus, a middle-class woman who worked was made invisible by her own society as it struggled to retain the myth of the serene, devoted housewife-mother, even though, as Elizabeth Wilson has suggested 'it has been an important part of feminism to argue that the private sphere is the *workplace* of the woman'.[14] This becomes more cognizable when the woman is an artist working at home in a studio – her conflation into the domestic speaks of a rigid categorization that fails to recognize flexible and transitional spaces.

The *'Glasgow Girls'* exhibition recognized the problems associated with the designations private and public and attempted to present an integrated view of women's art, one that accepted a blurring of the categories between fine art and applied art. Women artists educated at the Glasgow School of Art during the late nineteenth and early twentieth century frequently exhibited in both fine art and decorative art venues and in so doing moved between what often have been considered discreet areas of production. In recognition of this ability to cross boundaries, the *Studio* (1900) pointed out that the Glasgow School of Art was 'not only a school but also a workshop', where the students were 'brought directly under the influence' of skilled crafts-people.[15] Nowhere were the skills associated with an efficiently run workshop more in evidence than in the Embroidery Department founded by Jessie Newbery in 1894. Newbery's student, friend and colleague Ann Macbeth became her assistant in the classes in 1901 and, together, they succeeded in organizing one of the most renowned needlework departments in Britain.

However, even though work like Jessie Newbery's *Glasgow Rose* cushion cover (*c.* 1900) or Ann Macbeth's *Sleeping Beauty* embroidered panel (1902) may have figured largely in Glasgow Society of Lady Artists' exhibitions during the 1890s, in 1990, during the *'Glasgow Girls'* exhibition it was Margaret Macdonald or painter Bessie MacNicol who were most frequently profiled in press coverage of the exhibition.[16] As mentioned earlier, Margaret Macdonald's oil and tempera panel, *The Opera of the Sea*, was the image chosen for the book cover and for the poster which advertised the exhibition.[17] This was not an accidental choice and, while Margaret Macdonald's work is exquisite, interesting and exciting, singling her out for recognition has more to do with the reception of Charles Rennie Mackintosh and the role Macdonald played in his life and work than with Macdonald herself.

'Glasgow Girls' at the same time as it provided an alternative exhibition, succumbed to the patriarchally constructed fame of certain of the artists. Nevertheless, the Macdonald sisters did conflate public and private and, during the 1890s, represented a space women might occupy outside of strict dichotomies. Margaret and Frances Macdonald worked out of their Hope Street studio, never at any time belonging to the Glasgow Society of Lady

Artists as did the other women in the Mackintosh circle and as did their teacher, friend and colleague, Jessie Newbery. I have speculated elsewhere that the production of members of the women's societies may have tended toward the making of naturalistic landscape paintings, flower paintings and refined or tasteful applied arts. The Macdonald sisters, on the other hand, leaned toward more recent trends in art nouveau and distortion of shapes and figures, for example, the *Drooko* poster designed for the Glasgow Umbrella Factory (1895) (Fig.11). Perhaps because of this, or more likely because of their working and personal relationships with architect Charles Rennie Mackintosh, the sisters remained independent of organized women's groups. While it may be convenient to speculate that they therefore opposed the separate societies, I think it is more useful and probably more accurate to accept that their directions were somewhat different from the Society and, rather than assuming oppositions, I suggest that the different models or range of models available to women be considered. However, there is no doubt that attachment to a 'famous' man goes much further in securing a place for the historical female artist than does membership in a separate society. Hence, Jessie Newbery and Ann Macbeth although associated with the Macdonald sisters both professionally and privately – Jessie Newbery was a friend to both sisters, but particularly to Margaret, and Ann Macbeth worked with Frances Macdonald at the GSA – have not obtained the same kind of public recognition and posthumous fame as have the Macdonalds; neither have the four women pictured in the Dunure photographs with the 'Glasgow Four'.[18]

Lady artists' societies in Scotland

Rivalry between the east of Scotland and the west of Scotland, particularly between the two major cities, Glasgow and Edinburgh, played itself out in the art world much as it played itself out in business and industry: as a narrative that incited speculation and excitement. The press was quick to corroborate evidence in the form of public disagreements between the 'factions'. For example, in 1885 women art students were at the heart of contentions between the east and the west with the west assuming a superior and enlightened attitude toward art education for women.

Sir William Fettes Douglas's speech to the students of the Edinburgh School of Art coincided with the annual prize-giving. Held in the rooms of the Royal Scottish Academy, the event attracted students, their teachers, their friends and relatives and interested members from the art community. Statistics showed that while overall enrolment at the School had decreased, female enrolment had increased; the Male School had lost twenty-four

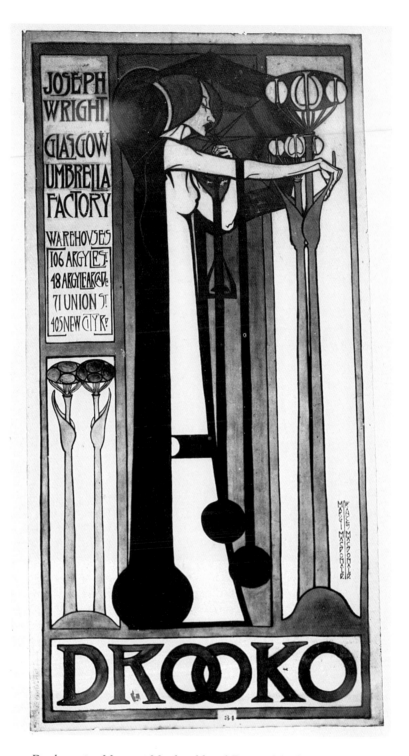

11 *Drooko* poster, Margaret Macdonald and Frances Macdonald, 1895

students (making a total of 457 students) while the Female School had gained twenty-one students (making a total of 324 students). Female students made up just over 40 per cent of the student population but when Fettes Douglas addressed these students, he spoke 'to the male rather than to the fairer section of the students'. He defended his position by saying that women 'rarely, if ever' applied themselves 'to the acquisition of any art or handicraft with that continuous attention which a thorough mastery of it demands'. According to Fettes Douglas, the 'inferior quality' of their work resulted from the female students' lack of seriousness: women were 'relative' failures in the art world and their work was amateur. He particularly attacked women's skills at drawing ('she has no talent for it') even though Annie Knight had received a bronze medal at the national level for her 'chalk drawing of figure from the antique', and Emily Henderson had received a Queen's Book Prize for a watercolour picture.[19]

All in all, the speech shocked the audience, particularly those who supported women's education and professionalism. It was most damning for those women hoping to receive further art education under the auspices of the Academy: Sir William Fettes Douglas, President of the Royal Scottish Academy between 1882 and 1891, unlike his fair-minded predecessor D. O. Hill who had endorsed the entry of female students to Edinburgh's School of Art in the 1850s, trenchantly opposed the expansion and improvement of education opportunities for Edinburgh's women artists. During his speech Fettes Douglas went so far as to criticize the dress of the female students: 'they go about dressed to look as much like men as possible – and miserable, puny, little men they make – and their works are like them'.[20] As one female student at the School of Art suggested: 'Sir William seems strangely wanting in gentlemanly feeling when he could hold up to ridicule the half or three-quarters of his audience composed of ladies in order to elicit the laughter and applause of the remainder, chiefly composed of boys.'[21] Another 'shocked' student wrote that the 'prize-list and the drawings on the walls were sufficient proof that the President's remarks on the relative merits of the male and female schools were open to question; while the criticism of feminine costume was so uncalled for, and so far removed from the subject in hand, as to produce among the audience only a mild bewilderment'.[22] Support for women artists in Edinburgh, as seen in Chapter 1, particularly from those who held powerful positions in the major institutions, either was not forthcoming or was sporadic.

In Glasgow, women artists received endorsement for their endeavors from leading figures in art education in the city and, in addition, the Glasgow School of Art was more successful than the Edinburgh School of Art in the annual Science and Art Department competitions in London. For example, in 1884 Scottish schools gained a total of twenty medals: thirteen of these

went to Glasgow.[23] The close connection in Glasgow between art education and the women's professional organization was obvious – five of the six female prize winners, Jessie Allan, Anna Bowie, Susan Crawford, Louise Perman and Emma Watson,[24] were members of the Glasgow Society of Lady Artists. Less than a month after the Edinburgh meeting, Sir James Watson used the annual meeting of the Glasgow School of Art to defend the position of female art students and to criticize Fettes Douglas for his outrageous humiliation of women studying in Edinburgh: 'The remarks I have made apply equally to the Ladies attending this school. I utterly discard', continued Watson, 'the extraordinary views expressed by Sir Fettes Douglas in his address, on a late occasion, to the Students of the Edinburgh School of Art, as to the work and capacities of women.'[25] Contrary to his Edinburgh counterpart, Sir James commended women for their hard work and insisted that should they continue to apply themselves, they would take a distinguished place in the art world.

The debate between William Fettes Douglas and James Watson replicated in a public forum the discrepancies between women's art education in the two cities as well as the reasons for the formations of the respective women's art organizations. The Glasgow Society of Lady Artists was formed as an addition to the training the women received at the art school and as a professional organization that enabled them to continue their training or to provide simultaneously a space for an extended and expanded art practice. Edinburgh, on the other hand, organized because women did not have a 'good enough' training and because they were kept out of the Royal Scottish Academy's life-classes.

Having claimed differences between the east and the west, I must note that amongst women artists working in Scotland during the late nineteenth century dichotomies between west and east were not rigid and, while differences in education opportunities and methods of teaching did vary from Glasgow to Edinburgh, individual women moved back and forth between the two cities, in many instances belonging to professional associations in both places. For example, a number of women belonged to both the Glasgow Society of Lady Artists and the Edinburgh Ladies' Art Club. In addition, the two organizations attracted women artists who resided in neither of the two cities but who lived in smaller towns within travelling distance. Mary G. W. Wilson, for example, lived in Falkirk, studied in Edinburgh, exhibited in London as well as in many Scottish venues, belonged to the Edinburgh Ladies' Art Club, the Glasgow Society of Lady Artists and later, in the 1920s to the newly formed Edinburgh-based Scottish Society of Women Artists. Margaret Dempster studied in Edinburgh, kept a studio in Shandwick Place until she moved to Crieff with her husband Robert Buchan Nisbet, was Secretary of the Edinburgh Ladies' Art Club in 1896, and was a member of

the Glasgow Society as early as 1891.[26] Isabella Scott Lauder, trained in Edinburgh, founder-member of the Edinburgh Ladies' Art Club and sometimes living in Dundee or London, was nominated as a member of the Glasgow Society in 1897.[27] Jessie Algie studied at the Glasgow School of Art and belonged to the Glasgow Society but she lived and taught art in Stirling. Ellen 'Nellie' Harvey lived, worked and taught in Stirling after training with J. Denovan Adam at Craigmill and with Délècluse in Paris; she became a member of the Glasgow Society of Lady Artists in 1915. In addition, courtesies were sometimes extended to 'visiting' artists. Edinburgh's Emily Murray Paterson, for example, when she opened a solo exhibition in Glasgow in 1906, was elected an Honorary Member during the period of her exhibition.[28]

Even though most members joined the Society that was located in the city in which they lived and worked, the organizations served the interests of women from both the large cities as well as from the smaller areas with too few professional women artists to form a working organization. The Glasgow organization, however, was the first and the longest lasting of the women's societies in Scotland. The Society folded in 1970, 5 Blythswood Square and its furnishings were sold but, as Ailsa Tanner claimed, 'from the ashes, phoenixlike, a new exhibiting society emerged with a core of artist members of the older society'; this society still functions.[29] The Edinburgh Ladies' Art Club organized later in 1889 and by 1898 seems to have disappeared. Although the Scottish Society of Women Artists formed in Edinburgh in 1924 and included in its membership some women who had belonged to the Edinburgh Ladies' Art Club, it seems to have had no connection with the defunct nineteenth-century group and, indeed, its own history does not acknowledge its predecessors. Perhaps accounting for its survival, the Glasgow Society was the only one of the three organizations to remain strongly affiliated with an art school.

The Glasgow Society of Lady Artists

All the founder members of the Glasgow Society of Lady Artists had been or still were students at the Glasgow School of Art when they laid the groundwork for their long-lasting organization. Although the group rallied around Georgina Greenlees who had resigned her teaching position at the School in 1881 because of disagreements with the Board over teaching methods, the close relationship between female students at the School and the Society remained significant. The eight women assembled for their first meeting early in 1882 in the studio used by Georgina Greenlees and her father Robert Greenlees and, by late December, they were ready for their

first exhibition in a studio at the same address. When the exhibition opened, over thirty women were involved in what became a well-organized and rapidly expanding association.

The early exhibitions were predominantly composed of pictures with only some sculpture and 'plaques' and while the press insisted that 'with one or two notable exceptions they are all amateurs, painting mostly for the fun of it'.[30] Comments such as this represent the dominant ideology, not the daily situation of the artists: many of them worked consistently hard at their art production and most exhibited in the mainstream venues, as well as the women's society. For example, as mentioned earlier Georgina Greenlees, one of the founders of the Society, worked as a teacher at the Glasgow School of Art; by 1876 she earned £40 per year.[31] She added to that income by selling pictures; in 1880 she sold one watercolour picture, a landscape, for £40, as much as her entire annual salary. Ann Macbeth, who followed Greenlees's path as a teacher and practising artist, later would complain that the heavy demands put upon her by teaching interfered with her ability to make art: 'my time at the school is so fully occupied', complained Macbeth to School Principal Francis Newbery, 'that any personal work is practically impossible ... This means a serious loss to me – both as regards general repute as an artist & as regards the money I would get for it.'[32] From Georgina Greenlees in the 1870s and 1880s through to Ann Macbeth in the early twentieth century and on until the present time, artists have struggled to combine teaching with exhibiting and selling in order to earn their living. The Glasgow Society of Lady Artists responded to the needs of women artists and sought to provide solutions to some of the most frequently experienced frustrations.

However, contemporary critics rarely acknowledged the training or the experience of the artists nor was it understood that the women included the kind of work for which they were most noted. Landscape artist Jane Cowan Wyper, a founder-member of the Society, contributed work that represented her oeuvre and spoke of her interest in travelling and hiking (she did not paint 'domestic subjects' as the *Herald* critic would have liked). Wyper was from a large, securely middle-class family of seven children (all three of the female children studied art), she never married and, unlike Georgina Greenlees, she did not have to support herself. However, she exhibited widely and successfully and probably funded many of her travels by selling her pictures. She often painted the area around Tarbert, Anstruther and Iona and sometimes made pictures of the south of England. For example, she exhibited two large oils, *A Cornish Seaport* and *Tarbert Town*, in 1895. *A Cornish Seaport*, according to the *Herald* was a 'pleasing view of one of the quaint fisher villages of the most southern county in England'; her Scottish picture, *Tarbert Town*, was a 'carefully considered composition'.[33] Both pic-

tures attest to Wyper's love for the sea and her ability to travel about making sketches or painting the scenes she most enjoyed. Dramatically, Jane Cowan Wyper's death signified her life: she fell from the western cliffs of Sark where she had gone to sketch. She had spent some weeks on Sark with a woman friend and, wanting to draw one of the most picturesque sites on the island, had climbed by herself to 'Les Autelets', three pillars formed of granite and accessible only when the tide was out. In its report of Wyper's death, the *Glasgow Herald* wrote that she had a 'fearless and adventurous disposition' and that she was 'fond of outdoor sports, swimming and yacht-sailing being favourite amusements'.[34]

Wyper's pictures serve to remind us that many of the members of the Glasgow Society of Lady Artists were extremely mobile and often moved about the country searching out attractive landscapes to paint. In 1891 Jane Nisbet and Henrietta Smith Roberton travelled to the Vale of Llangollen in Wales together. From this trip came numbers of sketches as well as Nisbet's acclaimed picture, *The Home of the Ladies of Llangollen* and Roberton's equally well-received *Plas Newydd*.[35] Both pictures venerate the 'Shrine of Friendship' which commemorated the fifty-year-long relationship between aristocratic celebrities Eleanor Butler and Sarah Ponsonby who had eloped to Wales in 1778 from their family homes in Ireland. Their eighteenth-century house, Plas Newydd, 'had reached its apotheosis' by the 1890s serving as a site of tourism for ardent admirers of the Ladies, among whom were obviously the two Glaswegian artists.[36]

In 1892, Agnes Gardner King had exhibited pictures (her 'pleasant' reminiscences) of Venice as did her colleague Julia Mann (for example, *On the Lagoons, Venice*) while one of their Edinburgh colleagues, Barbara Peddie, exhibited watercolours she had made during a trip to Norway (for example, *Hardanger Fjord, Norway*).[37] In 1898 Wyper exhibited pictures made during a trip to Holland and Agnes Kemp exhibited *Brass Bazaar, Cairo*, a 'vigorous drawing' made during her trip to Egypt.[38]

Marion Grieve and her sister Elizabeth Proven, both of whom painted still life, shared Provan's house. Provan's husband, an accountant, had died, leaving her a small private income, and Grieve and a third sister, Agnes, had small annuities from their father. The three woman lived together in a large ten-room house on Hill Street not far from the present-day location of the Glasgow School of Art (Fig.12). Their lives, more than many of the others, resembled the quiet, domestic and genteel life of the 'lady' artist but, while the image is conveniently stereotypical, their work was practised and serious. And, in all instances, regardless of the circumstances of their lives, the women were provided a place to discuss their art, to exhibit and to sell their work by the new Society. It also affirmed their professionalism in a world that largely excluded them: there were no women members of the Royal

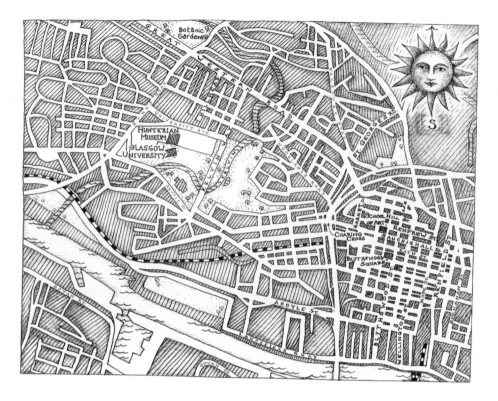

12 Map of Glasgow, Cynthia Hammond

Scottish Academy, no females allowed in the Glasgow Art Club and very few women in the Royal Scottish Society of Painters in Water Colour, 1888.

Thus, the opening of a space specifically for the excluded encouraged women to speak for their own professionalism in the way artists did best – by showing their work. By the time the women opened their second annual exhibition in March 1885 with one hundred or so paintings,[39] they had taken on more members and they had a regular programme of lectures and meetings. By 1888 their exhibition had expanded to include decorative art and this would continue to be a characteristic of their exhibitions.[40] The Society still held their exhibitions in their rooms in Wellington Street (see Fig.12) but 1888 signalled a year in which they had increased their membership along with a consequent increase in the number of exhibits. The press, while continuing to ascribe feminine characteristics to the organization (it was 'modest in its aims'), applauded the members: the Society had 'managed to earn for itself the reputation of an earnest and painstaking band of workers in the field of art'. The 'quality' of the pictures in the 1888 exhibition attracted attention, particularly considering, according to the *Glasgow Herald*, the recent

'institution of the society'. This was attributed to a change in the members' method of study: lectures by established artists and art teachers had been replaced by 'occasional criticisms and suggestions from professional artists', who had been prevailed upon 'to come to the assistance' of the Society's members.[41] Obviously, by this time the Society had decided to encourage its members to continue their training under the auspices of the organization thereby enhancing the Society's professionalism while developing the skills of its members. The *Herald* approved this strategy as beneficial particularly because many of the women were exhibiting with the larger, more established Glasgow Institute of the Fine Arts.

By 1891 the Wellington Street studio space obviously was becoming too small for their purposes. A sunny, breezy March afternoon greeted the opening of the 1891 exhibition as though anticipating success despite cramped quarters, and the number of visitors supported the optimism: over 1300 people viewed the exhibition which, because of its popularity, was extended three days beyond the traditional week.[42] There were over 200 exhibits of pictures and applied art (in the 'industrial gallery') and while the *Glasgow Herald* commended the women for 'the knack of making the most of wall space, and even of converting structural defects into decorative triumphs', the Society obviously had to search for new premises.[43] The following year, in time for the opening of their ninth annual exhibition (Fig.13), they moved into new quarters at 'the Renfrew Street end of the rather mixed west-end block known as Charing Cross Mansions' which, according to the *Herald*, was 'a kind of architectural afterthought, a modest corner away from the noise of the madding crowd'.[44] The studio area contained two small rooms and a large apartment all of which were lit from the roof. A single flight of stairs, covered with a 'strip of soft carpeting', led up to the space from the street but the ascent was broken by a mid-landing area which contained spring flowers and potted plants 'set in windowed light'.[45] Reviews of the exhibition and of the space acknowledged the 'advance' and 'importance' of the Society.[46]

The move to Charing Cross Mansions proved only temporary: in 1895 the Society adapted its rules and purchased its own premises thus securely establishing itself within the Glasgow art community.[47] The Society celebrated its eleventh anniversary by expanding its membership to include a Ladies' Art Club for lay members. Candidates for lay membership needed to show themselves interested in art, music and literature, thus limiting membership to an educated middle class which complemented, in almost every way, the professional membership. In addition, the expansion undoubtedly brought badly needed funding into the Society. Many of the sixty-six artist members would have been struggling to earn their living but the lay members were aristocrats, the wives of well-known public figures or

13 Drawing of the Glasgow Society of Lady Artists' Annual Exhibition, Jessie
Algie, 1892

professional men (the wife of the Lord Provost, for example), or simply women with some money who wanted to attach themselves to the arts in a meaningful if non-productive way. This expansion would ensure the survival of the Glasgow Society of Lady Artists. As the *Glasgow Herald* aptly suggested: the women had shown prudence as well as courage throughout 'the various progressions of the society'. They opened the doors on their new 'club-house' at 5 Blythswood Square (see Fig.12) free of debt and with 'the first year's rent paid in advance'.[48]

The building in Blythswood Square was extremely suitable as a club and as a studio. The entrance hall was large and well lit. To the left was the 'commodious and handsome' dining-room, and beyond that the kitchen 'where modest luncheons and afternoon teas' could be prepared. Outside the dining-room a conservatory had been built to accommodate life classes while the floor above contained a 'spacious, elegant and well-furnished writing and reading room, a bed-room, and a dressing room'. The top flat was reserved for studios.[49] Now, with more space and with a burgeoning interest in decorative arts, the Society was able to hold two exhibitions a year, one of pictures and the other focused more specifically on applied arts. In addition, the advantages in occupying a permanent physical space were innumerable: the women had studio space and could actively participate in critiques of one another's work; meetings could be held, fundraising events such as concerts could be organized; finally, and most important, the women had their very own exhibition space. In addition, ownership of a particular space undoubtedly provided members with a sense of belonging; certainly this seemed true for the Glasgow Society.

Within two years of leasing No. 5, Blythswood Square, and because the dining-room-cum-exhibition space was badly lit, the members organized a Fancy Fair raising a total of almost £3000, enabling the women to purchase the premises and to build a new gallery designed by Glaswegian architect George Walton in partnership with Fred Rowntree.[50] Janet Aitken, Katherine Cameron, Jessie Keppie and Agnes Raeburn were among the women who painted scenery and 'performed' in the sixteen tableaux vivants (which included titles such as 'Tea and Scandal', 'Cleopatra' and 'Japanese') presented on three evenings to a delighted public.[51] The project invited participation from Glasgow's artistic community: Charles Rennie Mackintosh acted as stage manager, costumes were lent by well-known artists, George Henry and E. A. Hornel, and women members acted, painted scenery, and worked in stalls.[52] Certainly, charity bazaars, variously called fancy fairs, fancy sales, or ladies' sales were an often-seen nineteenth-century way of making money for diverse societies. F. K. Prochaska, in his study of nineteenth-century English philanthropy found that 'clergymen of all persuasions, not without a touch of compromise, looked to them as a last

resort to build a church or to enlarge a drawing room'. In addition, bazaars were used by hospitals, dispensaries, orphanages, and asylums 'as a means of offsetting debts or building a new wing'.[53] Glasgow's art community had participated in the Scottish Artists' Benevolent Association since 1889 and, in addition, assisted with large undertakings like the 1895 Arts and Crafts Exhibition to raise funds for the purpose of clearing the debt of the Maryhill Soldiers' Home. The Glasgow Society of Lady Artists' Fancy Fair which followed Glasgow's Arts and Crafts Exhibition by only a few months (the Arts and Crafts Exhibition took place in April; the Fancy Fair in December) represented the space designated as community and activated the sense of belonging experienced by all artists, male or female. Thus, male artists participated in fundraising for the women's space even though they were not permitted access to that space.[54]

The other four

While the Glasgow Society of Lady Artists linked together four of the women in the Dunure photograph – Katherine Cameron, Janet Macdonald Aitken, Jessie Keppie and Agnes Raeburn – art production brought them together with Margaret and Frances Macdonald, members of the more well-known 'Glasgow Four'. By 1893, the year that Aitken, Cameron, Raeburn and Keppie began their association with the Glasgow Society of Lady Artists, Jessie Newbery, friend, mentor and teacher of all the women, exhibited for the second time with the London Arts and Crafts Exhibition Society. A year later, Newbery began teaching embroidery at the Glasgow School of Art, thereby shifting her own interests away from painting toward the applied arts thus dovetailing her teaching with the direction taken by the Glasgow Society of Lady Artists.

In 1894 significant space had been provided for decorative arts and the Society held an exhibition devoted exclusively to this work. The *Glasgow Herald* informed its readers that 'every kind of artistic handicraft [was] represented, from embroidery to wood-carving'. 'Visitors at the private view were struck', according to the *Herald*, 'with the extent to which wood-work bulked in the show.' There were spinning-stool chairs, tables and settees, bronze and brass hammering (trays, door-plates and fingerplates), painting on muslin and linen, ironwork (flower-stands), leather-stamping, book-binding and painted panels. And, as the *Herald* noted, these were utilitarian items and they were 'meeting with a ready sale'.[55] Within ten years embroidery dominated the applied art exhibitions, replacing woodcarving and bent ironwork, and drawing complimentary comments from the critics for the more feminine work. In 1903, Jessie Keppie, usually noted for her

watercolour pictures, contributed an embroidered centrepiece, 'a design in pink Tudor roses on art linen' with a border of green Harris linen; it was, according to the *Herald*, 'hem-stitched in the fashion much admired by needlewomen of the new school'. Agnes Raeburn exhibited a 'coarse canvas cloth' which she had designed and executed.[56]

The making of embroidery reinforces the feminine while work in metal disrupts the accepted stereotype. Thus the late-nineteenth and early-twentieth-century press could stay within the frame of a separate sphere when discussing women as producers of designs on cloth but could not do this as easily when the women made metalwork, perhaps explaining why Margaret and Frances Macdonald were called the 'Messr.' Macdonald when the *Glasgow Herald* wrote about their exhibits in Glasgow's 1895 Arts and Crafts exhibition. It was their metalwork that singled them out from their four friends who favoured a more traditional medium. This might explain why the sisters preferred not to join the Glasgow Society of Lady Artists: they wanted to 'compete' in a market-place dominated by male artists and did not want to separate themselves out from their male colleagues in any way. In addition, and unlike their friends, they first collaborated together then later worked with their husbands: Frances Macdonald married her sometime collaborator James Herbert McNair in 1899; Margaret Macdonald married Charles Rennie Mackintosh in 1900 and worked exclusively with him after that.

The other four young 'Immortals' forged their relationships during their years as students at the Glasgow School of Art or possibly, given their social status in Glasgow, even prior to beginning their studies. Jessie Keppie, the oldest of the group, first registered as a 'designer' at the Glasgow School of Art in 1887 when she was seventeen years old and, like the friends she would make there, she lived with her family while she followed her studies. Of the four friends, she was a member of the most affluent family. Her father was a tobacco and snuff manufacturer and, together with her two sisters and two brothers, she lived in a ten-room house in Hillhead, a centrally located middle-class area.[57] The photographer Robert Annan and his family were the Keppies's next-door neighbours and close by lived an architect, an artist, a wine merchant, a power-loom manufacturer and an earthenware manufacturer. The professions of the occupants of the flats on St James Street signalled middle-classness as 'defined primarily by economic function (usually represented by occupation) and income which determine status, authority and power; and can be identified within social groups as common patterns of work, lifestyle, organisation, thought and behavior'.[58] Male and female children within these securely middle-class families would have been educated – certainly both Jessie Keppie's sisters and one of her brothers attended the Glasgow School of Art.[59] In 1889, while Keppie was still a

student at the School her father died leaving his family almost £23,000, a substantial fortune for the time. In their study on late-nineteenth-century dominant classes in Scotland, Nicholas Morgan and Richard Trainor found that no matter how much money people left, 'it is probably safe to assume that once they had reached the sum of about £50 they stood head and shoulders above the majority of the population in terms of accumulated wealth'.[60] Thus, examination of the amount left to families by the 'head of the household' provides a reasonably clear indication of the status of the children in the household and also of the variations between households.

Janet Aitken, for example, grew up in a smaller family than did Keppie – she only had two siblings, both brothers – but lived in a larger house. Her father, a master lithographer, earned a good living but did not accumulate as much wealth as James Keppie, leaving his family the much smaller but still substantial amount of £1100. Her father's occupation may have signalled the direction of Aitken's studies: she entered the Glasgow School of Art when she was only thirteen years old, the same year as the somewhat older Jessie Keppie. Beginning studies at such a young age indicated competency and seriousness of intent both of which were borne out by Aitken's decision to continue her training at Académie Colarossi in Paris later.

Agnes Raeburn, whose father like Keppie's was a merchant, also began classes when she was very young – she registered at the Glasgow School of Art in 1887 when she was fifteen years old. Her Irish-born mother, after whom she was named, died when Agnes was only seven years old and she and her five siblings lived with their father and one general servant in an eleven-room house. Most artists employed or lived in households that employed at least one servant thereby adding another characteristic associated with middle-classness to a description of the nineteenth-century artist.[61] While establishing the artist as a middle-class working woman, one must recognize that others often worked for her, either as servant or as model or, perhaps sometimes, as both. Martha Munro worked as a domestic servant for Agnes Raeburn's family and, like the women who worked for the families of the other young 'Immortals', Munro had moved to the city from the countryside. In Glasgow, the women working for middle-class families were usually in their early twenties, often came from the Highlands or the Western Isles and they spoke Gaelic as well as English. Young women like Munro often began working as domestic servants by the time they were fourteen and, because they worked for urban families, they were far removed from their own families in the north of Scotland.[62]

Although Agnes Raeburn and Martha Munro were separated in age by only two years, they probably had little in common nor would they have shared a friendship. In fact, Munro may have been quite isolated, working alone for long hours but, like Raeburn, she may have associated with young

women like herself living and working in the same neighbourhood. For example, Isabella McPherson who worked as a domestic servant and cook for the Keppie family (and, like Munro separated in age by only two years from Jessie Keppie) came to Glasgow from Tobermory on the Isle of Mull and, while she may have been isolated from her own family, the young woman who worked for the Annans next door was about her age and, like her, spoke Gaelic as well as English. Thus, the female servants probably had their own 'network' of friends but remained separated from the women of the household which employed them, and the class-defined gap between the servants and their employers was greater than the gap between Agnes Raeburn and Jessie Keppie even though Keppie was far wealthier than Raeburn. When Raeburn's father died in 1895 his estate was valued at only £350, substantially less than the Keppie fortune. Nevertheless, and although Agnes Raeburn worked as a teacher to support herself, Raeburn and Keppie were friends all their lives, united in their support of the 'lady' artists' club and in their commitment to art. In addition, and unlike Martha Munro and Isabella McPherson, their middle-class status enabled them to attend art school and to display their products in exhibitions thus allowing them to engage in the economy of buying and selling as well as being able to sell their services as teachers.[63]

Unlike Aitken, Raeburn and Keppie, Katherine Cameron never taught in schools and, again unlike them, she was able to support herself through her art production.[64] She is by far the most well known of the four women and, based on sales and media coverage, the most successful. For example, when she was in her early twenties, the *Artist* (London) commended her 'delicacy of feeling' combined with her 'strong artistic instinct'; the journal reproduced Cameron's *Wild Bees* (Fig.14) in which one could 'almost hear the buzz of the bee as it swings around, or feel the soft flutter of the butterfly as it but touches the blossom'.[65] Thirty-five years later the *Glasgow Herald* praised her 'executive finesse, great sense of structure, and discriminating, fastidious search for subject'. According to the *Herald's* critic, Cameron could paint 'a bee, "love-in-the-mist," a great mountain, or even a glittering poster'.[66] She had begun her studies at the Glasgow School of Art in 1889 when she was fifteen years old and, within four years, she and her colleagues Aitken and Raeburn had joined the Glasgow Society of Lady Artists (Keppie joined a few years later). Soon after this, in 1897, Cameron won a place as a member in the Royal Scottish Society of Painters in Water Colours – one year earlier than her older 'Immortal' colleague, Margaret Macdonald. Cameron was one of fourteen candidates (the only woman) and she was selected for membership in the first round of balloting; James Kay, the only other artist to be elected for membership that year, won his place during the second round.[67] She opened her first solo exhibition at James Connell & Sons in Glasgow in

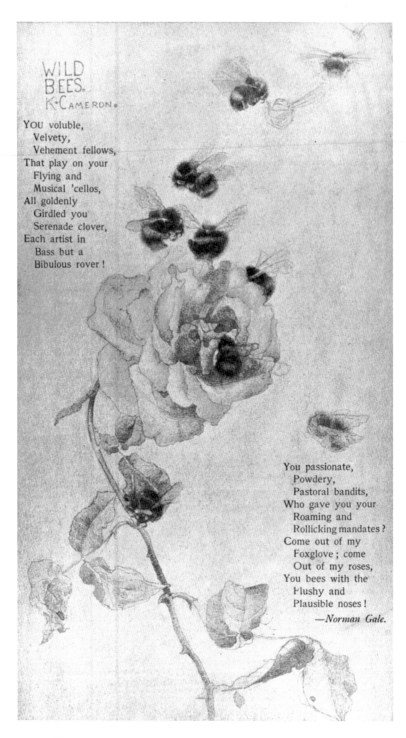

WILD
BEES.
K·CAMERON.

YOU voluble,
 Velvety,
 Vehement fellows,
That play on your
 Flying and
 Musical 'cellos,
All goldenly
 Girdled you
 Serenade clover,
Each artist in
 Bass but a
 Bibulous rover!

You passionate,
 Powdery,
 Pastoral bandits,
Who gave you your
 Roaming and
 Rollicking mandates?
Come out of my
 Foxglove; come
 Out of my roses,
You bees with the
 Flushy and
 Plausible noses!
 —*Norman Gale.*

14 *Wild Bees*, Katherine Cameron, 1896

1900. The *Art Journal*, in its review of the exhibition, located Cameron's identity as specifically Scottish: 'she has the true race feeling of the Celt for love and legend, the feeling which grows amongst the heather braes, and in spring woods, and by the side of murmuring water'. The two pictures the *Journal* reproduced confirmed this identity – in *Entangled* (Fig.15) a 'maiden' attempts to drive away 'the tiny goblins who are pulling at her hair' and *There Were Twa Sisters Sat in a Bower Binnorie O Binnorie* depicts an updated scene from an old Scottish ballad 'The Cruel Sister'. The *Journal*'s critic constructed a picture of Cameron that was more rural than urban, more nostalgic than contemporary and, above all, feminine: she was written about as a charming 'young painter full of gracious legendary tradition, on whom the modern spirit has not descended'.[68]

However, the 'modern spirit' had imbued Cameron as it had many of her friends and colleagues in the art world and, beginning as early as the 1870s, a number of Scottish women were travelling extensively and also studying abroad, particularly in Paris. Of the 'Immortals', it was Aitken, Cameron and Raeburn, the least wealthy members of the group, who travelled to further their art education. Aitken and Raeburn both put pictures of Dordrecht into the Glasgow Society of Lady Artists' 1907 exhibition suggesting that they had visited the Dutch city together. Cameron's travels are more difficult to trace because her subject matter remained so exclusively still life but she undoubtedly followed a similar route on her way to Paris. The women studied at the Académie Colarossi in the Rue de la Grande Chaumière during the early years of the century (not necessarily at the same time) where the 'tariff' was a little lower but where the hours of study were long and intense.[69] Although they did not leave written accounts of their experiences, Kathleen Bruce, a young sculptor who spent her childhood in Edinburgh, kept a diary during her stay in Paris which she subsequently published. From Bruce a picture can be pieced together of how a young woman with little money could live and study in Paris at the turn of the century. In addition, Bruce metaphorically captures the gap between the ideology of women's place with the reality of day-to-day existence by acknowledging the 'place' of the female while, at the same time, acting outside of it. 'In the first years of the twentieth century', wrote Bruce, 'to say that a lass, perhaps not out of her teens, had gone prancing off to Paris to study art was to say she had gone irretrievably to hell. Queen Victoria was only just dead. Her parasol of propriety still shaded the eyes of most well-bred young ladies from the too strong rays of the sunshine of life'.[70]

Bruce's account of her regular morning swim, her meagre budget, her exchange of work for fees – she posed the model one morning each week – and her enjoyable if hard-working lifestyle in Paris speaks of women moving about in urban spaces with few constraints. Although by 1899 when Bruce

15 *Entangled*, Katherine Cameron, 1900

first went to Paris the concept of the city as a male-dominated space for movement may have been waning, the *flâneur* has been theorized as an exclusionary position by feminist scholars such as Griselda Pollock and Janet Wolff.[71] According to Pollock, the free, self-possessed and masculine *flâneur* always 'symbolizes the privilege or freedom to move about the public areas of the city observing but never interacting, consuming the sights through a controlling but rarely acknowledged gaze.'[72] However, the *flâneur* is a fiction and the early-nineteenth-century 'gentleman' described by Baudelaire and later by Walter Benjamin is circulated and recirculated as a male myth by male writers. Elizabeth Wilson in her reassessment of the *flâneur* as a characterization of the public in opposition to the private, argued that ideological discourse 'constantly reworked this ideology, so that philosophy itself must be described as gendered; yet in attaching so much weight to these constructions we may lose sight of women's own resistance to, and reworkings of, these systems of thought'.[73] Wilson asks if prostitutes might be seen as the *'flâneuses* of the nineteenth-century city'[74] and while her question is astute and her arguments about the role of the *flâneur* are thought provoking and challenging, perhaps feminists writing about women in the city need to turn to women's lived experience; that is, rather than inscribing Baudelaire or Benjamin as literature or theory and thus inserting their points of view into a 'true' picture of reality, feminists might read someone like Kathleen Bruce and theorize her position.

Bill Smith in his study of Katherine Cameron's artist brother, D. Y. Cameron, writes that 'what Katherine thought of her time in Paris is not recorded. Certainly it does not appear to have had much effect on her work but,' speculates Smith, 'she may have been there for too short a time or may have found neither the subject matter nor the teaching to her liking'.[75] Smith's statement could apply equally to the other members of the Dunure group; none left an account of her experiences in Paris and no change in style or choice of subject matter materialized. The women continued to paint still life pictures that most likely sold to a middle-class audience.

Jessie Newbery and Ann Macbeth

Neither Jessie Newbery nor Ann Macbeth studied in Paris. Like Georgina Greenlees before them, both obtained all their training in Glasgow then taught at the Glasgow School of Art. Jessie Newbery, like Ann Macbeth after her, became and remains most known for embroidery although she exhibited pictures during the late 1880s and the early to mid 1890s. By 1894, when Newbery established embroidery classes as part of the curriculum at the Glasgow School of Art, she had less time for painting – certainly she devoted

most of her time to needlework after that. By doing this she became easily subsumed into the realm of the private and the domestic by critics and historians; wresting her free of these constraints is much more difficult than lifting and shifting the Macdonalds away from the private. Media and association helps define and categorize; hence the Macdonalds, their production of metalwork and their association with a male architect-designer enables them to be constructed as part of a mainstream while Newbery rests in the margins. The politics of Newbery and Macbeth also have remained marginalized, and although Newbery's programme for needlework – utilitarian as well as decorative, to be worked on inexpensive fabrics as well as on expensive – reflects her socialism, this is rarely articulated.

In addition, by the beginning of the twentieth century, reviews of the Glasgow Society of Lady Artists' exhibitions emphasize the 'womanly' arts thus highlighting needlework and reinforcing ideologically inscribed characteristics. By 1903 embroidery, in the Glasgow Society of Lady Artists' annual exhibition of decorative arts, had outstripped woodcarving and metalwork. The *Glasgow Herald* wrote that 'bent iron work, once an important feature', had completely disappeared, and, 'instead of devoting time and space to wood-carving, at which few excel, the ladies have wisely turned their attention more to needlework, an art in which woman has abundant opportunities to display good taste and neat-handedness'.[76] It is here that the conundrum of feminine embroidery surfaces, sending out its most trapping tentacles. Jennifer Harris specifically located the problem in her essay for Manchester's Whitworth Art Gallery exhibition 'Embroidery in Women's Lives 1300–1900' (1988): 'The teaching methods pioneered at the Glasgow School laid the foundations for the creative embroidery taught in art schools in the twentieth century. Although, however, their innovations transformed the teaching and practice of embroidery, they did not succeed in shaking the traditional associations of women with the craft.'[77]

It is at this moment that the feminist art historian must effect a displacement. While striving to recuperate the applied art worker for the edification and pleasure of the late-twentieth-century viewer, one must also effect strategies and tactics that shift historical 'understanding' or displace an ideology. Common understanding leads toward the effacement of the workplace of the applied arts worker and the marginalization of her space and place along with the feminization of her production – her studio as place becomes domestic; her frame of reference or psychic space becomes separate, feminine and secondary. The displacement, I suggest, should include the artist's place as an empirical historical subject while, at the same time, theoretically shift her representation not so much away from domesticity which would devalue the domestic space, and not toward domesticity which would glorify the naturally feminine, but to a moving space which collapses

public space (the venue) into private space (the studio) becoming, in this process, a coherent whole: the applied-art worker selling commodities and earning her living.

Following feminist theorist Rosi Braidotti, feminism must expose the dual-isms inherent in patriarchy while at the same time redefining relations of knowledge and power. Braidotti argues for a 'new kind of female embodied materialism': this new trend in feminism, 'emphasizes the situated, specific, embodied nature of the feminist subject, while rejecting biological or psychic essentialism'.[78] In order to displace the feminization of applied arts, particu-larly textile arts, it is necessary to displace and rewrite the construction of separate spheres. The 1990 '*Glasgow Girls*' exhibition and the heated debates around the exhibition served to highlight the entrenchment of an ideology that sees separate as bad when it seeks to confront the status quo; 'quality control' plays a large role in the debate around art (Glasgow Museums' Director Julian Spalding insisted that the quality of the work concerned him) in the same way that it plays a role in the market-place.

As case studies, Jessie Newbery and Ann Macbeth and the work they produced can provide some insight into the ambiguous place occupied by the decorative arts. For example, the juxtaposition of Newbery's elegantly-designed silver chalice with her utilitarian designs for embroidery disrupts the stereotypical feminization ascribed to her work. The production of a chalice and paten along with an alms-plate, all made for the 1893 Arts and Crafts Exhibition in London, reverses the most frequently accepted pattern of production: designed by a male, executed by a female. Newbery designed the metalwork, it was made by her colleague at the Glasgow School of Art, William Kellock Brown. Similarly, she designed needlework which was then made by other women, for example, a quilt Newbery exhibited in London in the 1896 Arts and Crafts Exhibition had been worked by her sister Mary Rowat, while an altar frontal she had exhibited in 1893 had been executed by C. A. Dunlop who worked with Newbery at the Glasgow School of Art. Ann Macbeth, while she worked many of her own designs, also exhibited pieces she had designed but which were executed by other women and, like other artists in the arts and crafts movement, these women were often family members, friends or students.

Because Macbeth did not begin studying at the Glasgow School of Art until 1897 or three years after the Macdonald sisters and their future partners had completed their education, she is not usually considered part of the 'Mackintosh circle'. Despite exhibiting in the same venues – the Vienna Secession of 1900 and the Turin Exhibition of 1902 being the most famous – and working with Frances Macdonald, Macbeth retains a distance from the 'Four'. At the same time, however, she becomes subsumed within the Mackintosh 'text' like almost all the women artists of this era who were

associated with the Glasgow School of Art and then subsequently with 'The Glasgow Style'. The *'Glasgow Girls'* exhibition contributed to this construction by reinforcing Mackintosh's centrality: 'Unquestionably, the central figure of the era is Charles Rennie Mackintosh.'[79] While Macbeth has managed, historically, to achieve some little distance from Mackintosh, Jessie Newbery has been absorbed into the Mackintosh circle which, as discussed above, both provides a space for her just as it marginalizes her within that space.

Identification of Newbery coincides with affiliation to Mackintosh: for example, when Margaret Swain wrote her important article on Newbery for the journal *Embroidery* (1973), Newbery's pioneering approach to needlework and her association with 'Charles Rennie Mackintosh and his wife' provide an entry to the discussion.[80] Swain's articles about Newbery (she wrote another article, 'Mrs Newbery's Dress', *Costume*, 1978)[81] are important for Newbery's history because Swain had access to first-hand information from Newbery's daughter Mary Newbery Sturrock. An aside: Sturrock, who was a successful artist in her own right and a founder member of Edinburgh's Group of Twelve, complained to Swain that everyone who interviewed her only wanted to talk about Mackintosh (one can only estimate the tremendous loss wrought by Mackintosh enthusiasts).[82] However, even Sturrock's contribution to her mother's history must be tempered with some attention to Sturrock's own position: she always insisted upon her mother's role as her father's helpmate, a position that is not corroborated in contemporary writing. For example, in its 1913 article on Newbery and her work, the *Glasgow Evening News* highlighted Jessie Newbery as the 'brilliant' wife of Glasgow School of Art Principal Francis Newbery, but at the same time the paper insisted that domesticity did not 'absorb her'. She had, according to the *News*, 'a strong personality and an art life of her own, the value of which is recognized far beyond Glasgow'.[83]

Although, by 1913 Newbery had resigned her position as head of the Embroidery Department at the School, she remained an active designer. She designed patterns for Donegal carpets (one of her Axminster carpets had been praised in the Turin Exhibition of Modern Decorative Art, 1902), for Dunfermline linens and she contributed needlework to British exhibitions and to exhibitions in Europe. The *News* praised her role as a teacher: she was 'able to demonstrate by example that there was a very real outlet and demand for the work of [her] class which came well within the sphere of the woman worker'. Most important, she taught the designing and making of work that might 'absorb' one's interest while at the same time 'providing a profitable means of existence'.[84] Such applied training appropriately existed in an area heavily invested in textile industries; hence, in a locale where 'textile and clothing industries were a major source of employment',[85] Newbery's concern for the developing classes which complemented industry

spoke of a dual programme: women could accept positions as designers in textile companies, and textile companies endorsed the School and subscribed funding. In addition, according to Juliet Kinchen, '[w]oven and embroidered textiles were the most important of the traditional crafts practised by women in the rural areas of Scotland as an adjunct to their other domestic duties'.[86] Newbery's highly regarded 'practical' approach to needlework is layered upon concerns for material as well as concerns for material conditions.

Newbery was noted for her functionalism, for her concern for precision and linearity, and for her use of ordinary fabric most all of which was highlighted in Gleeson White's 1897 article for the *Studio*. White's thorough comment on Newbery appeared as the third part of his series, 'Some Glasgow Designers and Their Work', and the attention he paid Newbery much outweighs his emphasis upon Mackintosh. That is, while White is an often quoted source about early critical response to Mackintosh, the London-based critic directed much more attention to Jessie Newbery than he did to the architect. He commented upon the attention given to Newbery's work by 'those who are alive to modern design' and he quoted the artist at length on her own approach to her art. It is this source that gives us the most extensive information about Newbery's work, for example, her enjoyment of oppositions, straight lines to curved, horizontal to vertical, purple to green, green to blue. White considered Newbery's embroideries as 'essentially problems in the balance of colour, no less than in the distribution of line'; he saw her work as fresh, simple and direct – assuring his reader that 'their apparent simplicity is the result of real power'. 'Above all', wrote White,

they preserve the best traditions of the art, and yet never directly imitate early work; and therefore it is possible to praise them very highly, without once over-stating the case, and still less without regarding them patronisingly as women's work. It is pleasant to remember that they chance to be for a craft which has been pre-eminently the province of women from time immemorial; but they may take their place as examples of well-applied art, with no question of sex, and no attempt to evade criticism by a spurious chivalry which is often but a covert form of insult.[87]

While it would be convenient to agree with White and accept Newbery's embroidery as 'well-applied art' with no question of sex woven in with the threads, that is not how she has been written; it is not how she exists as a 'text'. My interest in Newbery is empirical; that is, I am concerned for her as a woman producer of applied art and I seek to understand her role in society and culture by using archival material and social history. However, I cannot disregard her textual existence as a creature of what has been written about her and around her. Thus, she exists in nineteenth-century press accounts of the Glasgow Society of Lady Artists, the Glasgow School of Art as well as in articles about her and her work. She also exists in recent writing

about, for example, the 'Glasgow Girls' exhibition. Jude Burkhauser in an essay in the book which accompanied the 'Glasgow Girls' exhibition links Newbery's use of the rose (attributed by Newbery's contemporaries to her interest in flowers and gardens) with Venus the Goddess of Love, with sexual mysteries, mysticism and vaginal imagery.[88] In this instance Newbery as text becomes a sign for feminine signification that goes much beyond her choice of textile as medium. Certainly, Newbery's energetic support for the 'separate' society, her production of needlework as design as well as for her own clothes and her daughters' clothes, her conflation of home with studio, and her choice of venue which was, after the mid 1890s almost exclusively a decorative arts venue, all lead inextricably toward the domestic or the separate sphere. This only emphasizes the need to rewrite the designer or applied-arts worker while, at the same time, disassembling the ideological concept of separate spheres. As Braidotti suggests, the 'challenge for feminist theory today is how to invent new images of thought that can help us think about change and changing constructions of the self'.[89] I suggest that feminist art historians write about applied arts by highlighting ideological constructions, particularly the 'separate sphere', by emphasizing space and place, and by refusing to accept fixed readings of any of these categories.

Jessie Newbery's diverse and accomplished role as an educator and designer corroborates the possibility of writing about needlework as a disruptive art form, one that upholds the traditional and stereotypical aspects of textiles and challenges these categories at the same time. Her own work relied heavily upon a combination of the ideals of William Morris and the Arts and Crafts Movement and an intimate, if somewhat class-bound, understanding of the textile industry. Newbery was born and raised in Paisley where her father, William Rowat, had been a shawl manufacturer until the 1880s when he abandoned textiles and invested his money in his brother's expanding and financially lucrative tea-importing business.[90] Her mother died within days of the birth of her fourth child when Jessie was eight years old and she was raised by an indulgent and politically radical father. She studied art first in Paisley and, by the time she was twenty (in 1884), at the Glasgow School of Art. Her marriage to the School's Principal Francis Newbery in 1889 was entirely in keeping with Jessie's politics, if not with her background.[91]

Together, Jessie Rowat Newbery and Francis Newbery, as teachers, friends, colleagues and patrons, provided a centre for an innovative and exciting art movement in Glasgow now called 'The Glasgow Style', and Jessie Newbery incorporated various aspects of the movement into the embroidery department she established at the Glasgow School of Art in 1894. The impetus for the development of Newbery's embroidery department came from the concerns voiced many years earlier by William Morris when he decried

the excesses of mid-nineteenth-century clutter but, in addition, relates to the location of the School in an area heavily invested in the textile industry. Glasgow's commercial success as the Second City of the Empire was due largely to the production of cloth which, in the eighteenth century, kept about 20,000 hand-loom weavers working in the West of Scotland.[92] While the making of cloth provided employment for numbers of people, changes in the industry which occurred with mechanization melded together radicalism and textiles in a union that would remain in place from the first weavers' strikes in Glasgow and Paisley in the late eighteenth century through to women's demonstrations of the early twentieth century when embroidered banners became a sign for political activism.

Newbery's Embroidery Department was well-placed both politically and aesthetically and the direction she and her students took in their advancement of needlework contains within it all the characteristics of the textile industry itself which was traditional and radical at the same time. The Department under Newbery 'rebelled against embroidery in which the colours used were predominantly dark, the design often stereotyped and the quality of the work judged solely on the intricacies of the stitchwork'.[93] The new programme encouraged individuality and originality in design, new, lighter colour schemes and new materials. Rather than making intricate stitches on heavy velvets and expensive silks, Newbery insisted that embroidery could be worked as effectively on cheap materials as on expensive materials and, in keeping with this, she introduced the use of unbleached calico, linen, flannel and hessian into her classes. For example, nineteenth-century appliqué work was usually made on luxurious materials like velvet and stitched on with gold thread. In the 1830s appliqué work was used to decorate handscreens and bags made of white grosgrain or other silk fabrics. Velvet leaves and flowers were cut out and attached to the silk with gold thread and while the popularity of such luxury goods waned during mid century, their use was revived again by the 1860s when they 'became the principal ingredient of fancy work'.[94] Newbery retained the technical characteristics of appliqué work but simplified the shapes and substituted easily obtainable, inexpensive material for class-identified luxury goods such as velvet and silk.

In keeping with her interest in simplicity, her lively, rhythmic designs (Fig. 16) seem to confirm Newbery's pleasure in her work. It was this pleasure and joy that she communicated to her students along with a concern for the integrity of the material upon which she worked. While the stitches did not have to be complicated she did insist upon a clean, precise technique which enhanced rather than detracted from the item being embroidered and which was appropriate to the design. By the turn-of-the-century, instruction in embroidery at the Glasgow School of Art had been integrated into the

16 Design for an embroidered panel, Jessie Newbery, 1897

training programme for primary and secondary teachers in Scotland. While teachers from the course encouraged students from all classes to experiment with their own designs and use material they had on hand, the programme reinforced embroidery as a female art form by offering the classes only to female students: the teaching of embroidery became an 'important part of the curriculum for girls in state schools, whilst the boys were assigned woodwork' and this 'allocation by gender of craft activities in schools continued in practice until very recently'.[95] Nevertheless, Newbery introduced a practical and beautiful art form that could be designed and made by the poor as well as the rich. In this, as a teacher of art she implemented the ideals of William Morris – teaching teachers how to work with inexpensive materials in their classrooms and teaching children to make their own designs, so that the poor as well as the middle classes could benefit from the creation of beauty. She demonstrated that practical socialism was more successful under her conditions of production, that is in education, than in William Morris's conditions of production which called for a market-place and the buying and selling of good design. But she did not displace embroidery's gendered identity even though the characteristics of her craft seem to suggest that a displacement could be effected.

Similarly, Newbery's friend and colleague Ann Macbeth with her commitment to women's right to work, education and the vote, selected embroidery as the medium of her art practice and, like Newbery, she both upholds a feminized tradition while, at the same time, she explodes the constructed boundaries. In keeping with a commitment to textile production as shared production,[96] Newbery and Macbeth produced a collaboratively made banner for Glasgow's International Exhibition of 1901 which was presented to the British Association for the Advancement of Science. Traditionally, embroidery was designed by one person and worked by another (Fig.17) but Newbery and Macbeth expanded this structure by working collaboratively and by encouraging their students to work with them.

Macbeth began working as Newbery's assistant in the classroom before she had completed her course at the Glasgow School of Art and she stayed on to become Head of Department when Newbery retired.[97] While Newbery's politics could be termed practical socialism, Macbeth's were actively political. She asserted herself as an instructor, insisting upon equal pay for equal work and, more dramatically and more publicly, she supported the suffrage movement during the early years of the twentieth century. Thus, the individual worker represents the radical edge of textiles with its history of uprisings, demonstrations and unionism but the association of her art practice with the feminine rather than feminism requires that writing about her and her work displaces and reassesses the circumscribed.

Macbeth represents the working female of the early twentieth century who

17 Embroidered tablecloth, designed by Ann Macbeth and worked by Christine
Lester, 1902

had to rely entirely upon her own resources for support and, like earlier counterparts such as Georgina Greenlees, she depended upon obtaining extra income from the production of her art. In a letter she wrote to Francis Newbery in the spring of 1910, she insisted upon an increase in salary because her heavy teaching commitments detracted from her ability to fulfil commissions. She had had to 'hand on' almost all her commissions to her students which was, she wrote, 'good for them' but a loss to her. Her 'day in the studio', according to Macbeth, was 'a series of constant interruptions somebody coming almost every ten minutes' making it impossible 'to do any serious work'. Not only was Macbeth concerned for her immediate situation but she was concerned about retirement: 'I would like also to feel that I had a prospect of being able to lay away a little money – since pensions do not obtain among us – so far as I know.' She also felt that 'going abroad' would be good for her work and she was unable to afford what she considered a comfortable place to live. Subtly and diplomatically she informed Newbery that she had an offer to go to the United States where she would earn 'considerably more'; however she felt she would regret leaving the Glasgow School of Art – that she was 'too fully interested in its welfare to care to contemplate a change'.[98] Within a month, her salary had been increased from £120 per year to £150 per year.[99]

Macbeth emerges as an assertive working woman willing to demand appropriate pay for her highly skilled labour and, in addition to demonstrating her commitment to teaching, she also staunchly supported her professional association, the Glasgow Society of Lady Artists.[100] Like many of her colleagues, she supported the suffrage movement in Scotland, enduring imprisonment, solitary confinement and forcible feedings in the name of the 'cause' and her employees at the Glasgow School of Art supported her protests. In May of 1912, Macbeth wrote to the secretary of the School thanking him for his 'kind letter': 'I am still very much less vigorous than I anticipated', wrote Macbeth, 'after a fortnight's solitary imprisonment with forcible feedings – & I sleep very badly – but the doctor thinks this will improve when I get away'.[101] She did not recuperate quickly. By June, when her doctor told her that she needed at least five months as a 'semi-invalid', it was obvious that like many other women protesters who were forcibly fed, she would suffer long-term ill health. Thus, Macbeth's politics and her career epitomize the relationship between textiles and the suffrage movement.

As Rozsika Parker suggested, embroidery, for the women in the suffrage movement, 'was employed not to transform the place and function of art, but to change ideas about women and femininity'.[102] Parker implies that when women made suffrage banners they did not desire 'to disentangle embroidery and femininity' but rather they accepted the conflation which,

for them, represented strength, not weakness. The analogy easily could be carried into the production of still-life painting or 'small' landscape scenes all of which were made by women artists working in Glasgow in the late nineteenth century. Certainly, such work was characteristic of the exhibits in the 'Glasgow Girls' and of the work made by the less well known associates of the 'Glasgow Four'. Rather than designate the pictures feminine (like the making of embroidery), perhaps they could be discussed as the fruits of labour of 'an earnest and painstaking band of workers in the field of art'.[103]

Locality and pleasure in landscape: a study of three nineteenth-century Scottish watercolourists[1]

Kate Macaulay (c.1849–1914) was one of many well-trained, technically proficient female artists who supported themselves by painting landscape and genre, most often in watercolours, during the last half of the nineteenth century. Frequently she painted near the ruins of Ardencaple Castle, once the property of her dispersed clan,[2] recording numbers of scenes in and around Loch Lomond, Gare Loch and Loch Long (Fig.18), sometimes moving beyond clan boundaries to Oban and Skye or to the area around her own 'Ardencaple House' in North Wales.[3] Although few artists represented landscapes so intimately woven together with loss and nostalgia, many selected scenes which elicited a romantic yearning for an untroubled countryside.

This chapter seeks to document an aspect of the representation of landscape by discussing the production of three artists as they worked in their studios and made pictures for sale. While their art was viewed as 'Scottish', their pictures today (unlike the work designated as 'The Glasgow Style') would not be considered representative of a Scottish 'identity'. The artists in this narrative of Scottish landscape painting include the 'displaced' Macaulay, Kate Macaulay, along with Glasgow artist, Georgina Greenlees and Edinburgh artist, Christina Paterson Ross. The story of this trio seeks to highlight the work of a middle-class working woman, the land she represented, and the narrative woven into and through her representations of land. She functioned in several different ways: as a recorder of nostalgic identity, as an interpreter of 'her' land which had been, by the late nineteenth century, colonized by capital and tourism, as an entrepreneur who marketed her own production in exhibition venues, and as an intruder in a male-dominated art world.

This intersection of the woman producer with her product represents an attempt on my part to enlarge the discussion of landscape painting and its ideologies to include the historical female worker/artist and to expose

18 Map of Scotland, Cynthia Hammond

another side of so-called 'British' landscape so as to encompass the representation of landscape within a particular Scottish experience. To begin with the latter, Scotland became a sign for romanticism by the early part of the nineteenth century, a sporting possibility for shooting enthusiasts about the same time, and a site for tourism after 1860 when the building of railways made the Highlands more accessible to the southern traveller.[4] As Scottish historian Tom Devine aptly stated: 'the new attractions of a Highland estate [were] stimulated by the success of Scott's novels, the romantic appeal of scenic grandeur, Queen Victoria's well-published interest in the Highlands and the superb opportunities the region provided for the fashionable sports of hunting, fishing and shooting'. The region was remote and offered solitude to business people wanting to escape ever-expanding cities and it provided an opportunity for 'absentee proprietors to make speculative gains by buying up the possessions of insolvent families'.[5] My discussion throughout this essay will be concerned with a representation of Scottish land, not by tourists such as the English artist J. M. W. Turner,[6] but by Scottish artists depicting their own land in the midst of an influx of travelling southerners. As for the female producer of 'native' landscapes, I am not suggesting she be constructed as any sort of authentic viewer or representor, either because, as woman, she could be essentialized as nature or because her representation is 'Scottish'; rather I wish to write about her as a working, middle-class woman, secure in her choices and content in her decisions to follow a career. The late-twentieth-century reader/viewer might consider her as confident and determined in her choices, committed to her art production and engaged in a debate with her male colleagues about her 'place' within their organizations, a place that was contested, supported or ignored by her contemporaries, but not a place that was either simplistically or clearly defined.

To begin, I should like to cast a retrospective mind's eye on Glasgow in the late 1870s, specifically upon a meeting arranged by a group of dapper Scottish artists. My picturing of the historical events resulting from this meeting is informed largely by the contemporary press and, following Andrew Hemingway, I should like to foreground the advantages and drawbacks of using such material. As Hemingway elucidates in his impressive study of landscape, ideology and culture in nineteenth-century Britain, the press provides historians with insightful readings of contemporary exhibitions despite the limiting or limited perspective of the critic. Hemingway suggests that criticism 'must work to a large extent within commonplace notions, and most critics presumed the exhibition would signify the same ideas for a section of the audience, which was also their ideal readers'.[7] While they have their limitations, such reviews open up a discourse that expands out from the more enclosed views of art critics writing for art

journals (their audience was smaller and more homogenous) and into the broader realm of the public viewer (the undefined category of the public viewer by its very nature enhances disparate viewing positions). In addition, and certainly in Scotland as I shall demonstrate, critics wove their comments about exhibitions into and through the social and political discourses of the 'nation'. Having articulated certain problems, I should like to proceed with a textual picture of Glasgow, 1877.

On a chilly December afternoon in 1877 a group of ten men gathered to voice their concerns about the lack of public interest in watercolour painting, and to decide how best to further the development of this art in Scotland.[8] Robert Greenlees, Head Master of the Glasgow School of Art, chaired a series of three meetings during which time the artists decided to call a larger gathering to which another thirteen artists would be invited; the intention was to form a new art society. The larger invited group would, in turn, decide upon the full complement of members and associate members. According to the widely circulated *Glasgow Herald*, the Scottish painters insisted that 'a love of water-colour paintings would grow' if their audience became more acquainted with the medium. As mentioned earlier (see chapter 2), Francis Powell, the Dunoon artist who would become the first president of the society and one of its most respected advocates, accepted that watercolour paintings in Scotland had been 'quite in the shade', but thought this was partly because of the venues in which the pictures were exhibited: water-colours were 'generally exhibited along with oil paintings and in rooms of the worst possible light'.[9] While signalling their difference from the already established artists' organizations, most of the men involved in the early meetings agreed with Robert Greenlees: the new Society they wished to form was not 'being got up in opposition' to the Glasgow Institute of the Fine Arts, the Glasgow Art Club or even to the Royal Scottish Academy in Edinburgh, but rather would provide a venue for watercolours where the pictures could be exhibited without competing against oil paintings.[10]

The importance of watercolour painting and its relationship to the Academy had followed a similar path in London albeit much earlier. The foundation had been laid for the formation of a watercolour society – the Society of Painters in Water Colours – as early as 1804 and although the organization floundered and re-formed under different names, by 1832 London enjoyed both the New Society of Painters in Water-Colours and the Society of Painters in Oils and Water Colours (which became known as the Old Water-Colour Society).[11] Scottish artists had participated in exhibitions organized by the Societies but removing pictures to London for show and sale did not encourage and, in many cases, did not enable a Scottish audience to view (and buy) pictures. In 1879 the Glasgow press acknowledged that 'the growing English fashion of water-colour collections has taken

hold in Glasgow, and there are connoisseurs who desire a reputation for refinement of taste by indulging in a luxury less expensive and in many respects more satisfactory than a collection of oil paintings'.[12] While the discourse around the organization of the Scottish society touted 'a love of water-colour paintings', economic reality formed a twined-debate: it was easier to sell pictures in one's 'home' city (or at least area) than arrange for travel, something that may have been quite difficult for some of the less-well-off artists. In addition, press coverage of London exhibitions tended to favour London artists; the art journals, all of which were London-based, definitely favoured London artists.[13]

French sociologist Pierre Bourdieu considers the art object as having been produced not only by the artist but also by 'critics, publishers, gallery directors and the whole set of agents whose combined efforts produce consumers capable of knowing and recognizing the work of art as such'. This 'set of agents', which includes the artist, produce 'the meaning and the value of the work'.[14] Although the group of artists meeting in Glasgow to form the new society may not have phrased their concerns in quite the same way, they would have recognized the parameters of the 'field' in which they worked and earned their livings. Having their own society based in a Scottish city ensured an audience and, as press reports clearly demonstrate, an audience which artists and press together could educate as to the value of watercolour painting.

While Glasgow painters had taken the initiative, Edinburgh artists promised 'joint co-operation'. The *Glasgow Herald* supported these efforts: 'The cultivation of water-colour, an art confessedly far more difficult than oil-painting, will tend to improve public taste more rapidly than any recent effort made in our city.'[15] 'Taste' signalled middle-classness which in turn, signalled culture in a society and a city (Glasgow) that perceived itself 'behind' London while, at the same time, was assured of its rapidly expanding industrial base (mercantile and rich but uncultured and crass). Critics during the 1870s and 1880s constantly lamented Glasgow's lack of support for its own artists and berated wealthy collectors for spending too much money on non-Scottish art. For example, in 1878 the *Herald* criticized Glaswegian collectors for their 'indiscriminate' patronage which had, according to the critic, gained for them 'a name for liberality' rather than securing them 'a reputation for taste'.[16] Early in 1880 the *Herald* commended the art community for finally supporting the purchase of galleries for the Glasgow Institute of the Fine Arts, the most 'suitable for their purpose of any picture galleries outside of London', while at the same time it criticized the 'slender support given to art exhibitions' by the wealthier population.[17] Two years later the same newspaper pointed to 'other cities' which had

acknowledged the 'artistic cultivation and social amenities' resulting from regular exhibitions while in Glasgow such support was left to a 'few'.[18]

However, the new watercolour society promised to attract public attention while at the same time providing another venue for Scottish artists. The organization called itself the Scottish Society of Water-Colour Painters (SSW), elected thirteen members, and began its cultural and entrepreneurial programme. Two months later, at a meeting in Edinburgh, the SSW elected another ten members and, in addition, arranged 'for the subsequent election of ten associates'.[19] While the fledgling society established itself as not antagonistic toward the already established clubs and societies, it also marked its difference from the traditional bastions of the Scottish art world: it allowed two female artists to become associate members. After initial discussions in which Georgina Greenlees, who was to play a leading role in establishing the Glasgow Society of Lady Artists (see chapter 3), was counted amongst the members, the Society decided to allow women to be involved at the associate level only – 19 names were put forward for the associate category, 17 men and 2 women; 10 were selected, 2 of whom were the women. Women could not become full members and they could play no role in management but their position had been debated, their affiliation as associates rather than as members had been contested and, even as associates, they were more directly involved with an art society than they had been during previous years.[20] Rather than highlighting exclusion, this election represents an inroad into societies that were almost always defined as 'male', thus encouraging and supporting women in their attempts to sell their art thereby earning income. Again, in this, the Scottish Society followed the London example: Anne Byrne, in 1806, was the first woman to be admitted to membership (as a 'Fellow Exhibitor') in London's Society of Painters in Water Colours. As Simon Fenwick noted, women 'rather gallantly' could share in profits of the Society but were 'not liable for any of its debts' and while this may be condescending in twentieth-century terms, the Watercolour Society 'was far more supportive than the Royal Academy'.[21] By the time Scottish artists met to form a new watercolour society there were a number of women artists working in the comparatively liberal atmosphere of the London society.

The two women first elected to the Scottish Society were Lily Blatherwick, a young woman of twenty-four who exhibited widely in Scotland and England and was noted for her pictures of flowers and gardens, and Georgina Greenlees, a twenty-nine year old teacher at the Glasgow School of Art who already had obtained a reputation as an exhibiting artist. While a Society with less than one per cent of its members and associates female (and both of these associates daughters of founder members) is far from a feminist's dream, in 1878 no other large Scottish artists' organization boasted any female members. In addition, both women who applied were accepted (a

100 per cent acceptance rate) hence signalling the support of male artists for their female contemporaries in the business of art making;[22] of the 17 men who applied as associates only 8 (or 47 per cent) were accepted.

The first exhibition, held prior to legal incorporation, had opened in the spring of 1878 at a time when the original group was still debating the admission of women. While the discussions around the issue are not recorded, the Society's Minutes chart the course of a debate that first included a woman member (Greenlees), then excluded her, then included two women (Greenlees and Blatherwick) but kept them on the periphery as 'associate members', later changing their title to 'lady members'. The 'Laws and Regulations' of the Society (1878) stated, 'Honorary members and Lady Members have no right or power in the management of the Society, or interest or liability in its affairs' thereby following the precedent established much earlier in London. The ensuing changes in the position of women artists within the Society suggests that heated debates took place amongst members themselves.[23]

Again, as can be found in discussions about the admission of women to art schools (see chapter 1), struggles around the issue of women and membership in professional organizations were multi-faceted and complex. Pamela Gerrish Nunn pointed to the jealousy of male artists as a leading factor in the exclusion of their female colleagues;[24] but it is necessary to consider jealousy in tandem with the deployment of resources particularly in a city such as Glasgow that was not noted for its generosity in the field of art. Only so many pictures would be sold and most artists strived to earn their livings; the market would have been jealously guarded from 'newcomers' amongst which women must have been counted. However, press reviews of early exhibitions organized by the original group included the women without any reference to their status; that is, a reader would likely construct them as 'belonging'. For example, the first exhibition included 'two studies from the forest' by Georgina Greenlees, Lily Blatherwick sent 'some boldly-drawn flowers', and Edinburgh's Christina Paterson Ross contributed 'an interior of a smithy, a powerful picture'.[25] Viewers, potential buyers and the newspaper-reading public would have construed the women as 'members'; certainly the women would have had an identity as public figures, known within the art world as teachers and practitioners.

Greenlees and Ross both taught art, publicly and privately respectively, exhibited regularly in a number of Scottish and English venues, and shared similar views and backgrounds: both had artist-fathers and both were committed to women obtaining an art education and following fine art as a career. Blatherwick's father was also an artist and a founder member of the SSW but because he earned his living as a physician in the village of Rhu near Helensburgh, he falls into the category of 'amateur' painter: he did not

derive his support from selling his paintings.[26] Lily Blatherwick exhibited consistently with the SSW and, although not a founder member of the Glasgow Society of Lady Artists, she became a member in 1893. She, like her father, hovered in the nebulous region of the 'amateur' not supporting herself by working as an artist (that is, by selling work and teaching) and not exhibiting as widely as Greenlees and Ross.

The first official exhibition organized by the newly formed Society opened in the autumn of 1878; each member could contribute up to eight pictures and only members could exhibit – all members despite the variations in their titles could exhibit the full complement of pictures. Thus, according to the *Glasgow Herald*, there would be little danger from 'amateur interference with taste' which apparently plagued many contemporary exhibitions.[27] Taste, in this instance and following Pierre Bourdieu, is constructed within the linked relationship organized between 'cultural practices' and 'educational capital' both of which are connected to 'social origin'.[28] Exhibition reviews in newspapers during the late nineteenth century were riddled with references to taste; certainly, the writers identified themselves as 'tastemakers', helping to educate the public and channel viewers' attitudes in a 'correct' or tasteful direction. The *Herald* critic perceived the SSW as one which would uphold current standards of 'taste' while at the same time, the pictures promised to 'bring out' whatever was 'essentially national and precious in Scottish art'.[29] Scottish watercolour painting, according to this critic (and probably many *Herald* readers agreed) had potential as a purveyor of national values as well as an educator of public taste – the two remained inextricably linked as if one could not be had without the other.

The Society was professional, and as such it supported and promoted its members, offering a venue from which work could be sold. The *Herald*'s critic was convinced that because Glasgow was a mercantile city it was 'inevitable that pictures should mainly be purchased to sell again' and, along with this, the kind of art promoted should be that which offered the 'largest prospect of profit'.[30] Because the taste of amateur and professional picture-dealers had dominated 'other considerations', and because foreign pictures had offered the 'best field for speculation', foreign pictures or imitations had been praised and promoted. The critic lamented this situation, proffering Scottish art as art that should be purchased in Scotland by Scots. Scottish art, like German or French art, 'must belong to the land and the people' and must find its inspiration from these subjects. The avid consumption of publishers' titles dealing with history and antiquarianism by Scotland's middle classes has been considered an expression of nationalistic sentiment in Scotland beginning at least by the 1880s, and for many 'such attitudes probably mixed with a rarely articulated romanticism'.[31] Artists and their supporters in the press seemed intent on promoting the consumption of

visual signs of nationalism as early as the 1870s and, together, they entered into a campaign of subtle (and often not so subtle) promotion.

The opening, in 1877, of the sixteenth annual exhibition of the Glasgow Institute of the Fine Arts was recommended as being of great interest to those concerned for 'the progress of our national art': there were Scottish landscapes, pictures of 'Scottish life' and they were painted by Scottish artists. 'Second-rate foreign pictures' on the other hand, were noticeable by their absence: 'it can no longer be said that our picture galleries, like our shop windows, are decorated to meet a vulgar taste for foreign wares'.[32] Several days later, another review of the same exhibition belied the notion that it was only in 'foreign and distant lands' that artists might find exciting subject matter and lamented an apparent 'expression of contempt for Scottish scenery'. Robert Greenlees was singled out as an artist who struggled effectively 'with this wretched prejudice – he did not prefer Molière over Burns, the Rhine to the Tay'. His picture *A Forest Glade at Inveraray* was Scottish and, according, to the critic, 'all that any artist might covet'. Georgina Greenlees, like her father, painted the Scottish landscape, trunks of spruce firs, the 'dun wood of a barked tree', moss, dead leaves and ferns.[33]

The penultimate critical notice of the 1877 Institute exhibition published by the *Glasgow Herald* reiterated its intention to promote Scottish artists who painted Scottish subject matter:

In a last notice some notes will be given on the English and foreign pictures, the shortness of which will be excused since the presence of most of these pictures is explained by the fact that no sort of writing has been of any service to them elsewhere. To our Scottish artists main attention has been devoted.[34]

This atmosphere of 'nationalistic sentiment' provided the foundation for the new watercolour society; the critics continued to support the painting of Scotland and associated this quite specifically with watercolour. Watercolour as a medium was said to belie imitation; therefore, according to the *Herald*, the watercolour painting of one country could not be imitated by the watercolour painters of a different country and, consequently, that which was 'precious' about art was 'the more likely to be preserved by the watercolour painter'. In addition, the critic implied that 'ordinary' people, who showed more concern for enjoyment than for profit, could purchase watercolour pictures whereas oil pictures (possibly because of their expense) were most frequently purchased by 'picture-dealers'. Finally, the *Herald* promised that the exhibition in the Society's West Nile Street gallery presaged 'a new reputation' for Scottish art.[35]

Men and women (mostly artists) from Glasgow and Edinburgh attended the opening of the autumn exhibition (1878) as did a number of artists from other areas. Guests could browse through the galleries looking at pictures

such as Georgina Greenlees's 'small and harmonious' landscape *A Summer Evening*, or Lily Blatherwick's *Neglected Flowers*, a 'fine contrast of flowers with the verdigris green of a vase', then wander into adjacent rooms to take tea.[36] Both Greenlees and Blatherwick were admired for their drawing skills and for the command they had over form in their pictures, which, according to the *Herald* was neglected by many other artists.[37]

The exhibition drew an unexpected number of evening viewers, suggesting that working people (although probably not the lower working classes) attended. The Society had decided upon evening openings between seven and ten o'clock in order to encourage attendance by those who were in offices, shops, or other businesses during the day, and the evening attendance fee was only 6d as opposed to the 1s (12d) entrance fee charged during the day.[38] In addition, wrote the *Herald*, the exhibition was attended by 'an unusual number of strangers from a distance' while the Glasgow public 'who are boastful of knowing nothing about pictures' were, of course, absent.[39] Far from being unusual, this image of the Glasgow viewer haunted press reports of exhibitions in the Scottish press as well as the London press: The *Art Journal* once sarcastically noted that the 'majority of the people in Glasgow are not art lovers; the circus is more to their liking than pictures'.[40] From a selling point of view the exhibition was not considered a success; the Society's gallery sales amounted to slightly more than £450,[41] and when the second exhibition opened in the winter of 1879, the *Herald* admitted that the greatest difficulty the Society faced was the apathy of the Glasgow public. It seemed that in Glasgow, those most in a position to patronize the arts, considered picture exhibitions 'beneath their notice'. Nevertheless, continued the *Herald*, a growing belief that 'choice' watercolours were a good investment 'must aid in bringing the art into repute'.[42]

Among works offered for sale Georgina Greenlees's *An Arran Path* was considered 'excellent', and newcomer Kate Macaulay's picture of one of the west coast's romantic sea lochs (Loch Tarbert) demonstrated her 'feeling for colour'.[43] Macaulay was the third woman to be elected an associate member, soon to be followed by Edinburgh's Christina Paterson Ross.[44] While, as Deborah Cherry has aptly demonstrated, women artists such as these participated in the growing desire for the visual reproduction of the rural landscape for urban consumption,[45] they also engaged in making their own employment. In addition, Scottish women artists who reproduced the landscape of Scotland were charged with a somewhat different mission than were English women reproducing their own or exotic landscapes. Thus, while acknowledging the emphasis of the *Herald* upon nationalism in watercolour, the late-twentieth-century viewer might be encouraged to probe a little further into the kinds of representations exhibited in the Scottish venues and the possible

meanings these might have had both for the female producer and for her (mostly) Scottish audience.

Many dialogues (or in some instances, monologues) crossed the highlands and lowlands of nineteenth-century Scotland, the most dramatic of which were about the clearances and tourism. The clearances or improvements as they are sometimes euphemistically called, shifted large numbers of Scots from one part of Scotland to another (inland to coast) and, in many cases, from Scotland to the colonies. In a recent essay, Allan I. Macinnes characterizes the clearances as

an integral aspect of the transition from a traditionalist to a capitalist environment accompanying industrialization and the commercialization of agriculture; a process which accelerated in the British Isles during the eighteenth century, spread to the rest of Europe and North America in the nineteenth and continues in the wake of colonialism to shape the economic development in the Third World – especially Latin America, central and southern Africa – to the present day.[46]

Without debating the 'cause' of the clearances, their effect was clear: numbers of people were displaced, these people were exceedingly poor, and the poverty was visible. Nineteenth-century Scottish landscape painting camouflaged the poverty and, by so doing, might be considered immoral or irresponsible, but camouflage, while misleading, is also an evasive precaution and therefore protective. Thus, the despairing face of poverty which coloured the countenance of Scotland as it was constructed for and by the outsider could be camouflaged, giving a reputable/respectable/desirable impression to Scottish people: pride and despair could co-exist.[47]

Tourism by outsiders, usually southerners, entered the Scottish economy as consumption and production by the early part of the nineteenth century. Clearance historian, Eric Richards commented upon English and Anglo-Irish 'shooters' who annually 'descended upon' tiny Highland villages and engaged in 'assaults on red deer, ptarmigan, black game and grouse'. Richards attributed the development to two trends: the 'increasing fashionability of expensive sport among the aristocracy and plutocracy of the new industrial nation', and a sharp decline in profitability of sheep farming in Scotland by the 1870s along with an increased profitability in 'providing for hunters'. For example, rental values of certain properties doubled between 1836 and 1872 entirely because of deer shooting.[48] While this was a tourism of outsiders and in addition focused upon sport, there was also a more gentle kind of tourism engaged in by Scots as well as southerners. Nicholas Morgan and Richard Trainor, in their discussion of Scotland's 'dominant classes' contend that by the 1880s and 1890s annual holidays 'loomed large' on the calendar of many Scots. The very wealthy often toured about aboard yachts or visited expensive country retreats; the less well off could take a

house 'in an appropriate location for the summer, to be reached for west-coast residents by an almost obligatory cruise down the Clyde'.[49]

Georgina Greenlees, one of the less well off, followed a small itinerary in her search for visual compositions which she could record in watercolours and sell in exhibitions. In 1878 she travelled north and west of Glasgow painting in and around Callander, near to the Trossachs, choosing simple landscapes by the River Teith or the more romantic ruins of the ancient Roman campsite.[50] Her choice signalled an understanding of the market for her goods. Little has changed in the intervening years; tourists still make excursions to the Trossachs in their cars or on coach tours that begin in Glasgow or Edinburgh, promising an 'extraordinary' look at Rob Roy country (Fig.19). Greenlees would have understood the popularity of the area in terms of Scott's novels or poetry, a popularity ensured by the opening of the railway in the 1860s; today's tourist can collect a brochure suggesting a trip 'in the footsteps of Rob Roy' graced by a full-length picture of Irish actor Liam Neeson in his role as lead in the 1995 film. The brochure promises to guide the visitor through the areas in which the story was filmed presenting a mélange of fancy, fantasy and history: 'It was here [Loch Earn] and on Rannoch Moor that they built the standing stones (which have since been removed) and filmed the capture of Rob Roy and the murder of his brother Alastair.'[51] Visual representation of the romantic and romanticized landscape continue to lure the visitor to the countryside; the medium changes but the subject matter remains the same.

Georgina Greenlees frequently painted the area around Loch Lomond. Her picture *Ben Lomond* (1874) (Fig.20) epitomizes the captivating scenery that attracted visitors to the area then as well as now. The hill rises from the picturesque loch, cattle wander to the water for a drink, and a skiff in the foreground waits for the absent holidayers to collect their basket from the beach. The picture suggests the best of summer's days in a wondrous landscape; it implies the presence of people nearby while maintaining the perfection of a calm, unspoiled nature. A few years later, in the 1878 winter exhibition of the Glasgow Institute of the Fine Arts Greenlees exhibited more landscape pictures of this area: *A Hay Field at Luss*, 'painted with much natural colour' was an 'effective', carefully made picture of 'a stretch of grass and waste ground'; *Bay at Rowardennan* included a 'stretch of Loch Lomond and a sweep of hills beyond'.[52] Her watercolour picture of Rowardennan sold for £40 from the exhibition, thus almost doubling her annual teaching income with the proceeds from one sale.[53] Elizabeth Patrick, Greenlees's friend and colleague from the Glasgow School of Art,[54] painted *A Lonely Shore*, a picture of 'the sea and the beach under a grey sky with much truth of colour, and that wet atmosphere which comes with the westerly wind', and *On the Kintyre Coast* which demonstrated the artist's ability to

19 Map of the west of Scotland, Cynthia Hammond

20 *Ben Lomond*, Georgina Greenlees, 1874

make a 'careful study of the ever-shifting forms of the waves'.[55] It is quite reasonable to assume that Greenlees and Patrick travelled north from Glasgow together, sketching scenes or painting out of doors, in preparation for exhibiting the pictures during the autumn and the winter. In 1879 both GSA teachers contributed again to the Institute exhibition: Greenlees had 'a Highland landscape with cattle, across which a rainy effect is cleverly drawn', while Patrick contributed 'a view of Tarbet', a small village near the north end of Loch Lomond.[56] A review written more than a month after the opening of this exhibition commended Greenlees's cattle picture as 'among the best landscapes yet exhibited' by the artist; this, along with other reviews from the 1870s, indicate that Greenlees was known for her landscape painting.[57] The *Glasgow Herald* in its 'Studio Notes' column recorded a visit to Greenlees's studio thus publicizing the artist's work before the Institute exhibition even opened. The 'Notes' intended a 'round of studio visits prior to the Institute's exhibition' thereby giving the public a sense of what to expect from the exhibition while advertising and promoting Glaswegian artists at the same time. Greenlees was 'busy with a large landscape' and, obviously from the comments, it was the landscape with cattle that appeared in the exhibition.[58]

In 1880 Greenlees travelled the short distance from Glasgow to Kilmalcolm and painted scenes of the Gryfe River.[59] The *Glasgow Herald*'s review of the

1880 annual Institute exhibition claimed that Greenlees, in her return to 'her woodlands' had never 'been happier in her contrast of stately trunks and feathery foliage'.[60] About 1882 she made a trip abroad, apparently to Italy: she exhibited pictures made from studies in the 1883 Institute exhibiton. *The Favourite Air* (which sold for £30) depicts a young man and young woman foregrounded against Mediterranean-looking architecture wearing traditional dress; *Absent Thoughts* is a portrait of a traditionally-dressed woman, again highlighted against ancient architecture. The small sketches done for the Institute catalogue remain the only trace of what appears to be Georgina Greenlees's one visit to Europe. In 1887 she painted in the north of Scotland again, this time on the islands of Mull and Iona (see Fig. 18). The image we might construct of the artist Greenlees is one of a teaching-artist working in her studio during the winter and spending part of her summer in the countryside, out of the city (but not far out), painting scenes which belonged, in a real sense, to her family, to her friends, to her ancestors and to her. She was a tourist – she lived in the city and travelled to the country – but she was a tourist in her own country, she spoke the same language, ate the same food, and had many of the same customs.

Walter Scott's early-nineteenth-century novels seduced the reader to a world of Celtic romance and travel writers eulogized spectacular scenery, but both belied the (living) Scot and this is nowhere more evident than in the journal of Dorothy Wordsworth, A Tour in Scotland in 1803. Wordsworth along with her brother and Coleridge travelled from the Lake District into Scotland passing through Glasgow to Loch Lomond and on to Loch Katrine (near to Callander), thus traversing roads and hills which would later be walked upon by Georgina Greenlees as well as by Kate Macaulay. Some of Wordsworth's comments[61] are worth considering:

A barefooted lass showed me up-stairs, and again my hopes revived; the house was clean for a Scotch inn . . . (p.67)

Left the Nith about a mile and a half and reached Brownhill, a lonely inn, where we slept . . . It was as pretty a room as a thoroughly dirty one could be – a square parlour painted green, but so covered over with smoke and dirt that it looked not unlike green seen through black gauze . . . (p.8)

. . . [a young boy spoke] . . . half-articulate Gaelic . . . his dress, cry and appearance all different from anything we had been accustomed to. It was a text, as William has since observed to me, containing in itself the whole history of the Highlander's life – his melancholy, his simplicity, his poverty, his superstition, and above all, that visionariness which results from a communion with the unworldliness of nature . . . (p.116)

In her discussion of Wordsworth's tour through Scotland, Elizabeth Bohls compares Wordsworth's description of Britain's 'own internally colonized Celtic backyard' with accounts of 'ongoing imperial adventures' in more

remote parts of the empire: 'The process of national modernization,' writes Bohls, 'involved keeping order on the periphery, forcing Scotland, Ireland, and Wales to develop in ways that would benefit the English centre of imperial power.' The scenic attraction of the 'fringe' provided a 'fantasy escape' while at the same time reaffirming it as Other.[62] While comments about the uncleanliness of the Scots abound, Wordsworth also relentlessly compared the scenery with her 'native' England – though spectacular it inevitably paled in comparison with her more civilized 'homeland'. Elizabeth Helsinger, writing about the increase of tourism within England in the late eighteenth and early nineteenth centuries suggests that drawings, paintings and travel books combined to provide a largely middle-class audience with an imagined 'inclusion within the ranks of the landowners' while, at the same time, constructing a social identity as viewer not subject of the landscapes: 'To be the subject, and never the viewer, of these landscapes means to be fixed in a place like the rural laborer, circumscribed within a social position and a locality, unable to grasp the larger entity, England, which local scenes can represent for more mobile picturesque viewers.' Helsinger designates this group of privileged tourists (and Wordsworth would fall into this category), 'internal immigrants' who are free to enjoy the privilege of possession while the poor or the labourers who inhabit the physical space of the toured landscape remained within the imagination of the tourist, fixed and immobile.[63]

Queen Victoria's comments about Scotland made during her first trip north (1842) reveal a more picturesque, less gritty picture of the country; she skimmed over harsher realities, cocooned off as she was from Dorothy Wordsworth's more intimate journeys upon footpaths, sleeping in common abodes. The Queen stayed in a luxurious and specially built apartment in Taymouth Castle from which she sojourned to observe the spectacular scenery of the Tay (see Fig.18): 'I walked out with the Duchess of Norfolk', wrote Victoria in her diary, 'along a path overlooking the Tay, which is very clear, and ripples and foams along over the stones, the high mountains forming such a rich background.'[64] The image of Scotland, like Janus, has two faces – the one is the primitive, dirty, backwardness of Wordsworth, the other is the romanticized image perpetuated by Victoria. In September 1842, Victoria wrote in her diary:

The country is full of beauty, of a severe and grand character; perfect for sport of all kinds, and the air is remarkably pure and light . . . The people are more natural, and marked by that honesty and sympathy which always distinguish the inhabitants of mountainous countries, who live far away from towns.

From her perspective she lived, in Scotland, 'a somewhat primitive, yet romantic, mountain life, that acts as a tonic to the nerves, and gladdens the

heart of a lover like myself of field sports and of Nature'. In appreciation, she acknowledged that Sir Walter Scott's 'accurate descriptions' made her familiar with the country.[65] Victoria's journals set the stage for increased tourism in Scotland from outside and inside the country.

Georgina Greenlees was an urban visitor (or 'internal immigrant') to the countryside who acted as a recorder, or more precisely as an interpreter, of the land around Glasgow. The pictures she made were for a Scottish audience (she exhibited almost exclusively in Scottish venues) and were purchased as far as I can tell by a largely Scottish audience. Her pictures, if we accept contemporary reviews, presented an already familiar scene to her viewers and buyers, a scene they passed frequently on travels to visit relatives, on business trips, or on holiday excursions. Greenlees was not, in her pictures of Scotland, representing the exotic, the primitive or the unfamiliar. Thus, while the power of looking at, representing and thereby controlling the land might be held by the artist, the artist undoubtedly also took pleasure in making a picture of the countryside (her own countryside) that would be purchased by another person who enjoyed the same pleasure. If the reproduction of a rural idyll could provide a diversion or contemplation for the urban sophisticate, it might also bestow a sense of community on the producer and consumer, particularly if they shared a vision of 'our' land. Locality, in a geographical sense and used as a term for studying small, community areas, might work to unite producers of landscape as well as viewers and consumers/patrons; put together with the pleasure obtained from recognizing a shared identity when viewing the pictured locale, the study of locality could provide an observably different model from one which implies an investment of power/control in landscape painting. To quote W. J. T. Mitchell, the 'semiotic features of landscape, and the historical narratives they generate, are tailor-made for the discourse of imperialism, which conceives itself precisely (and simultaneously) as an expansion of landscape understood as an inevitable, progressive development in history, an expansion of "culture" and "civilization" into a "natural" space in a progress that is itself narrated as "natural" '.[66] Mitchell continues from here to elaborate upon a 're-presentation' of the homeland as an imperial move to contain and control. Such arguments are persuasive and useful but work to contain what could be viewed as a more gentle reinvestment in identity (on a smaller scale) that might function to write a narrative of pleasure and pride in locale. Perhaps a Scottish buyer preferred to purchase a beautiful 'slice' of the Scottish countryside than to collude in 're-presentations' such as those offered by Wordsworth or Queen Victoria; in doing so she, for example, Greenlees, does narrate her culture but she also cultivates her 'place'.

Edinburgh artist Christina Paterson Ross exhibited with the SSW in its

21 Untitled, Christina Paterson Ross

pre-charter exhibition in the spring of 1878 but her name was not put forward for membership until 1880 when she and two male colleagues were chosen.[67] The thirty-seven-year-old Ross was, by this time, an established artist who had been exhibiting regularly with the Royal Scottish Academy and the Glasgow institute of the fine Arts as well as in numbers of venues in Scotland and England. The *Glasgow Herald* maintained that Ross was a 'powerful addition' to the Society, that the Society had been 'reinforced' by her 'clever work'.[68] Soon after joining the SSW, Ross travelled on the Continent and began to intersperse her local pictures with views of Holland, France and Spain, thus making a constructed form of the exotic available for viewers and buyers of pictures. For example, in 1883 and 1884 Ross exhibited a number of pictures of the Netherlands and Belgium such as *Windmill, Dort, Interior at Antwerp, At Rotterdam*. An untitled picture from this period (Fig.21) confirms the consistent critical praise given to Ross for her use of colour and her expert and engaging command of the depiction of light. In addition, this watercolour with its charming representation of a serene domestic experience which balances the implication of work with the gentleness and warmth of

relaxation and sunlight undoubtedly pleased the middle-class consumer of art in Scotland. Thus, while her picture as representation speaks of the pleasure to be gained from domesticity, her artistic work as production, which speaks of her travels and her technical abilities, challenges the ideology of the so-called 'separate' spheres and helps to establish Ross as 'not domestic'.

Between 1885 and 1887 Ross exhibited a number of pictures made in southern Europe and north Africa: 'they are all suggestive of picturesque Moorish architecture, swarthy, bright-robed people, and dazzling sunshine' and attest to Ross's travels taking her to the Alhambra and across the Strait of Gilbraltar to Tangier.[69] The *Scotsman*'s critic commended her 'evident appreciation of the general effects of strong colour and light, her drawings in that respect being more robust in tone than the majority of ladies ever attempt'. The largest picture in this group depicted 'a quaint, narrow, tall-housed street in Fuentarabia, with sunshine and shadow effectually contrasted'.[70] This small town on the border between France and Spain was then, as now, noted for its quaint, brightly-painted houses which no doubt delighted the artist. Within a couple of years of Ross's visit to the area, the *Woman's World* published a feature article praising Fuentarabia's beauty and suggesting that should one, 'in these days of universal tramping', seek for 'one old-world nook, forgotten in the march of progress', then this small town 'on the Spanish frontier' was the place to visit.[71] Ross's travels are not unusual; a quick glance at the titles of pictures by many Scottish women artists, particularly the group that founded the Edinburgh Ladies' Art Club, reveals active, travelling women abroad and at home. For example, and in addition to the more frequent travels around Europe, Mary Rose Hill Burton went to Japan in 1894 and Agnes Cowieson travelled to Africa in 1898. Such travels connected directly with their work continually erode the myth of the rigidly coded Victorian 'separate sphere'.

As Amanda Vickery has suggested 'separate spheres' is a contested category and one that requires substantial rewriting and reassessment. 'Whatever angelic uniformity was to be found,' wrote Vickery of the Victorian domestic ideal, 'it was not found in Victorian sitting rooms, despite the dreams of certain poets, wistful housewives, and ladies' advice books.'[72] Vickery's beautifully descriptive category, 'formidable travellers' may aptly apply to Christina Paterson Ross and her friends and colleagues in Edinburgh and Glasgow. A read through picture titles exhibited by Ross in the SSW during the 1880s establishes her as an active, energetic woman and suggests that her travelling was work related rather than vacation oriented, although she undoubtedly obtained pleasure from both the travel and the work. In addition to the travel pictures Ross exhibited in 1883, 1884 and 1885, in 1888 she exhibited *From a Train Window in Verona, Gateway in William the Con-*

queror's Palace, Rouen and Night at Venice; in 1891 she exhibited A Norman Draw-well, In a Norman Farm and A French Peasant. She was a 'formidable traveller', and while Ross could be thought of as importing the exotic to her northern home, more often she painted her own 'backyard'. For example, from her rented studio on Queen Street, which was next door to her parent's flat, she could make walks to historic Dean Village (see Fig.8).[73]

Dean Village, the largest of Edinburgh's milling settlements, flourished until the development of the large flour mills of Leith in the latter part of the nineteenth century. The area provided Ross with a charming, romantic site close to home – old, quaint buildings and the Water of Leith. Critics liked her representations of 'the picturesque Dean' and they often were listed for sale for £3 or £4 while 'foreign' pictures might sell for £7 or £8 and complicated interiors such as A Painter's Studio probably would sell for £20. Her expenses would have been less when she made local pictures; despite her travels she was not wealthy and the Dean Village site required little more than pleasant weather and good walking shoes. Ross supported herself: she was a middle-class working woman who needed to sell her work, attract students to her studio and obtain commissions. By the time Ross was 25 years old (in 1868), she was exhibiting with the Royal Scottish Academy; she worked and exhibited regularly with a number of venues until her death from cancer when she was 62 years old in 1906. Even trips to visit family in the border town of Berwick-upon-Tweed became opportunities to sketch, draw and paint outdoor scenes. She exhibited numbers of pictures of Berwick, one of which, The Quay, Berwick-on-Tweed (1885, private collection), confirms her interest in veracious portrayals of scenes of everyday life and attests to the critics' constant praise for her sense of design, her superb use of browns and greys, and her 'liquid touch'. Although she made three or four European tours, one of which was probably attached to a period of study in Paris, she favoured pictures of her home area.[74]

Ross combined landscape with genre, directing her images toward her market – she had a career, was an independently employed person and was earning her living.[75] Her landscape painting, like that of her colleague Georgina Greenlees, served to 'sell' Scotland to Scots and to earn enough to support the artist even though those earnings were modest. Ross consistently priced her pictures at the bottom end of the scale. In 1880, the average price for a watercolour picture selling from the exhibition was about £26, in 1881 about £23; the most expensive pictures consistently were by men. For example, in 1881 John Smart, one of the founder-members, was asking £200 for In the Track of the Storm, Lanrick, 28th December, 1879; Society President Francis Powell was asking £150 for Waves in the Bay at Sundown. Although these are Scottish landscapes, as were pictures by Ross and Greenlees, the complicated economic hegemony within which the women worked decreed

a lower price for what may well have been similar labour and technical proficiency.

Kate Macaulay's Scottish landscapes reflect a different location from either Greenlees or Ross: Macaulay did not 'belong to' anywhere. She must have lived, for at least a good part of every year, in Scotland while she was a member of the Society (1879–98) but she also stayed with her parents near Betws-y-Coed in North Wales, an area that had been popular with artists since the 1770s and, on occasion she appears to have had a studio in London. Born in Malta when her father was stationed there with the Commissariat General, she began her life as a displaced Macaulay – her father had been born in India; her mother in Quebec. She was educated in London at Queen's College but claimed descent from 'an old Highland family' and, although she visited Scotland regularly, she never 'belonged' to that land in the same way as did her other female colleagues in the SSW.[76] Any discussion of Macaulay encourages a discussion of identity, particularly as described by Stuart Hall. Hall posits cultural identity as 'becoming' and 'being', not as 'something which already exists, transcending place, time, history and culture'.[77]

Identity is fixed neither in history nor in the present and, by looking at Macaulay and writing about her possible experiences, I layer the story of her interaction with her ancestors' history with my story of that exchange. My discussion of Macaulay and her work constructs a multifaceted narrative of history: a layer of Macaulay narrative constructed in and around clan dispersion, woven together with a layer of my twentieth-century narrative that seeks to find a historical 'place' for the landscape painter, Kate Macaulay. To follow on from what Stuart Hall has called 'imaginative recovery', I might imagine the historical Macaulay as a visual inscriber of her story of land who is re-inscribed by my fictitious picturing of her. Also, she may be called an imperialist gypsy: an imperialist in that she probably advocated (or at least did not question) British control over the lands to which her father was posted, and a gypsy in that she wandered about these lands devoid of an invested ownership in them, without income of her own that could make her independent of the Empire, and subject to a commanded displacement based upon the decisions of senior officers.[78] No titles of pictures remain to indicate that Macaulay ever recorded scenes of exotic foreign places: she painted only her 'native' land or its coastline, from the north-west of Scotland to the south of England.

Her ancestor (or her imagined ancestor), Walter McAuley is thought to have built Ardencaple Castle sometime during the sixteenth century and by the seventeenth century the family's land stretched from Helensburgh north to Garelochhead and east to Loch Lomond.[79] Ardencaple property itself had been in the hands of Macaulays (or McAuleys) since the reign of Edward I;

the area around Ardenconnal was added to their holdings in the early part of the seventeenth century and, certainly during that century, the family was a prosperous one. However, by the eighteenth century, the family began its decline and with the ascent of the twelfth laird, during the second half of the eighteenth century, the Macaulay family was left totally landless.[80] The land belonged to the Dowager Duchess of Argyll until she sold it in 1862 to Sir James Colquhoun of Luss. When Kate Macaulay's father was born in Quilon in the southern part of India in 1824, the land which had belonged to his family or a branch of his family was in Argyll hands.

The earliest record I have of Kate Macaulay painting in this area dates to 1874 when she offered two pictures for sale from the exhibition of the London Society of Lady Artists: *A Sandy Bay near Oban, Argyllshire* and *Bay of Oban, Argyllshire, painted on the spot* (see Fig.18).[81] Until 1880, when the Callander and Oban railway was completed, she would have travelled by train from her North Wales home to Glasgow and then onward by ship from Glasgow to the ruggedly beautiful coast of Lorn. Obviously from the title of one of the 1874 Oban pictures, she sometimes painted out of doors; other pictures may have been completed later in her studio from sketches and, while she painted as far north as the Isle of Skye, she favoured the area around the sea lochs just north of Helensburgh or near to Ardencaple Castle. In 1880, when she exhibited 'a really beautiful picture from Tarbert', the *Glasgow Herald* commended the way in which her painting of the sea caught 'the shadow of a white house and some fishing smacks'; it was, according to the *Herald*, 'most harmonious' and one of the finest pictures of the exhibition.[82] The following year Macaulay exhibited a picture called *East Loch Tarbert* which was painted, again according to the *Herald*, with 'her own vivid style'; this style had a 'sparkle' which captured the 'dazzle and shimmer of the sea, with such success as water colour but rarely attains to'. It also was a style, noted the critic, that had the advantage of 'selling in an exhibition room'.[83] In 1882 she exhibited *Scotch Herring Boats – Loch Fyne* and a view of Tarbert harbour (also on Loch Fyne); the *Herald* wrote that she had 'painted the old harbour, full of rich shadows from the hill and pearly gleams from the summer sky'.[84] These critically acclaimed pictures might represent Macaulay's look at her nostalgic homeland – a pictured travelling from birth in Malta to roots in Scotland – while at the same time they represent a locality that could be produced and sold to those who identified with or valued their 'own'.[85]

Along with eight other painters, Macaulay had applied for an associate membership with the SSW in December 1878; she was the only woman to apply that year.[86] Two months later, early in 1879 she and two others were elected, thus making her the third 'Lady Member' of that Society (in 1890 the women became 'Associate Members' thereby doing away with the cate-

22 *The Wreck*, Kate Macaulay, 1879

gory 'Lady Member'). One of Macaulay's two 'diploma' pictures required for membership was *The Wreck* (Fig.22), a picture that demonstrates her commitment to landscape and seascape. She remained an active member of that Society until the autumn of 1898, when she resigned. Sales from the exhibitions are difficult to track but for some of the earlier exhibitions, the *Glasgow Herald* noted the artists, titles and the received prices. With these erratic records I have established that Macaulay sold two landscapes from the 1880 annual exhibition: *Tarbet Castle* for £16 16s and *Cairn Reflections* for £12 12s.[87] Thus, her income from sales during 1880 was, at the very least, just over £28, or slightly higher than the annual average Glaswegian income.[88]

Neither Macaulay nor her colleagues in the SSW inhabited a private and domestic sphere. Greenlees, Ross and Macaulay worked and, at least partially, supported themselves. Therefore, while they may have subscribed to an ideological organizing principle which historians have labelled the 'separate sphere', they were not inscribed by that ideology; that is, their lives were not ruled by it, and they most certainly were not defined by a rigid, overriding code of domestic behaviour. The work and movements of these women destabilize female identity as they construct Scottish identity and weave nostalgia into production as a saleable commodity. 'Place' might be identified as a site of nostalgia[89] and a visual reproduction of 'place' might reinforce this, but deliberate use of such representation to earn one's living shifts nostalgia away from the theoretical into the practical. In addition, the lives of the three women were quite ordinary: Ross and Macaulay never

married and, although they lived with members of their families (for example, after the death of her parents, Ross lived with her brother and sister until she died) they travelled about a great deal and made their 'own way'. Greenlees married when she was thirty-six years old but she continued to paint and exhibit under her own name.[90] To reiterate, these three women artists recorded their own identity as well as an identity recognized as Scottish by their patrons, they interpreted their country as insiders rather than as travelling strangers, they offered views of 'other' places which 'translated' foreignness for the Scottish viewer/consumer, and they marketed a nostalgia for place thereby authenticating their acumen in an economy from which they were often excluded.

While the artists traversed geographical terrain in slightly different ways – Greenlees as urban visitor to the nearby countryside, Ross as urban visitor but also as traveller to foreign lands, and Macaulay as a wanderer – they obtained contentment and pleasure from representing a landscape which most often was identified as their own. This was not a colonizing act nor a controlling act, but rather a movement and a means of obtaining income from a profession which gave them joy. Viewers of the represented landscape might obtain, as Gillian Rose suggests, a pleasure that can be 'interpreted through the psychoanalytic terms across which the gaze is made – loss, lack, desire and sexual difference'.[91] However, if pleasure can be shifted away from representation (and psychoanalysis) and be seen to interact with the material conditions of production and consumption, then enjoyment can be realigned with the ordinary lives of cultural workers. The women in this narrative – visitor, traveller or wanderer – far from representing visual imperialism in their landscape paintings, signalled an affirmation of their roles as productive members of society within a nineteenth-century economic structure: they painted, travelled and sold their goods with commitment and with pleasure.

Friends and colleagues

The view from the windows of Ramsay Garden's top floor flat is one of Edinburgh's finest; it offers a panoramic sight of the Pentland Hills to the south and the Firth of Forth to the north. In the late nineteenth century, when Anna and Patrick Geddes moved into Ramsay Garden, the cityscape would have been devoid of the high rectangular twentieth-century shapes that rise to meet the contemporary eye; only the occasional spire or tenement rooftop would have interrupted the long gaze to the hills. Inside the flat, a cosy room with a window overlooking the Princes Street Garden contains a partially restored three panelled wall painting made by Mary Rose Hill Burton for her friends.[1] The large centre panel celebrates Burton's ancestral Highland home Kilravock Castle, while one side panel (two out of the three original panels have been restored) depicts a dark, sombre Scottish landscape. The castle's moodiness is brightened only by purple, yellow and white crocus flowers spreading across the vast lawn leading toward the official entrance.[2]

The Ramsay Garden pictures are somewhat similar to a large decorative mural scheme for Geddes's University Hall (Fig.23) where Burton's seven-foot high panels represented the seasons and suggested her admiration for Japanese art. The *Studio* 'heartily congratulated' Burton for the 'complete success' of the project. Each wall depicted one season and, like the panels in Ramsay Garden, the sombre tones of the backgrounds were relieved by 'bright autumnal leaves', pinkish-white birch stem, and colourful flowers.[3] While the murals represent Burton's production and thus her life as a working artist, they also commemorate her friendship with Anna Morton Geddes and Patrick Geddes. The relationship between them is multifariously complex: Burton taught in Patrick Geddes's Summer Schools; she was a close friend and confidante of Anna Geddes; along with her mother and their friend, Jeanne Currie, she often tended the Geddes children when their

23 Decorative mural scheme for University Hall, Mary Rose Hill Burton, 1898

parents were travelling; and, her brother married Anna Geddes's sister.[4] While family ties wove together Burton's life with the lives of Anna and Patrick Geddes, friendship, shared goals and similar backgrounds laid the foundation for working relationships with the artists who joined together to form the Edinburgh Ladies' Art Club. Of the artist-members of the Club, London-born Florence Haig seems to have been Burton's closest friend.[5]

Unlike Christina Paterson Ross and many other colleagues in the Edinburgh Ladies' Art Club, neither Burton nor Haig had to support themselves. Both were prolific and committed painters but they can be constructed as 'workers' only uneasily: like many other middle-class artists they worked but did not have to earn. They made pictures for exhibition and sale, therefore they intended their work and by extension themselves to be in the public eye. Both taught art – Burton taught privately and to Patrick Geddes's School of Art, Haig, after her move to London, was 'Head Master' at Barnsley School of Art.[6] Nevertheless, history has tended to construct Burton, Haig and others like them as 'non-productive' members of society. Their

story, then, offers the possibility of reading around corners and seeking for different ways of constructing women of independent means.

Burton's career as an artist followed an independent path; there is no record of her attendance at the Edinburgh School of Art. Perhaps her mother, having been part of an earlier struggle to obtain entrance to the School (see chapter 1), encouraged her daughter to find other ways of developing her skills as an artist. Katherine Innes Burton was a formidable woman, well-educated in the lessons of women's rights and supported by a family whose members sought equality for women in education and in work; Mary Rose Hill Burton followed in her footsteps but took her art career much further than had her mother. Katherine Burton's attempts to study art at the Board of Manufacturers' School in Edinburgh had been thwarted by a conservative Board of Directors and, as mentioned earlier, she left art behind when she travelled to the Crimea to work with Nightingale. Her daughter opted to study first in Munich (for only one winter), then in Paris,[7] and Burton herself published an illustrated article about a summer class she followed near Amiens in France, a school she referred to as a 'hedge' school (Fig.24).[8] An 1897 review of a solo exhibition in London implies that, before Burton studied on the Continent, her artistic training simply had been part of the standard and general education received by middle-class women; it was the Royal Scottish Academy's decision to accept some of her watercolours for exhibition that 'induced her to decide to adopt art as a profession'.[9]

Burton's father was the well-known Scottish historian John Hill Burton and, while he was alive, the family lived in the large and comfortable Morton House in Edinburgh's Lothian Burn. After her father's death in 1881, Mary Rose, her mother Katherine, and her half-sister Elizabeth, settled into a smaller, but still comfortable flat owned by Katherine Burton in Montpelier Terrace only a few streets from the home of Florence Haig (see Fig.8).[10] While Burton's friendship with Haig was not based upon familial relationships as was the friendship with Anna Geddes, these two young women were of the same age and shared the concerns of the practising artist. Mary Rose Hill Burton and Florence Haig may have met through their families or in classes. Although the women did not attend the Board of Manufactures' Art Classes, they did follow university-level courses with the Edinburgh Association for the University Education of Women during the late 1870s and early 1880s. The Association had formed late in 1867 to advance the higher education of women and offered its first classes in January 1868; by 1870 Katherine Burton was a vice-president even though she did not always accept the goals of the Association's founder, Mary McLean Crudelius.[11] Neither Burton's daughter nor Florence Haig followed the most popular courses such as biblical criticism or English literature but selected, instead, subjects that would help them advance their careers as artists or that were seriously professional or

24 'A Hedge School in Airaines', Mary Rose Hill Burton, 1889

academic. Florence Haig studied geology, experimental physics and mathematics; Mary Rose Hill Burton studied mathematics and Latin.[12] In addition, both artists advocated women's rights and were supporters of the suffrage movement.

Haig, who moved permanently to London about 1912, held suffrage meetings in her Chelsea studio with speakers such as Mrs Pankhurst and Cicely Hamilton.[13] Burton's mother and aunt were both strident supporters of women's rights. Katherine Burton maintained her role as activist in the movement for women's rights and education throughout her life. In her work with the Edinburgh Ladies' Educational Association she insisted that young women not only receive an education comparable to that received by young men in university, but that women be able to use their education in the workplace.[14] Mary Burton, the unmarried sister of John Hill Burton, had much in common with her sister-in-law.[15] She fervently advocated women's education and women's right to work, as well as the right to the vote, throughout her long and active life. She actively supported the 1881 motion put forward by the Edinburgh branch of the National Society for Women's Suffrage to introduce a resolution into Parliament in favour of women's suffrage[16] and helped organize the 1884 Scottish National Demon-

stration of Women;[17] she was on the platform of an 1888 Glasgow meeting 'held with the object of forming women's trade unions' so that women 'might be in a position to protect their own interests';[18] and, she worked to have women educated with men at the Heriot-Watt College.

Almost twenty years before her niece Mary Rose entered into a public debate meant to halt British Aluminium's destruction of Foyers Falls on Loch Ness,[19] Mary Burton read a paper on a similar topic to the Social Science Congress in Aberdeen. Her paper noticed 'that where industry had planted itself' in Great Britain 'it had made a blot on the face of nature'. Burton insisted that this 'need not necessarily be the case'. She cited a Hartz Mountain mining operation that had 'adorned' the surrounding countryside 'instead of deforming the country' and, according to Burton, there were other examples of this kind of development on the Continent. Burton contended that Britain was 'ashamed of work', that workers took no pride in themselves or their 'accessories', and that they in turn were not valued. With a discourse similar to Octavia Hill's in London and one that would become familiar in Scotland amongst Patrick Geddes and his circle, Burton wanted to combine beauty with labour.[20]

Burton always valued workers, education and women's right to work and education and, as might be expected, her commitment to such programmes was not always lauded. Katherine Burton's stepdaughter (Mary Burton's niece) remembered her stepmother as 'a formidable woman' who had been a nurse in the Crimea. Together Katherine Burton and Mary Burton 'appeared on party platforms, ran committees and fought for women's rights' ('many were the excursions on which the two "bluestockinged" ladies went in the pony carriage'). The two women 'were among the first women to wear hats, instead of bonnets, in Edinburgh, and were followed in the street by hooting larrikins because of this'. Far from converting this young woman to activism, Matilda Lauder Burton reported that she 'grew up to hate cleverness'.[21] In addition, lest one be tempted to turn Mary Burton into a 'hero', while she advocated women's right to work, she insisted that feeding and clothing the children of the 'reckless class' was overly expensive, time-consuming and would lead to 'expecting more for nothing'.[22] Thus, while insisting that women should interest themselves in political affairs, she had her own very middle-class agenda. Exactly where her sister-in-law or her niece stood on issues of the 'reckless class' remains unknown; however, Mary Rose Hill Burton did express concern for workers and displaced tenants when she took up her public debate with the recently formed British Aluminium Company. Of this debate (and possibly with more compassion than her sister-in-law) Katherine Burton wrote to Patrick Geddes: 'Its ludicrously pathetic the way the poor people are played on & tossed to & fro'.[23] Mary Rose Hill Burton lost her battle with the British Aluminium Company but

her advocacy of an environmental issue highlights yet another aspect of her career as an artist in the same way that politicking for women's rights highlights an emphasis upon women as workers.

The women in the Burton family were not waged workers but their activities focused upon the issues of work for women as well as upon women's rights – that is, while they supported suffrage, their concerns went beyond the right of women to vote. Mary Burton, for example, was elected a life member of the Heriot-Watt Technical College Board in the 1890s because it had been through her efforts that the institution was opened to women.[24] In an 1896 interview done when she was an active seventy-seven years old, Burton reminisced about her initial consideration to join Nightingale in the Crimea (perhaps with her future sister-in-law); she abandoned that project while, at the same time, she 'determined to devote herself to working on behalf of women', and she was amongst the first to advocate their enfranchisement.[25] Although, in her interview, she exposed herself as moralistic, self-righteous and puritanical, she formidably maintained her campaign for women's education and right to work all her life, and while her namesake Mary Rose Hill Burton never seemed as severe, she certainly practised what her aunt preached.[26]

Burton's friend Florence Haig, who had visited Burton at Foyers Falls after the clash with British Aluminium, had been born into a landed Irish family with relatives on her mother's side of the family living in Edinburgh. Haig and her sisters often stayed with their aunt in Lansdowne Crescent near the west end of Edinburgh's Shandwick Place until, in the 1880s, their widowed father moved from London to Edinburgh with four of his seven daughters. The family first lived in one of the spacious Merchiston Avenue villas but moved within a few years to more modest accommodation in Hartington Place, just around the corner from the Burton's flat.[27]

Florence and her sister Evelyn Cotton Haig both were artists and lived together with Cecilia, a third unmarried sister, in Edinburgh until Cecilia's death in 1911.[28] Florence and Evelyn Haig shared studio space in 6 Shandwick Place beginning in the late 1880s. Rents for rooms in the building ranged from £6 per annum for a small studio to £250 for a ground-floor shop, but most artists' studios rented at the lower end of the scale. For example, Ada Barclay, an artist and art teacher who struggled financially, paid £9 for her studio, while the Haig sisters paid £17 for their space. Most tenants in the building were teachers of music or foreign languages or artists but there was also a nurse, an architect and a watchmaker. Shandwick Place housed a series of Victorian commercial buildings at the west end of Princes Street on the edge of Edinburgh's New Town and had become attractive to artists when the Albert Gallery, specializing in selling works by contemporary artists, was built there in 1876. Many women artists rented spaces in the

buildings along Shandwick Place, working in studios located next to their male colleagues and, appropriately, it was sculptor Amelia Paton Hill who was commissioned to make the life-sized figures of Painting and Poetry which graced either side of the entrance to the Albert Gallery.[29] From this location, the Haig sisters could work, discuss their ideas with other artists and participate in the public world of commercial activity.

Tracing the education, careers and lives of Burton and Haig constructs a broad vista of possibilities for work as it could be practised by middle-class women in the late nineteenth and early twentieth centuries; it also demonstrates that work does not have to relate to income. By weaving together a story of the women's art practices with their participation in various organizations and clubs which enabled the women to 'network', that is to share their ideas, comment on each other's work and learn more about their profession, I hope to continue to shift the boundaries between what is called the public and private spheres while layering the work of middle-class women (artistic production) with the work of their subjects. Amanda Vickery has called for a reassessment of women's roles during the Victorian era that would not dichotomize their functions into a separate and domestic sphere, but elucidate their societal and cultural roles. 'The rise of the new domestic woman', writes Vickery, '(whether in her seventeenth or nineteenth-century guise), the separation of spheres, and the construction of the public and private are all different ways of characterising what is essentially the same phenomenon: the marginalization of middle-class women.'[30]

Mary Rose Hill Burton and Florence Haig joined the Edinburgh Ladies' Art Club when it formed in 1889 and, from the scant information available about the Club, supported it throughout its short existence. Both had pictures in the inaugural exhibition which included work from twenty-eight women, each showing an average of four works. The titles of Burton's pictures were not listed in the review; Haig included two 'pleasing compositions' of interiors with figures.[31] In the Club's second exhibition (1890), Haig contributed a 'frank, realistic' portrait of a 'lady in light blue jersey, holding in her hand a tennis racket'.[32] Tennis, invented in England in 1873, became the sport most characteristic of middle-classness and, in addition, was a sport favoured by young women as well as young men. Competitive matches for women followed closely upon those established for men (Wimbledon competition for men began in 1877; singles competition for women followed in 1884). Eric Hobsbawn, in his discussion of the invention of traditions, contends that tennis 'provided respectable women of the upper and middle classes with a recognized public role as individual human beings, separate from their function as wives, daughters, mothers, marriage-partners or other appendages of males inside and outside the family'.[33] Hobsbawn establishes a clear link between a sport like tennis and class distinctions or barriers:

tennis represented an attempt 'to draw class lines against the masses, mainly by the systematic emphasis on amateurism as the criterion of upper- and middle-class sport'.[34] The sport, as a bourgeois leisure activity, represented a lifestyle that was urban (or suburban) and casually affluent. With this representation, Haig reified her own position as a well-educated, middle-class woman joining in debates and activities meant to establish her equality with her male acquaintances, friends and colleagues. Haig's portrait of a tennis player, exhibited only months before her half-length portrait of Edinburgh advocate Francis Russell (Royal Scottish Academy, 1890), suggests that she was already working on commissions and, by this time, may have established her reputation as a portraitist: English artist George Coates was later quoted as saying that Haig 'could paint a better portrait than a great many men'.[35]

The remainder of Haig's pictures in the 1890 Ladies' Art Club Exhibition, were genre paintings, not portraits; Burton's pictures were all genre. Most of their work, like Haig's elegantly composed and subtly coloured picture of an east coast Scottish fishing village (c.1890) (Fig.25), depicted women. Some, like Burton's *Fishing for minnows, Duddingston* (1891) (Fig.26) represented a favourite among viewers and buyers of genre pictures – children absorbed in their activities, apparently unconcerned about their role as models. In early Edinburgh Ladies' Art Club exhibitions, the two friends included work

25 *East coast fishing village*, Florence Haig, c.1890

26 *Fishing for minnows, Duddingston*, Mary Rose Hill Burton, 1891

made in Ireland or made from studies done while they were in Ireland. Because Haig's father held land in Connemara in County Galway and Burton's pictures represented Galway, sometimes specifically Connemara, the artists probably visited the country together.[36] A fanciful picture of Burton and Haig travelling about to make their pictures might be reconstructed from the reminiscences of Sommerville and Ross, *Through Connemara in a Governess Cart*, which was published by *The Ladies' Pictorial* in 1893.[37] Traversing Connemara in their small mule-driven cart to Ballynahinch and Kylemore Castle (today Kylemore Abbey), Somerville and Ross made a literary picture of the joys and problems of travelling through an area which included Haig land – Moyglass is about four miles from Clifden toward Kylemore Abbey.[38] The published account of their journey would parallel in almost every way any travels made by Haig or Burton in Connemara.

Certainly, Mary Rose Hill Burton was known for her pictures of Ireland and the Irish. The *Artist* (London) suggested that in Ireland 'her sympathies were first fully aroused, and in the remotest wilds of Connemara she found the most inspiring scenery and models, and until after her travels in the far East, she was chiefly famed for her reproductions of Irish scenery and Irish people'.[39] Burton had exhibited *An Irish Interior, Connemara*, 'a family cowering in a mud hut over a fire',[40] in London in 1892 and she would exhibit many other pictures of Ireland in London and Scotland throughout the 1890s. Not surprisingly, her aunt Mary Burton (President of the Edinburgh Women's Liberal Association for a number of years) supported Home Rule in Ireland – that the family was Catholic would not necessarily be a deciding factor in their support for Home Rule but religion may well have played a role. In March 1890 with Charles Stewart Parnell's downfall imminent (his relationship with Kitty O'Shea had become public knowledge during her divorce trial in December 1889), Mary Burton read her paper 'The Progress of the Irish Question' to an Edinburgh audience.[41] A few months later, Burton introduced Mrs Gladstone to a meeting of the Edinburgh Women's Liberal Association and, in her address, outlined the position of the Association in Ireland.[42] Irish Home Rule had been favourably discussed in London by Gladstone since the signing of the so-called Kilmainham Treaty of 1882 but Parnell's downfall in 1890 brought the concept of an independent Irish government into further conflict. Even the most apparently innocent pictures of Ireland exhibited anytime during 1890 carried with them various implicated meanings.

Mary Rose Hill Burton's *Irish Idyll* (1890) obviously depicted and was meant to convey a sense of romantic nostalgia for an untroubled peasant lifestyle. The press commended the picture of a girl feeding goats for its handling of the figure and the landscape; it was singled out as one of the finest pictures in the room. Florence Haig's 'remarkably effective' Irish pic-

tures were also praised – particularly her rustic scene of a peasant girl herding geese.[43] The following year, Burton exhibited more of her Irish pictures (probably from the same trip) with the Royal Scottish Academy. One in particular, romantic though it might have been, attempted to represent grief, loss and sadness. *Keening*,[44] set on the west coast of Connemara portrayed, according to the *Scotsman,* 'a curious phase of Irish life'. Again, Burton painted women: a 'group of women "keening" or sorrowing' in an ancient churchyard with a Celtic cross and 'rough, flat gravestones'.[45] Despite the romanticism or nostalgia suggested by the titles and descriptions of Burton's pictures, she did fervently desire to protect the interests of the crofters and tenants near Foyers Falls. Additionally, it seems likely she would have known about the Irish famine and its attendant devastation as well as the activities of Anna Parnell and the Ladies' Land League[46]; the political acumen of her mother and her aunt would have assured the inclusion of such topics of conversation in household discussions.

In 1894 the Edinburgh Ladies' Art Club celebrated their fifth exhibition and the last one to be reviewed in the leading newspapers. Even though women were still struggling to market their art product, the *Scotsman* presumed they had so many opportunities of exhibiting their pictures in other galleries that an exhibition of their own was no longer necessary. With little concern for the women learning as a group or an understanding of the need to share their experiences and support one another in their careers, the *Scotsman* assumed that the 'stronger' of the women would 'no doubt, prefer to take their chance along with their male brethren of the brush in passing their work before a neutral council'.[47]

The fallacy of the suggestion that the juries of the larger venues such as the RSA or the Glasgow Institute of the Fine Arts were 'neutral councils' is, again, one of the ideological constructs which helped brand the women's societies as 'separate'. A more appropriate analysis can be made with the assistance of late-twentieth-century feminist theory. For example, Lorraine Code in her writing about 'spatial metaphors' discusses locations where 'resources are variously available . . . and where hierarchies of power and privilege always contribute' to the construction and reconstruction of identities; sometimes the locations are 'receptive, friendly environments' while, at other times they are 'oppositional or indifferent'.[48] The environment into which women entered when they chose to 'take their chances' with their 'male brethren' was anything but neutral. Quite the contrary, it was an arena filled with vested interests, not the least of which sought to limit and control the market-place.

When the *Scotsman* intimated to its readers that 'others' [women artists who did not compete with men] needed the 'encouragement which the exhibition of their work in a friendly atmosphere' was calculated to 'afford

them', the newspaper recognized a problem but remained oblivious to how invasive it was. If the venue is recognized for what it is, a market-place, and the organization supporting the venue recognized as a guild or union, then both the RSA and the Edinburgh Ladies' Art Club performed exactly the same functions: the difference resides in one being in and the other out of a hierarchical power structure. Sally Alexander, in her discussion of women factory workers in western Europe, clearly articulates the 'notion that an identity of interest among a group of workers is established through common practice of, if not exclusive possession of a skill'.[49] 'Exclusion,' continues Alexander, 'or at least segregation, remains a principle of organisation in many trade unions'. Obviously this kind of exclusion did not favour women workers and the situation with regard to art practice does not differ even though nineteenth-century academicians would deign to place themselves in the same category as a union labourer. Thus, while the academicians considered their organization a prestigious validator of artistic achievement, women sought to construct a place for their own work and achievements.

Critics of the 1894 Edinburgh Ladies' Art Club Exhibition commended Mary Rose Hill Burton's *Irish Potato Digger* (which she had exhibited before), along with her other paintings. While these pictures commemorated Burton's trip to Ireland with Florence Haig, Burton herself was onboard ship returning from a much more extensive trip – she had been visiting her brother in Japan.[50] Burton's pictures from Japan as well as from Scotland and Ireland gave her enough material for three solo exhibitions in London and, like her earlier work, the pictures based upon her observations in Japan mostly represented women. Haig also pictured women from a class and culture different from her own – the most memorable, *Straw Gatherers in Roxburgh-shire* (1900) (Fig.27), portrayed female farm labourers or bondagers as they were most often called. In both instances, Burton and Haig made 'pictur-esque' images of people different from themselves.[51]

Mary Rose Hill Burton's picturing of Japanese women complicates atten-tion paid to historic Japanese women with late-twentieth-century concerns for colonization by visualization. As Linda Nochlin suggested in her critique of Orientalism, 'time stands still' in nineteenth-century Orientalist paintings as well as in 'all imagery qualified as "picturesque" ';[52] both Burton and Haig 'buy into' this pastoral and tranquil timelessness in their representations of women. Burton's Japanese women could as easily be from the fourteenth century as the late nineteenth century; Haig's farm workers could exist on a feudal estate rather than a turn-of-the-century farm, and all the women appear ever calm, serene and unsoiled. Marcia Pointon aptly discussed this kind of representation of others as ethnographical, citing the artist as an ethnographer working 'as a sort of translator' who decodes and interprets and, following Nochlin, she reiterates the importance of timelessness: 'the

27 *Straw Gatherers in Roxburghshire*, Florence Haig, 1900

value of what was deemed timeless was marketable precisely because it was threatened'.[53] The irony Pointon finds in this situation readily applies to the intrusion by Burton and Haig into 'foreign' places: 'The irony that underlies all ethnography, the fact that the very act of entering the domain where ancient customs are thought to be maintained threatens the survival of those customs, also underlay the activities of traveller-artists'.[54] In 1896 when London's Clifford Galleries opened its second exhibition of Burton's work, a critic writing for the *Artist* praised her 'simple and direct' methods and named her an 'apt observer of manners and customs' whose studies 'in foreign lands are of historic as well as artistic value'.[55] Haig also aptly observed even though the difference she recorded existed alongside her own location in Scotland. In both instances, white, middle-class women constructed a narrative of women who were culturally and economically different from themselves: what follows is a story of that narrative.

Different women: a visitor represents Japan

Upon her return to Scotland from Japan, Mary Rose Hill Burton wrote an article on Japanese photography for the *Studio*. She recounted her visit to a Tokyo studio where men 'evidently of a humble class', clad only in 'jacket and loin cloth', squatted on the floor, their 'brushes, blocks, paint-saucers, and the inevitable teapot and smoking box', arranged around them.[56] Although in her article Burton recalls meeting male artists, the pictures she made either during the trip or from sketches mostly portray women and gardens. For example, *Fishing under the Cherry Tree* (exhibited 1896) (Fig.28)[57] shows three Japanese women in traditional dress fishing in a lush garden. The scene is tranquil and inviting, offering London viewers an intimate look at Japanese women on a sunny, warm day enjoying the outdoors and indulging in a quiet sport. The sporting activity itself would have been recognized as relatively undemanding, requiring little exertion on the part of the women (the small stream undoubtedly contained small fish). The clothes, particularly of the standing woman in the foreground whose padded *obi* (sash) is clearly visible, along with the hairstyles suggest the 'typical' Japanese woman already familiar to Westerners and definitely represent a middle- to upper-class female; the garden with its spring blossoms rephrases or translates Japanese landscape for a British viewer.

According to Patricia Fister in her discussion of Tani Kankan's late-eighteenth-century picture *Fishing in the Moonlight*, 'it is believed that certain Japanese painters communed with nature by imagining themselves as inhabiting their landscape paintings'.[58] Mary Rose Hill Burton had an intense love of nature and gardens; one might almost wonder if she knew about and accepted this Japanese belief. Burton's *A Japanese Water Garden with Women Crossing a Bridge* (c.1895) (Fig.29) continues her theme of women in gardens, this time including a slight reference to a pagoda in the background while clearly delineating the architectural form of a small bridge. Again, the women represented in the picture appear leisurely, serene, not concerned with earning a living and, characteristically, Burton displays her own love of nature by reproducing the vegetation with loving care and attention – certainly in this picture, plant life, not people, attracts and holds a viewer's attention.

Although her article on photography in the *Studio* confirms Burton's interest in the art and the process of art-making in Japan, there is no indication that she met or depicted any women artists even though two extremely well-known female artists were working in Tokyo during the time of Burton's visit. One of the artists, Okuhara Seiko (1837–1913) had opened a school in her own residence in 1871; a year later she added a boarding house where her female students were allowed to live (male students had to commute).[59] She

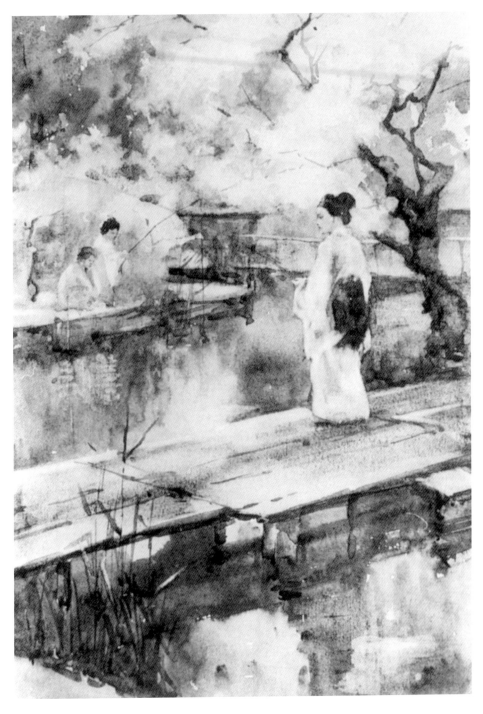

28 *Fishing under the Cherry Tree*, Mary Rose Hill Burton, c.1895

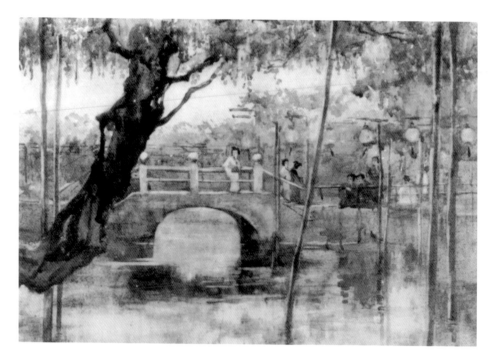

29 *A Japanese Water Garden with Women Crossing a Bridge*, Mary Rose Hill Burton, c.1895

is thought to have had as many as 300 students at one point during her career, certainly many more than Scottish women artists would have had during an entire career of teaching. Seiko was part of a large, well-established cultural group in Tokyo that could boast political connections as well as literary and artistic accomplishments.

Her slightly younger and equally well-known colleague, Noguchi Shohin (1847–1917) began studying painting when she was eight years old. She was the daughter of a medical doctor who insisted upon educating his daughter himself (he thought the recently expanded education system not adequate); in addition to reading, writing, playing the *koto*, sewing and archery, she engaged in discussions about poetry with her parents and their friends.[60] Despite the apparent privilege of her lifestyle, her father died when she was only sixteen and from that time on she supported her mother and herself by painting. A few years before Burton's trip to Tokyo, Shohin was appointed Professor of Painting at Peers' Girls' School. That same year (1889) she entered works in the Paris Exposition and, in 1893, she received a prize for a landscape she exhibited in the Chicago World's Fair. Although she resigned her position at the Peers' Girls' School in 1893, she was so renowned that

she was appointed a painting instructor to members of the Imperial family.[61] Perhaps unknown to Burton, Shohin painted an elegant hanging scroll which celebrated 'the artistry of women'; *Women Practicing Arts in a Garden* (1872) represents 'women playing music (both lute and flute), listening to music, reading books, painting, and practicing *sencha*'. According to Patricia Fister, Shohin created a 'playful variation' on the frequently painted theme of Chinese scholars in garden settings 'by depicting Japanese women instead of men'. Fister suggests that Shohin 'may have wanted to express her feelings that females could be just as talented and intellectually oriented as their male counterparts'.[62]

Unfortunately, neither Burton nor contemporaries such as George Henry, Edward Hornel or Alfred East presented such enlightened images of Japanese women. Fellow-Scots Hornel and Henry who arrived in Japan in 1893 for a stay of eighteen months made numbers of boldly executed pictures of Japanese women but most, like Hornel's *A Geisha* (1894),[63] represent what had become the quintessential Eastern woman – elegantly robed, colourful, made for 'looking at'. The sweeping political and social reforms that accompanied the Meiji Restoration of 1868 remained elusively absent from Western representations of Japan and although those reforms did not move Japanese women as far into the political world as many activists wished, the passive 'Geisha-girl' image favoured by Western artists did little to subvert a traditional image of 'woman'. Burton's *Fishing under the Cherry Tree* does permit women to participate in an activity but cannot relate changes that had occurred in Japanese culture and society; it remains 'timeless'.

Nonetheless, in 1873 the Japanese government required that both male and female children receive a primary school education and, in light industry, women outnumbered men in the workforce. It is estimated that light industry (textiles for example) whose workers were 60 to 90 per cent female, produced 40 per cent of the gross national product.[64] This is not to suggest that Japan's attitude toward women differed significantly from the West but rather to indicate that, like the West, situations for women were varied and diverse. As the nineteenth century drew to a close, upper- and middle-class Japanese women became inextricably tied to the home or to a role of nurturing 'however, women below the ranks of the middle class could scarcely afford the luxury of focusing only on the care of their husbands and children, and official rhetoric did not ask them to do so'.[65] The ideology that prescribed the role of nurturer to Japanese women did not rest upon women's weaknesses as it often did in Britain. According to Sharon Nolte and Sally Ann Hastings in their discussion of Meiji women, 'the justification of women's political exclusion was primarily in terms of their home and family duties, and not of their physical, mental, or moral incapacity'.[66] Despite the pre-

vailing official discourse, agitation for social and political reform, education and the right to vote involved female activists in Japan as well as in Britain.

Mary Rose Hill Burton's first exhibition of Japanese pictures took place in London in the spring of 1895. Burton wrote to Patrick Geddes in February still concerned about the threatened destruction to Foyers Falls by the British Aluminium Company and informing him that she would have to spend most of April in London getting ready for the exhibition.[67] True to her interest in nature and gardens, the show was called *Japan: The Land of Flowers*; it included fifty-five pictures the titles of which provide some insight into what Burton saw and wanted to remember: there were images of children playing among azaleas, tea houses, a village carpenter, a washing-day dance, an open-air theatre, a gardener's daughter, and the geisha. However, Burton's geishas tended to be active: for example *Geisha dancing* or *Geisha Practising* where she intimates the training entered into when one seeks to become a geisha.

Her titles also provide an itinerary of her travels around Japan (Fig.30); in most instances she represented gardens – an iris garden at Horakiri in Tokyo, an azalea garden in Tokyo or a lotus pond in Tokyo's Ueno Park. For the novice traveller, or for those who observed exotic scenes via the eyes of others, Burton sometimes provided short explanations of selected sites. She made two pictures of Ikao [Ikaho], a town north of Tokyo, *Ikao, Evening* and *Main Street, Ikao* which she wrote was 'a village of inns and bathing-houses built over rapids of natural hot water'. For the painting *The First Lotus* she wrote: 'The Japanese grow their flowers in large masses of one species. As these successfully come into bloom, the people go in crowds to see them.'[68] She described the *Torii* of *Miajima* [Miyajima] as 'the gateway of a Temple built on piles in the sea' and *A Summer Night, Kyoto* as representing the inhabitants of the city seeking 'coolness on rafts and tea-houses on the river'. These descriptions added to the catalogue served to help British people browsing through the Clifford Galleries understand the representation; concomitantly, they served to authenticate the visual image and reify Burton's class. The picture as a commodity represented a distant and, for most people, inaccessible culture while, at the same time, viewers were assured that Burton had seen what she pictured and was able to faithfully replicate her vision – she assumed the role of artist-ethnographer. That it remained her vision, albeit a vision that could be purchased, becomes most obvious when she chose specific people for representation. Although she did include images of women and children in her pictures of gardens, in only a few instances did she select out specific people; in these instances many of the represented were not of her own class.

She made two pictures of people from Japan's north island: *The Aino* [Ainu] *Girl* and *An Aino* [Ainu] *Chief*. According to Burton, the 'hairy

30 Map of Japan, Cynthia Hammond

Aino [sic] are a singular race of savages of whom a few still remain in the North Island of Japan. The women ornament themselves by tattooing their lips and hands'. Pictures such as these, particularly when such a graphic literary elaboration has been added to the visual description, remind one of the difficult conflation of woman traveller and imperialistic eye. Karen Lawrence in her provocatively titled *Penelope Voyages* explores the relationship between the liberation experienced by the female traveller ('the value of travel in testing out cultural freedoms and restraints') and the imaginative and colonizing view of different cultures. Lawrence is concerned with 'travel narratives written by white, aristocratic or middle-class Englishwomen, whose race and class inform their expectations of mobility as thoroughly as they inform their domestic ideologies'.[69] Burton made images of what she observed but the objectivity of her way of looking requires the same scrutiny as travel writing. The problems of such representation appropriately is addressed by critics of imperialism and postcolonial theorists. However, accepting such a re-viewing of colonial representation has done little to reposition an artist like Mary Rose Hill Burton who remains trapped within an unwritten history and doomed should she emerge. While one might challenge her observations and question their 'accuracy' or 'truth', there is little opportunity to do so. For example, Burton was absent from the Barbican's large 1991 exhibition *Japan and Britain: An Aesthetic Dialogue 1850–1930*, as well as from an Edinburgh exhibition held in the same year *Opening the Window: British Artists in Meiji Japan, 1880–1900*.

Some of her pictures may be more intimately woven into her own life than first appears. Burton's will designated that £500 was to be given 'to the little girl known as Tomo who has lived for some time in the house of my brother'. This was equivalent to the amounts willed to the Geddes children with whom she had an extremely close relationship. Burton's sister also remembered the child Tomo; Elizabeth Paton Burton left money to a convent in Tokyo 'to assist with the education of the child Tomo' who was, according to her testament, the adopted daughter of her sister-in-law Matsu Burton thus indicating that William Burton had married a Japanese woman.[70] Certainly such substantial care taken to secure the child's future suggests that Burton's relationship with Japan was somewhat more intense than the reproduction of its scenery or some of its people must indicate. In addition, a glimpse into her experience with Japan remains behind in the letters she wrote to Patrick and Anna Geddes.

One letter, written from Sapporo in the autumn of 1894, confirms that she travelled about in Japan with her brother: 'Willy & I are residing here in an unfinished & deserted imperial palace. The object of coming here is for Willy to photograph Curios'.[71] The building was not a palace but, undoubtedly, the Hohheikan which was constructed as a hotel in 1880 and in which the

Emperors of the Meiji, Taisho and Showa eras stayed. Today this building, considered representative of Western-style wooden architecture, is designated an historic building; in the 1890s it would have been one of the few places available to house foreigners.[72] Burton, like her brother, sketched the curios which, she wrote, were 'awesome ugly' but interesting. 'In Japan', she wrote, 'there is a great deal that is quite after my heart: I wish you could see the queer little gardens, the way every foot of ground is made use of. I fear we could not copy it at home for want of the sunshine & rain that are so plenty here'.[73] A near contemporary of Burton's, the American artist Helen Hyde who took up residence in Japan in 1899 shared Burton's enthusiasm: 'Japan was a gem, a revelation, a new world filled with art possibilities beyond one's dreams, and coming into Japanese life, I was overjoyed by the infinite opportunities offered in colour and the charming quaintness of the environment'.[74]

Burton left Japan on 6 October 1894 aboard the SS Melborne, travelling via Aden and Port Said and arriving in Marseilles on 15 November, a trip of over five weeks' duration. Although letters survive only from her 1894 trip, a short article in the *Glasgow Evening News* suggested that Burton returned to Japan in 1896 and that she was a 'frequent visitor' to the country.[75] Her excursions yielded two solo exhibitions in London (1895 and 1896) both held at Clifford Galleries in the Haymarket. Titles of pictures from the second exhibition give the reader additional information about her trip: for example, *Meeting of the Photographic Society at Kyoto* must have complemented the article she wrote for the *Studio; A Scot Abroad* obviously represented another traveller, perhaps her brother or perhaps either Hornel or Henry who may have been there during Burton's first stay;[76] *A demonstration in the art of arranging flowers* and *A lesson in the art of flower arranging* must have captured something of the tradition so important to Japanese culture; and, *Gathering flowers at dawn for Tokyo Market* reinforced her interest in scenes of everyday life. Some pictures were exhibited both in 1895 and 1896 confirming that not all the work was sold.

Her last solo exhibition in London took place in 1897 and attested to her travels around Scotland rather than abroad. Two pictures were of her loved, and by then partially destroyed, Foyers Falls, others were scenes from the area around Boleskine (the home she shared with her mother near Foyers Falls) or around Edinburgh. Another voyage in 1900 was to Italy to prepare for yet another solo exhibition in London, this time her focus was to be exclusively upon gardens. One of her last letters home was to Anna Geddes: she was enjoying the trip ('this is a wonderful fascinating place, and I find it quite easy to get on with people') but she was missing the Geddes children and anxious to be with her friends ('I shall settle when I'm near my friends again').[77] A few days after writing this letter, Burton collapsed in the railway

station in Rome and died in hospital within hours. She was forty-two years old.[78]

Later that year Florence Haig included pictures by Burton in the London exhibition of the Paris Club of International Women Artists. Her 'faithful representation' of *Ikao, Japan* hung beside pictures she had made in Scotland such as *Poppies, Foxgloves* and *Hide and Seek*. The review of the exhibition in the *Art Journal* commented on the sorrow attending the artist's death: 'Her loss will long be felt not only by those who had the privilege of knowing her personally, but by the larger circle of the many who knew and admired her work'.[79] The following year when the Paris Club opened its second exhibition, two pictures by Mary Rose Hill Burton were exhibited, *Garden Scene* and *Boleskine, Loch Ness*. Both pictures were owned by Florence Haig, reiterating her desire to commemorate Burton by keeping her friend's work visible even after her death.

One of Haig's own contributions to the Paris Club's first exhibition was her picture of female farm labourers in the south of Scotland, *Straw Gatherers at Roxburghshire*. Like many of her friend's pictures, this one also is of women. While not as exotic as images of Japanese women, Haig made one of the few representations of bondagers working in the Scottish lowlands thereby transporting the women field workers from historical obscurity to visualization within the culture of a different class.

Different women: bondagers

The Bondagers by Scottish playwright Sue Glover played to large and enthusiastic audiences in Scotland in 1991 and again in 1995; in 1996 it opened in Toronto to glowing reviews. Canada's widely-circulated newspaper, the *Globe and Mail* headlined its review, 'Of human bondage, Scottish style', and called the players a 'vigorous ensemble' who brought to life 'this stirring tale of female migrant workers'.[80] Almost one hundred years earlier, in the inaugural exhibition of the Paris Club of International Women Artists, Scottish artist Florence Haig presented for sale her picture of bondagers, *Straw Gatherers in Roxburghshire* (1900). The critic for London's *Art Journal* recognized Haig's picture as 'full of sunshine, and very pleasing to look at';[81] neither the representation nor the discourse around it acknowledged the women as hard-working field labourers.

In this discussion, I seek to combine an analysis of late-twentieth-century response to the 'emotional and historical authenticity' of Glover's play with a close reading of Haig's turn-of-the-century picture. My purpose is not to insist upon a 'realism' in Haig's picture that transgresses the romanticized version of field and worker nor to highlight Glover's play as a more accurate

representation of the labourers but, rather, to suggest that categories of work, representation and location are flexible and layered. Florence Haig, for example, was far removed from the physically inhabited place of the bondager as well as from her intellectual space. Haig travelled in an educated circle of artists and suffragists; her product circulated among a secure middle class. Unlike the bondager she represented, Haig laboured with the awareness that, were she not to work and sell her goods, she had private income to protect her or, at least, a large, extended family to fall back upon. Thus, on the surface, the class difference between Haig and the women she represented was more a chasm than a gap; but, where their lives and work overlapped and where gender assumed a greater role in their production than did class, was in the area of wage differentiation. That is, neither the Roxburghshire farm labourers nor Haig occupied a pure and private zone of domesticity; all worked and within certain parameters accepted responsibility for their own actions and wellbeing, but neither were paid as well as men doing the same work. Separate spheres, rather than representing a living situation, provides an ideology that serves to camouflage a very basic discrepancy: the amount of money women earned.

The Scottish female farm worker (Fig.31), although better paid than her English counterpart, earned less than either the hind (a male farm worker) or her father or husband; Haig sold her pictures for less than a similarly

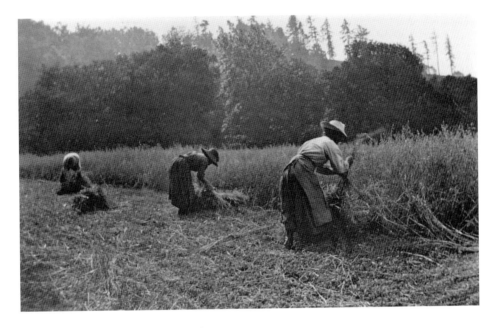

31 Female farmworkers in Scotland

trained male artist. While the late-twentieth-century viewer might sympathize more with the farm labourer – Glover's play attracted large audiences in Scotland as well as in Canada while Haig's picture and her 'story' have disappeared – the wage differential was more rigidly entrenched and much more difficult to combat in Haig's situation because of the tendency to dismiss Haig's middle-class plight (not to say she perceived the plight) as irrelevant. Perhaps it is more helpful to consider complex categories of labour that include the middle-class woman and, at the same time, deflate romanticizations of the artist and 'pastoral' worker.

Returning, for a moment, to Haig's 1900 picture of 'straw gatherers' in the border area, a viewer of the picture could contend that separate spheres has little or nothing to do with the everyday working life of either Haig or of her subjects; all the women, the workers and the producer of the picture of workers, inhabit a world of labour in which their product is offered for sale. In the case of the 'straw gatherers', they offered their labour for sale at annual hiring fairs during the spring when hinds organized their need for female farm workers by bidding for bondagers or, alternatively, their labour was kept within a family unit. Barbara Robertson's research on female farm labourers suggests that women could earn as much as 12s per month or about £15 per year plus their room and board (many earned less than this);[82] a domestic working in a large farmhouse earned about £2 for six months work plus her room and board;[83] a touring actress, as mentioned earlier, might earn about £2 per week when she worked; a highly skilled woman working in the Edinburgh printing trade could earn more in one week (about 20s) than a bondager earned in a month.[84] A successful artist could sell one picture for more than a highly-paid bondager earned in an entire year: Haig's *Straw Gatherers* was for sale in 1900 for £31 10s. Haig was not guaranteed a buyer but she did not have to offer her labour for sale at a hiring fair and most important for her middle-class status, her body was not visible in the transaction. The work bondagers accepted to do was arduous and physically exhausting and, by the time Haig made her picture, the jobs women held in agriculture were becoming more menial as specialization and mechanization increased.

During the nineteenth century women often did weeding, hoeing, gathering and stacking; in addition, they began to leave farming for positions as domestics or factory workers in the urban areas.[85] This migration threatened the economic structure of farming particularly in the labour-intensive Border farms. Concomitantly the rural good was often juxtaposed to urban temptation. In 1899 a short article in the *Kelso Mail* insisted that women workers were much better off on farms than in the cities; work on a farm kept them 'out of the way of much temptation', provided them with a decent wage, developed their muscles and kept them in good health.

Thus, when the time came for them to marry 'each would bring to her husband strong arms, pure blood, the savings' bank book, and a clean conscience'.[86] As the plea might suggest, 'tied' female labour, or bondagers, who were available for seasonal tasks remained crucial in the south-east of Scotland. Because the area comprised large, isolated farms and because the industrial structure of the area was poorly developed, farmers in East Lothian, Berwick and Roxburgh 'were among the most significant employers of women in agriculture'.[87]

Farmers, then, depended heavily upon such labour even though, as a mid-nineteenth-century observer noted, 'farmers employ women because their wages are about half what is expected of men'.[88] By 1893, only seven years before Haig painted her picture of female fieldworkers in Roxburghshire, a Royal Commission on Labour reported that while women's wages had doubled over the previous forty years, 'the fact remains that often when working side by side with the orra men and hinds she is doing as much as a man, and yet only getting half a man's wages'.[89] Money earned for labour expended remained more divisive between women and men than did their ideologically defined separate places. The border farms themselves were rented to farmers who, in turn, hired those who worked on them. For example, a notice in the *Kelso Mail* announced that 780 acres belonging to Lord Shelbourne had recently been let to Francis Scott; 50 acres were meadows, 105 acres were permanent pasture, the rest was 'good sheep and barley land'. The rent was £400 annually.[90]

What remains challenging (and possibly unfathomable) to the late-twentieth-century historian is the relationship between work and pleasure: did Haig obtain pleasure from the making of pictures of women working in the fields? From the actual sketching practice itself? Did the workers obtain pleasure in their labour? It seems that hierarchies fell into place in the fields as they did in the art institutions. In an article written to celebrate a 1986 exhibition of photographs, *Bound to Work* (Border Country Life Museum, Thirlestane Castle), a *Scotsman* reporter insisted that 'despite their romantic appearance bondagers led hard lives, for they did the same work as men'. And, like the men they worked with, some had privileged tasks: the 'elite bondagers' drove horses, while 'the majority worked in the fields where in winter they bound straw ropes around their legs and arms to protect them while they were hoeing turnips'.[91] An interview with a bondager who was working in the fields by 1908 (eight years after Haig painted her picture) confirmed this image: Mary Rutherford who at eighty-two years old was almost six feet tall, remembered that, as 'a strong girl and a hard worker' she never had difficulty finding work and she drove a horse. 'I went out to work when I was 12 or 13,' said Rutherford. 'I drove a horse and a cart. It wasn't often that women got their own horse, but I had a horse.'[92] Another

experience remembered by a 'tiny bondager' was not so positive. She had gone into her first hiring fair with her brother when she was fourteen years old: 'I remember standing in the town square feeling like an animal and being so ashamed because no one wanted us; but we got a job eventually.'[93]

Both Sue Glover in her 1990 play and Florence Haig in her 1900 painting provide representations that are accurate as much as they are inaccurate, that falsify while they reiterate the truth. Glover understood the downside of labouring on a farm, sharing crowded living conditions, not earning much in wages but despite hardships the women 'enjoyed great camaraderie with their fellow workers'. 'When women are all together,' said Glover, 'they tend to have a good crack.'[94] Six women performed the play; the men who often controlled their lives (Ellen becomes a farmer's wife; Tottie was raped by a 'stable lad') were absent: 'The men may never be seen, but their controlling influence is always felt, whether as the rulers of the women's hard regime or as the object of their desires'.[95] Later, when the play opened on stage in Canada, Toronto's theatre critic Kate Taylor wrote that the script was 'peppered with archaic terms and delivered in broad accents' that might be difficult for those 'unfamiliar with Scottish dialect to understand' but the 'overall effect' was of 'emotional and historical authenticity'.[96]

Haig's picture also 'authenticated' the historical bondagers: she captured their youth, their dress and the rigour of their labour. Juxtaposed to the three bending bodies of the bondagers, the male figure stands in the background. He is visibly present (unlike Glover's absent but controlling men) and, although he is further away from the viewer thus smaller than the women, his body rises above the ground line. Haig painted the women foregrounded against the hills, the one standing figure bends her head causing the line of her hair and hat to follow the curve of the land. The bondagers represent the land: they did in 1900 and they did almost 100 years later. Neither they as labourers nor Haig as artist can be 'truly' authenticated. The trueness of their historical place can only enter into a narrative which can, in turn, preserve the memory of both working positions.

Working women

Haig and Burton made art from their positions as securely middle-class, well-educated women, committed to their careers as artists, and confident in their friendships with each other and with colleagues similar to themselves. They travelled and recorded their experiences, exhibited their pictures, worked in a career they desired and enjoyed. They made choices and negotiated their place within a society that limited them but also gave them a broad vista from within which to work. Writing their history estab-

lishes their difference from many of their subjects while, at the same time, it exposes similarities. The juncture between them and those they represented appears briefly and only for moments but, as Haig and Burton negotiated their place within society, so too must the writer of history negotiate a space for them within this present moment. Looking at the two artists together with the people they represented does not displace the privilege of the artists nor does it alter the status of their subjects, but it does give viewers and readers an opportunity to contemplate the historical past and to remember that women's roles as workers was (and is) multifariously complex.

Energy to fearlessness: the artist as exotic

By the early 1900s, Mary Cameron's name was inextricably linked with Spain; her career, however, had started much earlier in Scotland. She had studied in Edinburgh, she joined the Edinburgh Ladies' Art Club and later became associated with the Society of Scottish Artists, twice her name was put forward for membership in the Royal Scottish Academy and, like all the women in this story, she sought to establish a career in the art world. Her large 'frank and unconventional' oil paintings earned her a reputation as 'the most vigorous of the woman painters in Scotland'.[1]

Her work, particularly her military pictures and her Spanish pictures, shifts her away from the private and domestic and inserts her into a transgressional space: in Scotland she can be configured as a self-sufficient traveller and in Spain, as an outsider who entered the mysterious machismo of the *corrida de toros*, the bullfight.[2] In its review of a 1909 exhibition, the *Art Journal* told its readers that, since Cameron's first visit to Spain in 1900, she had 'directed her strenuous talent mainly to the representation' of blood sports such as bullfights and cockfights and, in this, one would not find 'an element of pity', rather 'energy to fearlessness' was the note she sounded.[3] In 1910 the *Queen* considered her work 'powerful, decorative, and brilliant, but . . . marred by a certain brutality of statement'.[4] A Scottish paper commended Cameron's 'virile skill' and her vivacity: 'Spain is painted as Spain . . . the bull ring with its horrors, the cock-pit with its varied intensity of devotion to so-called sport, the tavern dance, the love episode – all powerfully painted'.[5] Her friends in Scotland even whimsically nicknamed her 'Bloody' Mary after England's sixteenth-century Spanish-aligned queen, Mary Tudor, and in honour of Cameron's visceral representations of Spanish bullfighting which intrigued Scottish audiences at the turn of the century.[6]

However, before looking closely at her Spanish work, particularly the critical reception of those pictures, I shall seek to locate Cameron within

Scotland. Her formal art education began at the Board of Manufactures' Trustees' Academy when she was about sixteen years old; at seventeen, she was winning prizes.[7] As her training progressed, she probably joined other Edinburgh women at the life class organized to help women obtain skills in an area forbidden to them by the Academy and, along with this group of women, participated in the formation of the Edinburgh Ladies' Art Club in 1889. The twenty-four-year-old Cameron had exhibited three Dutch land-scapes and a study of French soldiers 'reclining on a bank' in the Club's first exhibition.[8] The subject matter confirms that she had been travelling in Europe and that, by this time, she had possibly completed her studies in Paris 'in Colarossi's studio and in a private military studio'.[9] The following year (1890), Cameron again exhibited French military studies with the Club, quite likely the same pictures she had exhibited with the RSA in the spring of that year – *Near Vallière, 1870* and *Waverley Market, 21st May 1888*, a 'vivacious little reminiscence of the Waverley Market military tournament in which we have a couple of huzzars on horseback'.[10] A second military picture, *An Important Capture, Bazielles, 1870* (1891), appeared in the Academy's exhibition the following year attesting to Cameron's interest in and study of contem-porary military history. Both *Near Vallière, 1870* and *Bazielles, 1870* may have been commissioned; they are untraced and represent specific and contro-versial moments in the disastrous war between France and Germany. Very little description remains of the pictures although the scene of the Vallière ravine, according to a review of the picture in the *Scotsman*, depicted French soldiers 'skirmishing in a leafless wood'. This particular ravine was the site of battles between French and German soldiers during August 1870; the outcomes were unresolved with both sides claiming victory. *An Important Capture, Bazielles, 1870*, whatever moment Cameron actually selected to depict, had to commemorate some aspect of a much more poignant and contentious event. Bavarian troops were accused of virtually wiping out the town of civilians: 'women and children, and the aged who tried to escape were thrust into the flames without mercy, and literally roasted alive, while others who took refuge in the cellars were suffocated by the smoke' as the troops fired the town.[11] Cameron's portrayal of two very specific events twenty years after they took place, suggests that she researched military history and made the pictures for someone who had a particular concern for specific events rather than selecting the historical moments based upon her own interests.

The inclusion of military pictures in the exhibitions indicated a change of direction that would lead Cameron to paint horse races, hunting and, by 1900, bullfighting. Thus, while the titles of many of Cameron's earlier pictures exhibited with the Ladies' Art Club and the Royal Scottish Academy are somewhat similar to her colleagues, for example, *The Fishmarket, Bergen*

(1889) or *Rainy Day, Bergen* (1889), her interests and her training drew her toward a different kind of subject matter. Certainly her pictures differ from her older colleague Christina Paterson Ross, her friends Barbara Peddie and Emily Murray Paterson and many other members of the Ladies' Art Club. Nevertheless, like other Edinburgh women, particularly Ross and Florence Haig, Cameron joined and exhibited with the Paris Club in London after the Edinburgh's Ladies' Art Club ceased to exist thereby remaining consistent in her support of the 'separate' venues.[12]

While Cameron was still studying at the Edinburgh School of Art, her family moved from the modest Portobello home in which she had been born to spacious accommodation in Arniston Place south of Edinburgh in Bonnyrigg; by the time she was twenty-four (and still living at home) her father's stationery business had become so successful that the family moved into an eighteen-room Victorian house in Clarendon Crescent. The move to Clarendon Crescent may signal an apotheosis resulting from Duncan Cameron's astute business sense and the clear-minded patenting of the well-known Waverley pen but it also put Mary Cameron's living quarters much closer to Edinburgh's artistic west end: most artists' studios were located in the west end of the New Town and soon Cameron would occupy her own studio in nearby Melville Place (see fig.8). The Dean Bridge linking Queensferry with the New Town had been completed in 1832, thus Cameron's home in Clarendon Crescent which was immediately across the bridge would have been a short ten-minute walk away from her studio and the activity of the artists of Shandwick Place.

The financially secure position of the Cameron family implies that the two daughters Mary and Flora inhabited a private and non-working space; they did not have to earn their livings. However, neither Mary nor her sister opted for that lifestyle. Flora Cameron became the editor of the *Oban Times* when her older brother Duncan had to return to the Edinburgh part of the family business in the 1890s; she remained active in that position well into old age. Mary Cameron devoted herself to her art career, beginning with classes at the Board of Manufactures' School and in Paris as well as following classes at the Edinburgh Veterinary College for two years in order to perfect her understanding of animal anatomy, particularly of horses.[13] The *Ladies' Field*, in an 1898 article about Cameron's large 'presentation picture' (Fig.32) gifted by the Duke of Buccleuch to J. W. J. Paterson, master of the Eskdaill Foxhounds,[14] acknowledged that because it was 'so unusual for a woman to paint hunting and sporting subjects well', her work was 'attracting considerable attention in Scotland'. While the *Ladies' Field* congratulated Cameron for following courses in anatomy at the Veterinary College ('lessons in horse anatomy are not easy to get'), it also acknowledged that she was helped by having a horse of her own to use as a model: 'a professor of the

32 *J. W. J. Paterson Esq., Terrona, Master, Eskdaill Hounds*, Mary Cameron, 1898

Veterinary College, Edinburgh, gave Miss Cameron a safe lead over the first fence, and she surmounted the second with the help of a thoroughbred hunter of her own, with the result that her reputation is growing steadily, although it is only about three years since she turned her attention to this field of art'.[15] This same year, academician Alexander Roche wrote Cameron a letter apologizing for the bad hanging of her 'really admirable portrait of the young doctor dissecting the horse's head' thereby implying some support for women artists among the academicians; unfortunately, members like Roche were a minority. Roche felt compelled to tell Cameron how much he admired the picture which he found 'full of genuine searching and good constructive stuff'.[16] The press, too, admired her ability to paint people and animals, particularly horses. This kind of painting and Cameron's total devotion to it, required years of study and practice in anything but a desultory fashion: it was work. In addition, her practice delineates clearly her privileged class; she owned a thoroughbred hunter, she

associated socially with the people for whom she painted and she travelled extensively.

The *Oxford Dictionary* defines work as 'the application of mental or physical effort to a purpose' thus, although Cameron did not recognize an income from her labour while she was studying and she may have earned so little from the sales of pictures that, without family support, she could not have survived, she nevertheless worked. She exhibited regularly and she continued to study her craft even after she was 'established' as an artist; no artist can stop working if she wants her product to improve. For example, Edinburgh artist and curator of the Portrait Gallery, James Caw, writing to Cameron immediately upon seeing 'the gold label' attached to her prize-winning painting in the 1904 Paris Salon, observed that she seemed 'to have done a great deal to it' since he had seen it in her studio.[17] This, of course, is typical of artists and their work, and does not vary according to the sex of the worker; rather it is part of the 'trade' of art-making. Cameron herself, when questioned about her painting, insisted that it was 'hard manual labour'.[18]

Despite Cameron's designation of painting as work, middle-class women and certainly middle-class women artists, suffer a kind of extinction in the midst of discussions of work. Neither Mary Cameron, in her paintings of horses, nor Florence Haig in her painting of bondagers are 'in the picture' in any sense: they are not represented as working and their status as middle-class women ideologically negates their position as workers. In addition, both Cameron and Haig visually colonize a lower class for their own representational ends. For example, when Cameron painted *Newhaven* (1887), a beautifully crafted watercolour of a fishwife working, or when Haig painted bondagers, there was a transgression of class boundaries: one privileged class, and there is no denying their privilege, represented or captured the appearance of a lower, less privileged class.

The colourful, distinct dress of the Newhaven fishwife provided many artists, not just Cameron, with a taste of the exotic located right near the edges of fashionable Edinburgh. Cameron's colleague Jessie Gray also had pictures of Newhaven in the 1887 Academy exhibition. Cameron had 'two nicely selected oils at Newhaven, and a life-like sketch of a fisher lad'; Jessie Gray exhibited 'an attractive group of fisher children' also from Newhaven.[19] An Edinburgh woman writing during the 1880s suggested that 'a painter might go far' before finding a 'more tempting subject than a troupe of these bait girls, their plentiful hair covered by gaily coloured kerchiefs, clean print gowns drawn over ample layers of dark blue petticoats sufficiently short to allow a sight of shapely ankles and feet'.[20] Newhaven Harbour, built by James IV at the beginning of the sixteenth century, was a working harbour when Cameron visited to make her sketch of the woman who earned her

living from the sea: two days a week the fishwife gathered bait and put it on hooks, four days a week she carried fish in creels (large baskets) to Edinburgh to sell.[21] Cameron sought to depict a young woman with the accoutrements of her work around her.

A few years earlier, when Mary Burton (Mary Rose's aunt) had addressed the Social Science Congress in Aberdeen (1877) on the issue of the compatibility of beauty with labour, she had used the Newhaven fishwife as an example of a woman able to combine picturesque and pleasing costume with hard work and toil; Burton like many painters and their patrons preferred to 'see' the working classes as committed, diligent and beautiful.[22] Cameron's picture satisfied the contemporary desire for images of the labouring class that glorified work while, at the same time, constructed the labouring body as 'picturesque and pleasing'. However, Cameron also sought out a subject noted for her strength (the creel could hold as much as 150 pounds of fish), independence and fortitude. Fishwives, like artists, were 'independently employed' and while the conditions in which they worked and lived remained far removed from the female artists who represented them (as were the bondagers), neither group can be identified clearly within an analytical structure centred upon wages. In addition, representation cannot negate production any more than production can negate representation. But both can misrepresent the other and while there is considerable discussion of the misrepresentation (or romanticizing) of the lower class there is little of the same concern for a misrepresentation of the so-called privileged woman. And, as I mentioned above, while their concerns are far from similar, they do share one concrete feature: lower income for equal work.

Today in Newhaven, the romanticism ascribed to nineteenth-century artists is reinscribed in the Newhaven Heritage Museum which prides itself on being staffed largely by volunteers whose families were connected with the fishing industry. Visitors can view a reproduction of Mary Cameron's watercolour picture immediately prior to donning the fishwife costumes hanging nearby which are meant to provide an 'authentic' experience for the viewer. While the act of pretending to experience a Newhaven life or the seeking for a nostalgic past, is more complicated than museum-goers might wish to acknowledge, the Museum (and its experiences) commemorates a community displaced by late-twentieth-century development. Similarly, Cameron's genre picture reminds viewers of the historical existence of Newhaven fishwives while its location within a social history museum recontextualizes the painting itself providing links between past and present, nostalgia and remembrance.

Addressing Cameron as a working woman requires an examination of how she herself was contextualized, particularly how she was perceived by her own class. How was she 'constructed' in the ladies' magazines of the

day, magazines ostensibly read by women from her own class? The *Scots Pictorial*, for example, was a weekly magazine devoted to reporting social events, often of the aristocracy, picturing women's fashions and offering suggestions for 'good' hair and skin – in short, not remarkably different from many magazines on the market today, albeit the use of the language seems somewhat archaic to late-twentieth-century readers. In December 1898 Cameron's picture graced the pages of the magazine as a 'Scottish Artist at Work' (Fig.33).[23] Shown on a stool, in front of a large easel with the accoutrements of her profession around her, she is indeed a working woman. The large picture of jockeys with their horses is probably *At the starting point* which she exhibited with the Academy in 1899.[24] A few months later the *Art Journal* reproduced Cameron's 'large work', *Leaving the Paddock* (1899–1900) (Fig.34) as an example of 'one of several excellent racing pictures this clever artist has recently painted'. Again, the press applauded Cameron's extensive study of the horse: 'her knowledge of it is reflected in the spirited manner in which this noble animal is placed upon the canvas.[25]

A couple of years later the *Scots Pictorial* featured Cameron in its 'Social and Personal' column as 'a young Scottish artist' who had already 'made for herself a solid reputation as a portraitist and a painter of animals'. This time rather than showing her 'at work', the journal reproduced a photograph of Cameron wearing 'the picturesque shawl of the Spanish ladies', highlighting her interest in Spain ('she very frequently visits Madrid in order to enlarge her ideas on Iberian art'); the article closed by praising her artistic talents as well as her gifts of a 'great charm of manner, appearance, and personality'. Thus, while the *Scots Pictorial* commends Cameron for her success as 'a portraitist and a painter of animals' it assures its readers of Cameron's charm which is reinforced by reproducing not a picture of her work but a photograph of a very 'womanly' Cameron.[26] Similarly, the *Ladies' Field* (1901) acknowledged that 'besides being young, pretty and smart she [Cameron] bids fair to become a worthy follower of Rosa Bonheur and Lady Butler as a painter of horses'.[27]

The *Queen*, a widely circulated fashion journal that included articles on home decoration, fashion, etiquette, gardens, dogs, fashionable marriages, sports and art, immediately preceded its comments about Cameron with a discussion of an 'extraordinary' exhibition of Japanese art in the Fine Art Palace in Shepherd's Bush. Cameron's art allowed for a continuation of the writing of the exotic and the unusual. The *Queen* reproduced a 'peculiarly Spanish' picture, *The Girl and the Beggar*; the three figures were identified by the *Queen*'s critic as an 'elaborately attired lady dwarf', her duenna and a 'picturesque beggar'. Juxtaposed to the reproduction of her picture was an attractive, posed photograph of the artist in profile wearing grapes in her elaborately-dressed hair and, beneath that, one of her 'powerful' Spanish

33 Mary Cameron on the cover of the *Scots Pictorial*, 1898

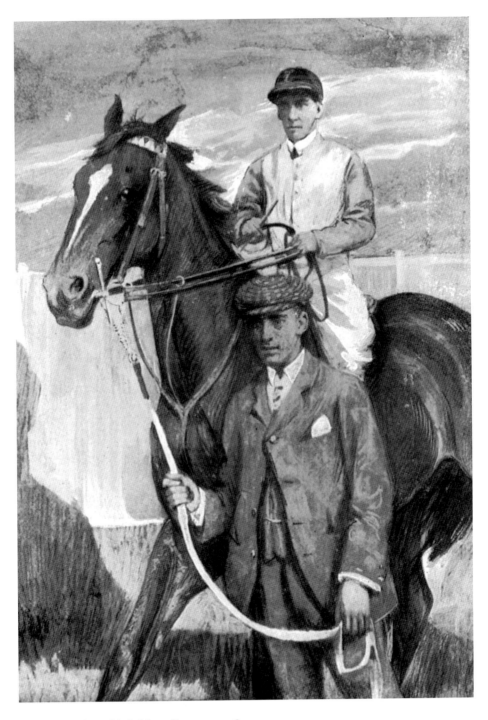

34 *Leaving the Paddock*, Mary Cameron, c.1899

landscapes. The *Queen* did not reproduce any bullfight pictures but warned readers that the 'bullfights are horrible'. As paintings, the *Queen* found the bullfights remarkable despite their explicit violence but, at the same time, insisted that Cameron could appreciate and reproduce the 'charms of land-scape and the poetry of quiet moments'.[28] The photograph of Cameron reinforces the poetic and highlights the charm of her femininity; it captures her beauty thereby containing or controlling the image of British woman/Spanish bullfight.

Cameron exhibited her first bullfighting pictures in 1901: one painting appeared in a Paris Salon, another in the Glasgow Institute of the Fine Arts. According to the *Scotsman*, Cameron's *Picadors About to Enter the Bull Ring at Madrid* (1901) (Fig.35), brought 'honours' to the Edinburgh artist by being exhibited well in Paris and attracting a great deal of attention in the French press. In addition, and by special agreement with the artist, a 'well-known firm of photographers in Paris reproduced the picture as an illustrated post-card' which was widely-circulated in France and Germany.[29] Cameron's picture postcard of 'the green room of the arena, an enclosure strictly for-bidden to outsiders' was used as propaganda by the French government in its campaign to prevent the introduction of bullfighting into France. The government had 'resolved to put down with a firm hand all such attempts' and Cameron's image was meant to assist their cause.[30]

When *Picadors About to Enter the Bull Ring* was exhibited in the Glasgow Institute of the Fine Arts, the *Glasgow Herald* commented more upon the content than the quality of the picture but the *Scotsman* insisted that the 'frank and unconventional' picture was powerful, excellent, and constructed with much thought.[31] The *Sphere* found the picture 'powerful' and Cameron's depiction of these 'grim realities' indicated her 'trenchant realism'.[32] The *Scotsman* described the picture as graphically depicting a 'poor white horse gored to death', a group of stable workers who are busy looking after the other injured but still-standing horses, and a group of 'gaily dressed, swaggering picadors' ready to ride into the arena totally 'unconcerned at the gruesome sights around them'. The Edinburgh newspaper clearly viewed the picture not as a celebration of the bullfight but as 'a powerful protest against the barbarity of the Spanish national sport'.[33] While not at all arguing from the same position, Spanish poet and essayist José Bergamín later wrote in support of his country's national sport: 'cruelty is an unavoid-able condition of beauty because it forms part of an uncluttered sensibility . . . A *corrida de toros* is an immoral spectacle, and therefore educational'.[34]

Behind the scenes, although the Glasgow Institute accepted the picture for exhibition, the Royal Scottish Academy refused to place it. In February 1901 Cameron received a letter from the Academy's secretary George Hay requesting that she 'have the goodness to withdraw the work in question'

35 *Picadors About to Enter the Bull Ring at Madrid*, Mary Cameron, 1901

(*Picadors About to Enter the Bull Ring at Madrid*) and substitute 'some other work in its place'.[35] Perhaps coincidentally, the Academy denied Cameron nomination membership that same year.[36] The following year, the Academy accepted for exhibition, amongst others of her works, her 'dramatic' picture *Saludando – The Matador's Ovation* (1902). Cameron selected for her canvas the moment immediately after the kill when the victorious matador received 'the plaudits of the spectators' among whom, of course, was the artist. Perhaps unwittingly or perhaps seduced by the exoticism of the picture, the *Scotsman's* critic focused on a description of the matador 'in a tight-fitting green and gold dress, holding aloft, in a grandiose attitude, his sword with one hand and with the other the red muleta or drapery with which he keeps the bull in play'.[37] In addition, distance between cultures was maintained, if not in the picture, certainly in the press: 'the Spanish types are happily rendered, and the costumes correctly recorded'. Like Mary

Rose Hill Burton, Cameron assumed the role of dedicated and scrupulous cultural ethnographer.

In 1903, when Cameron again exhibited Spanish pictures in the Royal Scottish Academy Exhibition, letters to the editor printed in the *Glasgow Herald* provided a reading audience with some insight into viewers' responses to the pictures. One letter written by an Edinburgh viewer elaborated upon the 'great educational value of the painting, as to the influence of religion on national customs and amusements, specially in relation to that of the Romish Church'. According to the letter writer, the English Reformation was responsible for 'the complete suppression of all barbarous amusements, such as cock-fighting, bull-baiting, and the sports of the prize-ring'. That this was not true (fox hunting, for example, was a national sport that Cameron also painted) did not bother the writer who condemned bull-fighting as part of Catholicism:

in such Catholic countries as Spain, where the priesthood has dominated for so many centuries both its religion and its morals, very largely also its politics, the horrible barbarities of bull-fighting, almost too horrible to be described in full, have remained undisturbed, and continue to the present moment.

Mary Cameron, according to this viewer, captured the horrible atrocities 'with realistic fidelity' and, in so doing, gave an 'impressive object-lesson' about the comparative value of 'Romish and Protestant teaching of Christianity'.[38] This opinionated, ethnocentric reading of the pictures and the culture they depicted did not pass unnoticed. Another letter appeared a few days later disputing the dour and Protestant declaration:

It is idle to fancy that the Romish Church in Spain has one whit more real power over the Spanish Catholic peoples in regard to their national sport than the Established Church in Scotland possesses over the Scottish people in regard to whiskey drinking – a game that has far worse results to body and soul.[39]

Such controversy and publicity around her pictures only enhanced Cameron's reputation. Not surprisingly, she became known as Scotland's 'most vigorous' woman painter, a hard-working, dedicated and prolific artist,[40] a view shared by Spanish critics even though Cameron's picturing of the bullfight was seen in Spain with 'different' eyes.

Madrid's *Sol y Sombra* (1902), like its British counterparts, considered Cameron a 'remarkable' painter as well as a beautiful, elegant woman 'of distinguished bearing' whose photograph they reproduced 'for the pleasure' of their readers. There any similarity ends. *Sol y Sombra* insisted that Cameron, far from painting to condemn the bullfight, demonstrated 'the enthusiasm of a true fan and devotee'; she conveyed in her pictures 'the magical effect that bullfighting produces on one's mind'. Recognizing the hostility to bullfighting that did exist inside and outside of Spain, the journal

bluntly asked: 'What will the ill-tempered detractors of the most national of shows say of a lady, foreign to boot, born and educated in one of the countries most opposed to the entertainment of bullfighting?' Cameron was one 'amongst the vast number of personalities which support bullfighting'. She had arrived in Madrid, according to *Sol y Sombra*, intending to study Velázquez; upon arrival she attended a bullfight 'and from then on deemed it the most beautiful spectacle remaining in the world'.[41] The *Scotsman* was pleased to recount the 'Spanish recognition of a Scottish artist': *Sol y Sombra*, an 'influential illustrated paper of Madrid' had recently published a story about Mary Cameron who had been 'painting in Spain for the better part of the past two years'.[42] Either the *Scotsman* could not or did not read the article; certainly the Spanish rendition of Cameron's relationship to the bullfight was misunderstood or censored.

The bullfight

Heat, dust and the smell of blood soaking into the soil combine with noise, rich colour and the excitement of a spectacle to characterize the exotic world of the Spanish bullfight, a world that captivated and fascinated Mary Cameron in the early years of the twentieth century. Touted as 'young, pretty and smart' by the conservative *Ladies' Field* and 'vigorous' by the slightly less conservative *Glasgow Herald*,[43] Cameron decided early in her career to paint animals as well as people and, while this places her securely within a British painting tradition, her travels to Spain and her subsequent represen- tations of Spanish bullfighting displace tradition and disrupt borders. More than a sojourner (she lived in Spain for a few months out of every year for the better part of seven years) but not an immigrant, she inhabited the space reserved for an interloper but her intrusiveness was tempered by her use of language (she spoke and read Spanish)[44] and by her desire to understand. As mentioned earlier, Cameron is the quintessential artist ethnographer (Fig.36); her work exemplifies James Clifford's definition of ethnography as 'diverse ways of thinking and writing about culture from a standpoint of participant observation'.[45] Clifford has traced the 'formation and break-up of enthnographic authority in twentieth-century social anthropology' that has taken place since the 'redistribution of colonial power in the decades after 1950' and in the wake of the 'radical cultural theories of the 1960s and 1970s'.[46] Any discussion of Cameron's place in Spanish society or of her representation of Spanish culture must be informed by an acceptance of her intrusion into a culture that was not/never could be 'hers'. Nevertheless, while her own place can be identified as Scottish and within that securely middle class, her space is mobile and meshes with her movements away

36 Mary Cameron in Spain

from Scotland to the Continent, away from the drawing-room and into the bullring.

To that end, Cameron said in an interview, she learned the language: 'I learned the language, of course. In that way I get in touch with the people. I read their newspapers and know what concerns them; I can talk to them and show sympathy in their affairs, and so I understand them.' Cameron kept a studio, sometimes in Madrid, sometimes in Seville but after a 'spell of hard work' she would leave the city, 'travelling the country in out-of-the-way places in a mule cart',[47] sketching the buildings and fields of rural Spain (Fig.37). It is the interstice or intervening space between one culture and another that informs this chapter, particularly Cameron's 'ethnographic' pictures of the bullfight. It was Cameron's transgressional pictures of Spain, not her earlier pictures of Scotland or Northern Europe, which most effectively positioned her as a working woman artist who represented a conflation of public and private spheres, and it was her Spanish pictures that 'made her name'.[48] The *Edinburgh Magazine*, when it reviewed Cameron's first 'one-woman show' in the city's French Gallery (1908), insisted that she painted 'with power, ease and fearlessness'.[49] Her production collapsed an ideo-

37 *Seville*, Mary Cameron, c.1905

logically defined private space into a more materialistic narrative of negotiation, independence and determination.

When given the opportunity to speak for herself, Cameron constructed herself as a worker: painting to her meant 'hard manual labour', 'pulling up your sleeves', and 'setting to work' – making art required physical endurance. She also was aware of her interviewer's desire for text that would please readers: 'It is not technique that interests you, it is the life of a woman artist who overcomes difficulties in painting on large canvases and travelling to Spain.'[50] In this Cameron was correct. As she travelled to and lived in the exotic, she too became exotic and exoticism more than artistic success led to the long interview published in the *Westminster Gazette* which coincided with her large, critically acclaimed solo exhibition in London in 1910. This meeting between a Scottish woman and Spanish culture entranced the press and viewers as surely as it entranced Cameron herself.

Carrie Douglas, writing about Spain's continued interest in the bullfight even as the twentieth century draws to a close, explains the undiminished fascination of the event. According to Douglas, the spectacle of the bullfight in its contextual relationship creates a 'dynamic discourse about significant cultural categories in Spain'. 'Specifically', writes Douglas, 'these different taurine formats are used to talk about male/female, urban/rural, national/local, class and political relationships; hierarchy and equality; history; world-view'.[51] Additionally, Douglas suggests that the idea that underlies all the

multivocal symbols and 'many contested meanings' of the bullfight in Spain is the 'Spanish opposition between modernity and tradition' as well as 'the construction of the Spanish state and Spain's relationship with Europe'.[52] Cameron's intimate relationship with a part of Europe that historically has provided Britain with an opposition – close enough to be familiar but distant enough to enchant, sunny warmth to misty rains, colour to drabness, costume to clothing, Catholicism to Protestantism – provided Cameron with a vivacity which proved seductive to critics and public alike.[53] The zenith of this relationship corresponded with two exhibitions and spanned two years: the 1908 Edinburgh exhibition and her 1910 exhibition in London's McLean's Gallery.

The 1908 exhibition was local and guaranteed to attract Scottish viewers already familiar with Cameron's work; the 1910 exhibition secured a more prominent place for her across Great Britain. A local critic in 1908 reiterated Cameron's own feelings about Edinburgh as the large, bold canvases were contrasted to a Scottish autumn: visitors could suddenly slip 'from the foggy Northern street into the delightful light and colours of ancient Spain' and, while commenting on the variety of subject matter, the critic predictably focused upon the bullfight: 'Here we see the gaiety, colour, human interest, romance, and repulsive brutality of this extraordinary relic of the barbaric arena strongly and unflinchingly delineated.'[54] Another Scottish review supported the 'reality' of the pictures: 'The bull fighting incidents are all pictures of actual realism, and one can fully endorse the Spanish criticism that has been bestowed on Miss Cameron, that she is the one British artist who has truly assimilated the national amusement.'[55] Certainly less than two years later when Cameron opened her London exhibition she was accepted as a British painter who 'understood' Spain.

Standing beside one of her large canvases (twelve by seven feet) Cameron repeated back a question asked her by a reporter: 'How I bring the life and joy and the colour of Spain to London on such a canvas?' Obviously, she was responding to a frequently asked question, one that interested her while, at the same time, amused her. It was, perhaps, the critic for the *Evening Standard and St. James Gazette* who most aptly captured the enigma of Cameron and Spain while subverting the most frequently constructed image of Spain. The astute critic first noted that most English painters who went to Spain seemed 'to corrupt their impressions of that country and its people with what they remember out of *Carmen*'. This confusion of the dramatic with what the painter actually saw affected artists not so much in their own home territory but rather when they 'go abroad': 'when they go abroad they paint what they hear instead of what they see'. Mary Cameron, 'by some happy fortune', was able 'to see and paint the life of Spain without the pathetic fallacy induced by reminiscences of *Carmen*'.[56]

The *Queen* concurred: it considered Cameron 'imbued with the spirit of the country' but expanded the discussion to displace Cameron's 'femininity'. She was, according to the *Queen*, a woman artist who vindicated 'the argument that women's work can equal men's in its power and breadth'. Her pictures were 'triumphantly produced' by a woman 'who had the nerve to make herself familiar with the bull ring in Madrid and the cockpit of Seville'. Unable to locate comfortably Cameron as a successfully competent artist, the *Queen* postulated the difference between Cameron's work and work produced by other women which, according to the *Queen*, was usually subtle, elusive and feminine.[57] Like Rosa Bonheur and Elizabeth Butler (also painters of animals), Cameron's critical 'equality' or her 'being like a man' came at the expense of denigrating other women. Disappointingly, it was magazines claiming to be 'for women' that most often accepted the prose of established difference as a key to success.

Newspapers like the widely circulated *Daily Telegraph* and the *Evening Standard and St. James Gazette* constructed a difference not between Cameron and other women but between Cameron and other painters of Spanish subjects. The *Telegraph* selected John Phillip and David Wilkie as representative of those artists who painted the 'pretty and picturesque side of Spanish life and manners' which, in turn, grew into a convention that was 'shattered only by Spanish artists themselves'. Cameron, unlike other British artists, captured 'the heat of the scorching plain', the cockpit and the bullfight: there was 'no siesta of ease in these games of action and enthusiasm'. Cameron offered her viewers a 'faithful presentment of actuality, rather than picturesque paraphrases'. Her picture of a cockfight, *Cockpit of the Calle Maria Coronel, Sevilla*, was considered 'unsparing in its sordid adjuncts of brutality and callousness', her bullfight showed 'no flinching in the painting of a gored horse'.[58] Cameron, without apology or explanation simply said, 'I have seen many a cockfight. It's perhaps not very nice.'

Similarly, art critic Frank Rutter writing for *The Times* insisted that there was 'very little rose water in Miss Cameron's art' and that the 'gored horses give one a sickening sense of horror'; Rutter also accepted Cameron as 'ethnographer' – 'it is clear that both the country and the people profoundly interested her'.[59] The *Observer* claimed that an uninformed viewer would not believe that the 'virile, strongly handled pictures of Spanish life and sports' were the 'work of a British artist – and of a woman painter!' Cameron, according to the *Observer* had replaced the 'tourist's curiosity' with the 'native's deeper insight into essential character'. *Sol y Sombra* certainly agreed: 'We delight in looking at her [Cameron's] Spanish *toreros*, unquestionably Spanish . . . gone are the completely ridiculous depictions of them as insignificant puppets and buffoons with sequinned clothing, which for

many years we had to endure from foreign painters, who probably have never seen a bullfight in their lives.'[60]

The British press inevitably conflated exoticism and blood sport with Spain and Other, accepting that Mary Cameron as an artist (and like an ethnographer) coolly and clearly represented the spectacle she observed – detachment was expected and understood. A Scottish paper insisted that her pictures, made with 'kindly sympathy', were visual pleas for the cause against cruelty:

what we in this country frankly – and rightly – regard as brutality. The tortured bull at bay, the gored horse sickened in its last misery – these are represented, as such horrors ought to be in a civilised day, with the faithfulness and appalling reality which is the best indictment of such scenes. Miss Cameron's brush is not merely a tool for producing fine pictures – it has a mission, and behind that mission true sympathy and ability.[61]

The Spanish press understood Cameron as aficionado and connoisseur; the relationship between these terms as understood within the *corrida de toros* and art is worth exploring.

Timothy Mitchell in his social history of Spanish bullfighting, contends that bullfighting is best understood within the context of Spanish society and history; nevertheless, he insists that most writing about the sport has removed it from its sociohistorical context. While all the problems of ethnographical observation (as raised by Clifford) enter into any such discussion, representations continue to be constructed now as they did when Cameron painted, and weaving through the material involves constant negotiation with 'information' and theoretical positionings. Mitchell includes a discussion of the aesthetics of bullfighting within the Spanish experience; that is, relating the sport as art, the viewer as connoisseur and in so doing, tangentially alters or shifts a discussion of Cameron's painting from ethnography to connoisseurship. According to Mitchell, elite aficionados consider bullfighting a fine art: 'as such it can only be understood and appreciated from an aesthetic point of view'. Such a perspective, writes Mitchell, is easy to assert particularly if Edmund Burke's definition of the sublime is applied to the fine art of bullfighting:

The feeling of the sublime, to begin with, involves a degree of horror – controlled horror – the mind being held and filled by what it contemplates. Thus, any object that can excite the ideas of pain and danger, or is associated with such objects, or has qualities that can operate in a similar way, can be sublime.[62]

Like the art connoisseur, the aficionado enjoys and experiences the work of art (the bullfight) 'on its own terms, without reference to its possible utility, rightness or wrongness' and without reference to one's own life. The aesthetic attitude is independent of the moral attitude: the object is admired for its

'form, elegance, grace, economy of means, and so on'.[63] Following the aesthetic, Spanish poet José Bergamín insisted 'that a bullfighter's death in the line of duty is not tragic, nor honorable, nor glorious, but quite irrelevant to the only thing that matters – art'. Cameron conflated two arts, painting and bullfighting. Thus, she can be discussed as ethnographer or connoisseur equally well, slipping from one category to another without establishing a fixed position in either, but assuming a multifarious position that adds meanings to the complicated pictures she made and exhibited.

Mary Cameron emerges in the press as a strong, 'virile' painter who, if she once was a tourist in Spain, has become by 1910 a 'native'. Her travelling surpassed Christina Paterson Ross's traversing of Europe and supplanted Mary Rose Hill Burton's visitation to Japan. She emerges as ethnographer and connoisseur, multi-dimensional and versatile, reproducing perversity and pleasure. The press accepted her pictures as strong and vigorous but contained their descriptions by representing Cameron herself as charming and beautiful; no woman who plays a role in the narrative of these pages was as frequently reproduced as was Cameron. Her 'energy and fearlessness' was written about, then suppressed or restrained by her own body. While Cameron clearly desired to present herself as a labouring body obtaining pleasure from her work, the press just as clearly desired to reify her as a purely feminine body. Within the tradition of Western philosophy, the sublime consistently has been identified as masculine, the beautiful as feminine;[64] because Cameron represented what Mitchell considers the ultimate 'sublime', the fine art of bullfighting, an excessively feminine portrayal of the artist was then required to ward off any image of her as sublime. In the process, the critical writing of Cameron-as-artist attempted to conceal her pleasure and deny her as worker. The long interview with Cameron in the *Westminister Gazette* remains the one instance where 'the physical endurance involved in her work' is acknowledged and the interest her pictures might hold for the 'woman worker' is recognized. Fortunately in this conversation, Cameron left words behind with which to replace her own image in history: painting 'means hard manual labour . . . It means pulling up your sleeves and setting to work'. Of the attention paid to her appearance, she said: 'I was sometimes told first of all how beautiful I was – figure me', and she laughed, 'in a painting-blouse, with my sleeves rolled up and my muscular hands paint-stained!'[65]

Afterthoughts

Emily Murray Paterson (1855–1934) and Susan Crawford (1863–1918) are shadowy figures on the pages of this book. They appear fleetingly in association with some of the 'larger' players but little of their work or their lives was reconstructed. There is no particular reason for this: the women selected for discussion were chosen specifically because they worked as professional artists (although the term has yet to be satisfactorily defined) and they belonged to at least one of the societies that sought to promote and support women artists. Paterson and Crawford fit both categories and share many other characteristics with the selected artists.

Emily Murray Paterson was born in Dublin Street at the east end of Edinburgh's New Town in 1855. Her father was a Solicitor of the Supreme Courts from Dundee; her mother was from Aberdeen. Emily was their first child and when she was still very young, her parents moved to much larger and more prestigious accommodations in Bruntsfield Crescent. The Lorimer family lived close by: James Lorimer was a professor of law at Edinburgh University; his son John Henry Lorimer was a painter, another son Robert Lorimer became a successful architect. Paterson became a well-known artist in Edinburgh holding her first solo exhibition in the city in 1904. Like her friend Mary Cameron she preferred to paint what the critics referred to as masculine pictures. In 1902 the *Scots Pictorial* wrote: 'Perhaps the highest compliment that can be paid to Miss Paterson's art is to say that she displays an almost masculine breadth of tone, that her colours are boldly and skillfully blended, and that there is nothing "ladylike" in her treatment of her subjects.'[1] Also, like Mary Cameron, her name was put forward as an associate of the Royal Scottish Academy (never successfully), she was a member of the Society of Scottish Artists, exhibited regularly with the Glasgow Society of Lady Artists, and she seemed to prefer to spend much of her time away from Edinburgh. She studied in London before the turn of the century (there

is no record of her having studied art at the Board of Manufactures' School in Edinburgh); as early as 1902 she was spending her summers in the Netherlands or in Italy; she lived in Switzerland for three years (approximately 1911 to 1914); and by 1917 she had moved permanently to London. Her pictures were most frequently landscape or seascape noted for their 'grandeur and dignity'. By 1909 she was exhibiting regularly with London's Society of Women Artists as well as in numbers of other venues across Britain. She and Mary Cameron were undoubtedly the most cosmopolitan of the women artists mentioned here: both women were well off and had the temperaments or inclination to resist settling in one location.

Susan Crawford became a member of the Glasgow Society of Lady Artists about 1893. She had studied at the Glasgow School of Art and when her studies ended she took up a teaching position in the School. A photograph of Crawford published by the *Glasgow Evening News* (Fig.38) in 1911 shows the artist working at a small desk in her studio surrounded by pictures which designate the space as working and Crawford as 'serious'.[2] Crawford never married (neither did Paterson), she shared her living space with

38 Susan Crawford in the *Glasgow Evening News*, 2 August 1911

another artist Annie Burton, shared studio space with colleagues Louise Perman and Emma Watson, and followed a successful career as a teacher and an artist.[3] Most noted as a printmaker, she exhibited regularly with the Glasgow Society of Lady Artists but also in larger venues such as the Glasgow Institute of the Fine Arts and the London-based Royal Society of Painter-Etchers.[4]

During the 1908 autumn exhibition of the Glasgow Society of Lady Artists, the *Glasgow Herald* commended Emily Murray Paterson and Susan Crawford as exhibitors who had 'won distinction in wider fields'.[5] The following year the *Herald* praised Paterson's pictures of Dordrecht and Venice and singled out Crawford's 'original view' of Linlithgow Palace thereby signalling one of the differences between the two women: Crawford spent most of her time in Scotland portraying Scottish subject matter while Paterson spent most of her time away from Scotland painting in Continental Europe.[6] A couple of years later Paterson's *On the Maas* (Fig.39) provided a reason for naming

39 *On the Maas*, Emily Murray Paterson, *c*.1905

40 *The University, Glasgow*, Susan Crawford, *c.*1910

her 'the most successful of those who have found material in the Low Countries'; Crawford's etching of *The University, Glasgow* (*c.*1910) (Fig.40) was acknowledged as representative of the artist's 'sense of picturesque composition'.[7]

Crawford and Paterson easily could have slipped into the earlier part of this book in a more substantial way; they did not have to be an addendum at the end, recollected but not part of the larger narrative. Drawing them into the story only to end the narrative highlights the problems inherent in any retelling of history. Selections are made: some are remembered, some are left out, the ensuing text is always partial, always in formation. French theorist Roland Barthes justified or explained his writing of the nineteenth-century French historian Jules Michelet as follows: 'That Michelet's oeuvre, like any object of criticism, is ultimately the product of a certain history, I am quite convinced. But there is an order of tasks: first of all, we must restore to this man his coherence.'[8] Adrienne Rich feared historical amnesia. She suggested historians seek 'memory and connectedness against amnesia

and nostalgia'.[9] Rich argued that women's pasts must be known 'in order to consider what we want to conserve and what we want not to repeat or continue';[10] 'we need to know where we have been: we need our history'.[11]

The previous pages in different ways and by focusing on a number of characters have sought to defer amnesia and to 'restore' to these women their 'coherence' but, in so doing, I have replaced some 'players' while others remain forgotten. Barthes and Rich are far apart in their concerns – in their methods and with their choice of material. When Barthes reconstructed a text of Michelet, he had volumes of sources to select, order, re-order and present; Michelet wrote and was written about. Barthes's wish 'to describe a unity, not to explore its roots in history or in biography' is theoretically exciting and textually daring; Barthes's ability to accomplish his venturous and exhilarating task is possible because the opportunities for it already exist. Rich has a different task, a different set of circumstances, little material and few opportunities. Women's histories must seek for a balance in-between, doomed always to be challenged, never quite belonging.

Finally and without resolution this was a story written for my friendships with women, for my commitment to women's history and for my own pleasure. It ends with an insight from fiction:

History is everywhere. It seeps into the soil, the sub-soil. Like rain, or hail, or snow, or blood. A house remembers. An outhouse remembers. A people ruminate. The tale differs with the teller.[12]

53. Minutes of the Trustees of the Board of Manufactures, 6 July 1882. Scottish Record Office, NG. 1/1/47.

54. *Courant*, 3 April 1882. Clipping Book, Scottish Record Office, NG. 1/68/1.

55. *Scotsman*, 18 January 1889, p.3.

56. School of Art Report for Year 1887–8 presented to the Board of Manufactures 17 January 1889. Scottish Record Office, NG. 1/1/49. See also *Scotsman*, 18 January 1889, p.3.

57. Unfortunately, MacGoun died of cancer (an ovarian tumour) when she was only forty-nine years old.

58. Minutes of the Trustees of the Board of Manufactures, 11 July 1889. Scottish Record Office, NG. 1/1/49.

59. ibid., 6 June 1889.

60. This contradicts Sir William Meir's 1886 speech to the Annual Meeting of the Board of Manufactures that the art school in Edinburgh 'was one of the first to admit women'. *Scotsman*, 22 January 1886, p.8.

61. Minutes of the Board of Governors, Glasgow School of Art, 29 November 1861.

62. The GSA appointed Robert Greenlees master of Elementary Sections in 1854, Deputy Head Master in 1861, Head Master two years later.

63. Glasgow Government School of Design Annual Report, 1852. The largest number of students (86) were between 15 and 20 years old; 32 students were between 12 and 15 years old; 29 were between 20 and 25; and, 5 were between 25 and 30.

64. Glasgow School of Art Annual Report, 1871 and 1872.

65. ibid., 1882.

66. The GSA assigned Georgina Greenlees a salary of £25 per annum in 1872; her salary rose to £40 per annum in 1876. Minutes of the Board of Governors, 31 July 1872 and 5 October 1876. Elizabeth Patrick first appeared in the Governors' Minutes when she was employed as an assistant teacher in the afternoon Ladies Class in 1855; she was paid £10 per annum. She remained an assistant teacher but by 1869 her salary was £40.

67. Greenlees exhibited regularly with the Glasgow Institute for thirty years, until 1897.

68. *Glasgow Herald*, 26 January 1878, p.7.

69. Minutes of the Board of Governors, 15 January 1878.

70. At this time design generally meant drawing.

71. Minutes of the Board of Governors, 15 January 1878. In its report of the Annual Meeting of the School of Art, the *Glasgow Herald*, 26 January 1878, p.7, indicated that 327 women were registered in the morning and afternoon classes for ornament, landscape, and figure drawing.

72. Letter to Greenlees from the Governors recorded in the Minutes of the Board of Governors, 3 April 1878.

73. ibid., 7 January 1881.

74. ibid., 18 March 1881.

75. ibid., 22 March 1881.

76. Robert Brydell became Head of the St. George's Art School which was similar to St. John's Wood School but with 'a wider range of study more suitable to a mixed population'. Unlike the GSA, St. George's was not connected with South Kensington. *Glasgow Herald*, 16 September 1881, p.4. Brydell felt strongly enough about his resignation that, when a reviewer of the autumn Dumbartonshire Art Club exhibition cited him as a teacher at the GSA, he wrote a letter to the editor of the *Glasgow Herald*, correcting the error. Letter to the editor from Robert Brydell, *Glasgow Herald*, 13 October 1882, p.4.

77. Glasgow School of Art Letter Book, 23 June and 28 June 1881.

78. Minutes of the Board of Governors, 22 April 1881.

79. *Glasgow Herald*, 30 January 1884, p.8.

80. *Glasgow Herald*, 9 September 1881, p.8.

81. Woon exhibited two obviously commissioned portraits in the 1876 Royal Scottish Academy

Exhibition, *Muriel, daughter of the Hon. Lord Craighall* and *Esther, daughter of the Hon. Lord Craighall*; both pictures were lent to the exhibition by Lord Craighall.

82. Margaret Macdonald was a highly skilled artist and an outstanding student: she won a Queen's prize in 1874 for a design for a claret jug, a Haldane prize and a 'free studentship' in 1875, another Haldane prize in 1876 (for lace design), and book prizes in 1880 and 1881. She is not to be confused with Margaret Macdonald (b. 1864) who later studied at the GSA and became one of the 'Glasgow Four'.

83. The Society formed in 1855 and opened their first exhibition two years later in 1857. For information about the Society see Katy Deepwell, 'A History of the Society of Women Artists', Charles Baile de Laperrière, ed., *The Society of Women Artist Exhibitors*, 1996. The Society changed its name from the Society of Female Artists to the Society of Women Artists in 1899.

84. *Glasgow Herald*, 5 January 1884, p.4.

85. Sir William Fettes Douglas as quoted in the *Scotsman*, 23 January 1885, p.7.

86. *Glasgow Herald*, 19 October 1882, p.4.

87. *Glasgow Herald*, 6 February 1883, p.4.

88. *Glasgow Herald*, 16 April 1883, p.6.

89. *Glasgow Herald*, 23 April 1878, p.4.

90. *Glasgow Herald*, 9 September 1881, p.8

91. Clare Henry, *Arts Review*, 7 September 1990, p.488.

92. Figures quoted in Adele Patrick, 'Boy Trouble: Some Problems Resulting from "Gendered" Representation of Glasgow's Culture in the Education of Women Artists and Designers', *Journal of Art and Design Education*, vol. 16, no. 1, 1997, p.13.

93. *Studio*, January 1899, p.276.

94. Minutes of the Trustees of the Board of Manufactures, 25 June 1902. Scottish Record Office, NG. 1/1/50. All teachers were asked to resign including Woon's male colleagues. The Glasgow School of Art underwent a similar reorganization but with less drastic results for their teaching staff. See the *Studio*, November 1903, pp.107–115.

95. The only female staff member was a 'Special Assistant Teacher for the Female Class'.

96. When Surenne began studying at the School of Art, she lived with her older brother and sister in a nine-room flat at 6 Warriston Crescent.

Chapter 2

1. This is the dictionary definition of 'guild' as found in *The Oxford Concise English Dictionary* (1995 edition).

2. Lucy Toulmin Smith, 'Introduction' to Toulmin Smith, *English Gilds*, 1870, p.xiv. She later wrote: 'It is worth noticing who were the persons who composed the Gilds. Scarcely five out of the five hundred were not formed equally of men and women, which, in these times of the discovery of neglect of ages heaped upon woman, is a noteworthy fact.' p.xxx.

3. R. A. Leeson, *Travelling Brothers: The Six Centuries' Road from Craft Fellowship to Trade Unionism*, 1979, p.25.

4. ibid., p.27.

5. For a discussion of the rise of the interest in saleable art and of artists' organizations, see Iain Pears, *The Discovery of Painting: The Growth of Interest in the Arts in England, 1680–1768*, 1988.

6. London's Old Watercolour Society had controlled the number of women allowed to exhibit and by mid century there were only four women associated with the Society; they were Honorary Members. The New Watercolour Society (formed 1832) was slightly more liberal; they had eight 'Lady Members'. See Pamela Gerrish Nunn, *Victorian Women Artists*, 1987, pp.95–101. Deborah Cherry observed that the Old Watercolour Society 'ejected women from full membership in 1850'. Deborah Cherry, 'Women Artists and the Politics of Feminism' in Clarrisa Campbell Orr, ed., *Women in the Victorian Art World*, Manchester: Manchester University Press, 1995, p.55.

7. *Scotsman*, 18 February 1889, p.6.

8. She also exhibited *The Farmer's Bairns*, *Afternoon Tea* and *The Favourites* thus confirming her specialization in genre painting.

9. *Scotsman*, 2 March 1889, p.9.

10. *Scotsman*, 28 February 1889, p.5. Ninety-five women participated in the 1889 RSA with 153 exhibits. Catalogue of the 1889 Royal Scottish Academy Exhibition.

11. *Scotsman*, 15 February 1889, p.5.

12. *Glasgow Herald*, 20 February 1882, p.10.

13. *Glasgow Herald*, 27 February 1882, p.8. In 1882, 47 artists were from Glasgow, 97 from the rest of Scotland and 104 from 'other countries'.

14. *Scotsman*, 8 March 1887, p.5.

15. Adélaïde Labille-Guiard's, *The Artist with Two Female Pupils* (1785, Metropolitan Museum of Art), painted over a hundred years before Ross's picture has become one of the more famous statements about women practising as professional artists and teachers while, at the same time, being excluded from the prestigious and often commission-granting organizations.

16. J. D. Stephenson and C. G. Brown, 'The View from the Workplace: Women's Memories of Work in Stirling *c*.1910–*c*.1950' in E. Gordon and E. Breitenbach, eds, *The World is Ill Divided: Women's Work in Scotland in the Nineteenth and Early Twentieth Centuries*, 1990, p.9.

17. *Glasgow Herald*, 16 January 1863, p.4.

18. For example, in 1873 the name of only one woman (Mrs J. Graham Gilbert) appeared on the list of subscribing members and she was one of the few who gave £25 or more; amongst the second group of subscribers who gave £10 most were merchants and amongst the third group who gave £5 most were artists.

19. *Glasgow Herald*, 17 January 1878, p.4. Greenlees sold her picture *Bay at Rowardennan* for £22 10s and Elizabeth Patrick sold *On the Kintyre Coast* for £20. Glasgow Institute Sales Books, Glasgow Room, Mitchell Library. Glaswegian Laura Chapman moved to England in 1880.

20. See Catalogue of the Exhibitions of the Glasgow Institute of the Fine Arts, Mitchell Library. The Institute paid the cost of transportation but was not responsible for damage.

21. Sales Records, Glasgow Institute of the Fine Arts, Mitchell Library. Ross sold *Washing Day* to Thomas Rowat of Paisley, Jessie Rowat Newbery's uncle.

22. For example, in 1876 all three Rosses exhibited in the Institute exhibition: Christina Paterson Ross, *White Horse Close, Edinburgh*, £14 14s, and *Morning*, £5 5s (watercolours); R. Thornburn Ross, *The Spinning Lesson*, £200 (oil), *Playmates*, £50 (watercolour); R. Ross, Jr., *Gathering Fallen Apples*, £8 8s (watercolour). R. Thorburn Ross as an Academician could command large prices for his pictures and one sale represented a much larger income than many people saw in a year's work.

23. *Glasgow Herald*, 12 January 1878, p.4 and 19 January 1878, p.3. While artists from both cities did collaborate, Glasgow artists had taken the initiative.

24. Francis Powell as quoted in the *Glasgow Herald*, 19 January 1878, p.3.

25. *Glasgow Herald*, 15 November 1878, p.3.

26. *Glasgow Herald*, 14 December 1878, p.7.

27. *Glasgow Herald*, 4 January 1879, p.4.

28. The women exhibited alongside already established artists who were members of the traditional societies, such as William McTaggart, John Smart and William Ewart Lockhart.

29. *Glasgow Herald*, 10 January 1881, p.4.

30. John Ure also purchased Ross's picture *Berwick* from the Glasgow Institute for £7 7s in 1886.

31. *Glasgow Herald*, 10 January 1881, p.4.

32. Tracy C. Davis, *Actresses as Working Women: Their Social Identity in Victorian Culture*, 1991, pp.25–6.

33. Cyril Ehrlich, *The Music Profession in Britain since the Eighteenth Century*, Oxford: Clarendon Press, 1985, p.104.

34. Roger Simon, *Gramsci's Political Thought: An Introduction*, London: Lawrence & Wishart, 1982, p.22.

35. Royal Scottish Academy Notes, 1878, p.96. The 'Notes' reproduced Ross's small drawing of the picture.

36. John Barrell, *The Dark Side of the Landscape: The Rural Poor in English Painting 1730–1840*, 1980, p.5.

37. *Glasgow Herald*, 5 December 1884, p.9. The *Glasgow Herald*, 21 February 1884, p.4, commended this 'charming' picture: it was 'suffused with excellent colour, and entailing drawing of the severest kind'. Ross exhibited the same picture, or one like it, in the Kilmarnock Fine Art Exhibition, 1884. To give some perspective as to the number of viewers seeing pictures like this which were exhibited outside of the larger cities, 4000 people visited the 1887 Kilmarnock exhibition, *Scotsman*, 2 February 1887, p.7.

38. The *Studio* later praised Ross's *The Sailmakers' Loft* for its 'powerful handling of a difficult subject'. This review was published after Ross's death; the *Studio* expressed 'deep regret that her undoubted influence on contemporary art should have been so prematurely withdrawn'. *Studio*, December 1906, p.258.

39. C. Ehrlich, *The Music Profession in Britain since the Eighteenth Century*, 1985, pp.110, 157.

40. ibid., pp.150–52.

41. ibid., p.152.

42. Advertisements for the performance of Marie Schumann, solo violinist along with Jessie Griffin, a soprano, and Florence Winn, a contralto, were run in the *Glasgow Herald* during early October 1882.

43. Ehrlich, op. cit. p.159.

44. Lucy Green, *Music, Gender and Education*, Cambridge: Cambridge University Press, 1997, pp.52–3.

45. The Edinburgh Club formed seven years after the more well-known and more long-lasting Glasgow Society of Lady Artists and differed from it by restricting its membership to artists, a move which may subsequently have led to its early demise: the Edinburgh Club seems to have disappeared by 1898.

46. *Scotsman*, 28 October 1889, p.8.

47. Pat O'Connor, *Friendships Between Women, A Critical Review*, 1992, p.27.

48. *Scotsman*, 28 October 1889, p.8. The first exhibition of the Edinburgh Ladies' Art Club opened 28 October at 90 George Street.

49. Membership in the so-called Paris Club required that the women had studied in Paris. See chapter 5 for further discussion of the Club.

50. *Scotsman*, 28 October 1889, p.8.

51. *Courant*, 3 April 1882. From the Board of Manufactures 'Clipping Book', NG. 1/68/1, Scottish Record Office.

52. 'Female Art Students', *Scotsman*, 10 April 1882, p.6.

53. W. B. Hole, 'Female Art Education', *Scotsman*, 11 April 1882, p.2.

54. In February 1889 at the annual dinner held for students attending the Life School of the Royal Scottish Academy, one of the speakers announced that the Academy was to be reformed and 'brought into proper relations to the times'; there was a proposal for a new charter to be presented soon which would open up the Academy and introduce a 'liberality of sentiment'. See the *Scotsman*, 14 February 1889, p.5.

55. *Scotsman*, 3 March 1890, p.7.

56. ibid.

57. ibid. In 1889 the *Scotsman* credited Margaret Dempster with 'first-rate work' and criticized the hanging of the picture; viewers were unable to appreciate it because it was hung too high. See the *Scotsman*, 28 February 1889, p.5.

58. *Scotsman*, 26 December 1891, p.8.

59. *Scotsman*, 24 November 1890, p.6. The exhibition opened on 22 November, The Galleries, 90 George Street.

60. *Scots Pictorial*, 13 November 1897, p.228.

61. *Scotsman*, 24 November 1890, p.6.

62. *Scotsman*, 10 November 1894, p.8.

63. ibid.

64. ibid.

65. Hall Caine read this rousing speech to his colleagues and in it he repeats many of the concerns stated by members of other clubs, professors at Scottish universities, and politicians. Caine as quoted in the *Scotsman*, 10 November 1894, p.8.

66. *Scotsman*, 10 November 1894, p.10.

67. ibid.

68. The Scottish Arts Club did not admit women as members until the early 1980s.

69. Hall Caine as quoted in the *Scotsman*, 10 November 1894, p.8.

70. *Scotsman*, 28 November 1891, p.9. An organizational meeting of 'over a hundred gentlemen' took place in the same venue, Edinburgh's Royal Hotel on 24 April 1891. It was at this meeting that the Marquis of Huntly was appointed president; Robert Noble was chairman and R. B. Nisbet, vice-chairman. Noble became an Associate of the Royal Scottish Academy in 1892, Nisbet in 1893; their activities with the Society of Scottish Artists did not deter them from becoming part of the Academy.

71. *Scotsman*, 28 November 1891, p.9.

72. The Scottish 'revolt' against the Academy was much less vigorous than some of the Continental situations. For a highly detailed and informative account of one secession movement, see Peter Paret, *The Berlin Secession: Modernism and its Enemies in Imperial Germany*, 1980.

73. *Scotsman*, 28 November 1891, p.9.

74. Joseph Thornburn Ross died as the result of a fall from a balcony staircase in his studio on to a concrete floor. Because of the circumstances of his death his studio was described in some detail in the press. His sisters were holidaying in Kirkcudbright when the accident occurred. *Glasgow Herald*, 29 September 1903 and the *Scotsman*, 29 September 1903. The *Scotsman* indicated there were two servants in the Ross household.

75. Dempster (b. 1863) won the national level Queen's Prize in 1882; in 1887 (she was one of 378 female students) she won a bronze medal for a painting in monochrome of figures from the antique. *Scotsman*, 13 January 1887, p.3.

76. The picture exhibited in 1892 may be somewhat similar to Dempster's later picture, *The Motoring Veil*, a portrait of Mrs Robert Meikle that was probably made between 1914 and 1918. I thank Robin Rodger, Perth Museum and Art Gallery for the information about *The Motoring Veil*.

77. *Glasgow Herald*, 21 April 1892, p.4.

78. *Scotsman*, 21 April 1892, p.5.

79. 'Can Ladies be Academicians?', *Pall Mall Gazette*, 9 March 1901, p.6. Josephine Cameron Haswell Miller (1890–1975), a member of the Glasgow Society of Lady Artists and the Society of Scottish Artists, became the first female associate member of the Royal Scottish Academy in 1938. See the *Scotsman*, 17 March 1938, p.10 and the *Glasgow Herald*, 17 March 1938, p.13. Of the nominees, Haswell Miller received the most votes.

80. *Scots Pictorial*, 15 April 1901, p.134.

81. *Studio*, May 1901, p.282.

Chapter 3

1. Julian Spalding, *Art Monthly*, December–January 1990/91, p.25.

2. Jude Burkhauser (1947–1998) died while this book was being written. In 1996 she wrote, 'I have lost my health as a result of the stress and distress associated with "Glasgow Girls" . . . I've paid an enormous price for my integrity but know that without it, life is worthless anyway'. Quoted by Elspeth King in the obituary she wrote for the *Independent*, 27 October 1998. See also, *Scotsman*, 8 October 1998.

3. Lynne Walker's review of *'Glasgow Girls': Women in Art and Design 1880–1920*, 1990, *Woman's Art Journal*, Fall 1993/Winter 1994, p.58.

4. For an astute critical comment about museum spectacles, see Blake Gopnik, 'Big shows, big crowds and a big waste of talent', *Globe and Mail* (Toronto), 24 April 1999.

5. A Memorial Exhibition of the work of Charles Rennie Mackintosh opened on 3 May 1933 at the McLellan Galleries in Sauchiehall Street. For a discussion of the debate surrounding the inclusions and exclusions of this exhibition see J. Helland, *The Studios of Frances and Margaret Macdonald*, 1996, pp.1–10.

6. Martin Filler, 'Big Mack', the *New York Review of Books*, 20 February 1997, p.10. 'The Four' included Charles Rennie Mackintosh, Margaret Macdonald, Frances Macdonald and James Herbert McNair.

7. Fiona MacCarthy, 'Mack, the Life', *Observer*, 26 May 1996, p.12.

8. A. Crawford, *Charles Rennie Mackintosh*, London: Thames & Hudson, 1995; J. Helland, *The Studios of Frances and Margaret Macdonald*, 1996; W. Kaplan, ed., *Charles Rennie Mackintosh*, New York: Abbeville Press, 1996; T. Neat, *Part Seen, Part Imagined: Meaning and Symbolism in the Work of Charles Rennie Mackintosh and Margaret Macdonald*, Edinburgh: Canongate 1994.

9. Crawford, p.25.

10. ibid., p.26.

11. Marcia Pointon in her study of women's culture in eighteenth-century England, explored 'the forms of representation that are at work in wills concerning not land but the personal possessions of women'. Marcia Pointon, *Strategies for Showing: Women, Possession, and Representation in English Visual Culture 1665–1800*, 1997, p.3.

12. The Glasgow Association for the Higher Education of Women was founded in 1877 and incorporated under the name Queen Margaret College in 1883 when John Elder, a Clyde ship-builder, gifted a house and land to the Association. See the *Queen*, 10 October 1885, p.360 and 3 March 1888, p.244.

13. Wendy Alexander, 'Early Glasgow Women Medical Graduates', in E. Gordon and E. Breitenbach, eds, *The World is Ill Divided: Women's Work in Scotland in the Nineteenth and Early Twentieth Centuries*, 1990, pp.71–2.

14. Elizabeth Wilson, 'The Invisible *Flâneur*', S. Watson and K. Gibson, eds, *Post Modern Cities and Spaces*, 1995, p.98.

15. *Studio*, February 1900, p.51.

16. See, for example, the *Independent*, 23 September 1990, the *Scotsman*, 17 September 1990, and *Books in Scotland*, December 1990–January 1991, pp.17–18. See also, Lisa Zeiger's review in *Apollo*, November 1990, pp.351–2 which insists that an 'individual unlike anybody else' is responsible for making 'great art'; Duncan MacMillan, *Art Monthly*, November 1990; and Clare Henry, *Arts Review*, 7 September 1990.

17. Glasgow art critic Clare Henry wrote: 'Margaret's rather twee *Opera of the Sea* 1915–21 from Darmstadt, used extensively on posters, brochures, invitation cards and book, is not a welcome symbol with which to advertise the creative leap which Glasgow women made at the turn of the century.' Nevertheless, Margaret Macdonald's *The Dew* was reproduced to accompany Henry's review. *Arts Review*, 7 September 1990, p.488.

18. Ann Macbeth's election to the Glasgow Society of Lady Artists was sponsored by 'Immortals' Jessie Keppie and Agnes Raeburn. Glasgow Society of Lady Artists' Members Book, 3 November 1903.

19. *Scotsman*, 23 January 1885, p.7.

20. ibid.

21. Letter to the editor from 'A female student at the School of Art', *Scotsman*, 28 January 1885, p.10.

22. Letter to the Editor from 'A. B.', *Scotsman*, 28 January 1885.

23. *Scotsman*, 30 December 1884, p.4. The Glasgow School of Art 'stood highest in the schools in Scotland', *Artist*, 1 April 1885, p.125.

24. *Glasgow Herald*, 29 December 1884, p.4.

25. *Annual Report of the Glasgow School of Art and Haldane Academy*, December 1884. Presented at the Annual Meeting, 9 February 1885.

26. Dempster exhibited with the Society in 1891. *Scotsman*, 14 March 1891, p.9.

27. Glasgow Society of Lady Artists, Minutes of the Meeting of Council, 5 March 1897. Mitchell Library, Glasgow.

28. Glasgow Society of Lady Artists, Minutes of the Meeting of Council, 1 March 1906. Mitchell Library, Glasgow.

29. Ailsa Tanner, *A Centenary Exhibition to Celebrate the Founding of the Glasgow Society of Lady Artists in 1882*, 1982, p.14. Ailsa Tanner is an artist member of the society and its archivist.

30. *Quiz*, 27 March 1885.

31. Governors' Minutes, Glasgow School of Art, 5 October 1876.

32. Letter from Ann Macbeth to Francis Newbery, 20 May 1910. Glasgow School of Art Archives.

33. *Glasgow Herald*, 9 March 1895, p.7. Wyper exhibited pictures of Cornwall (*Polperro Harbour*, 1894) and France (*Fish Auction, Etretat*, 1893) at the Paisley Art Institute; she seems to have travelled frequently and extensively, particularly painting sea coasts.

34. 'Death of Miss Jane Cowan Wyper, R. S. W.', *Glasgow Herald*, 19 July 1898, p.6.

35. *Stirling Journal and Advertiser*, 27 March 1891. The *Herald* deemed Nisbet's picture 'excellent and difficult', 14 March 1891, p.9.

36. Elizabeth Mavor, *The Ladies of Llangollen*, 1971. See pp.212–16 for a discussion of Plas Newydd as a site of tourism.

37. *Gentlewoman*, 2 April 1892, p.449 and the *Glasgow Herald*, 21 March 1892, p.6.

38. *Glasgow Herald*, 12 March 1898, p.4.

39. *Quiz*, 27 March 1885, p.9. *Quiz*, in its characteristically sardonic way considered the women as 'amateurs' but many were selling enough work to be considered 'professional'.

40. For example, Jessie Algie, known as a painter, included 'graceful designs on porcelain' and Jane Nisbet, also a painter, contributed woodwork decorations. *Quiz*, 16 March 1888, p.11.

41. *Glasgow Herald*, 6 March 1888, p.6.

42. *Stirling Journal and Advertiser*, 27 March 1891.

43. *Scotsman*, 14 March 1891, p.9, and the *Glasgow Herald*, 14 March 1891, p.9.

44. *Glasgow Herald*, 21 March 1892, p.6. The exhibition was open from 19 March 1892 until 2 April 1892. By 1891, the rooms in Wellington Street were too small for the exhibition. In 1889 the annual exhibition consisted of 120 oil and watercolour pictures along with some decorative art; by 1891 there were over 200 exhibits including oil paintings, watercolour drawings, black and white drawings and silverpoint and, in an adjoining room, there was a collection of decorative art (cabinets, mirrors and metalwork among other items).

45. ibid.

46. *Gentlewoman*, 2 April 1892, p.449.

47. The 1893 exhibition was held in March in Charing Cross Mansions; the new building at 5 Blythswood Square opened in December 1893.

48. The members included 66 artists, 40 honorary members, 18 associates and 200 lay members. The Club and the Society together had managed the arrangements for the five-year lease (at £150 per year) on the 'commodious and handsome' accommodations. *Glasgow Herald*, 5 December 1893, p.4.

49. ibid.

50. A. Tanner *A Centenary Exhibition*, p.8.

51. ibid., and *Glasgow Herald*, 6 December 1895, p.6.

52. Karen Moon, *George Walton: Designer and Architect*, 1993, p.40.

53. F. K. Prochaska, *Women and Philanthropy in 19th Century England*, Oxford: Oxford University Press, 1980, pp.47–8.

54. As late as 1906 a motion to allow men access to the premises on 'ordinary days' was defeated.

55. *Glasgow Herald*, 10 December 1894, p.10.

56. *Glasgow Herald*, 21 March 1903, p.9.

57. According to Annette Carruthers, in 1901 almost half Scotland's population lived more than two to a room, 57 per cent of accommodations were one or two rooms. Annette Carruthers, 'Studying the Scottish Home', in A. Carruthers, ed., *The Scottish Home*, 1996, p.15.

58. Stana Nenadic, 'The Rise of the Urban Middle Class', in T. M. Devine and R. Mitchison, eds, *People and Society in Scotland, Volume 1, 1760–1830*, Edinburgh: John Donald Publishers, 1994, p.110.

59. Jessie Keppie's oldest brother John was an architect while James, one year older than Jessie, was a joiner or furniture maker. Helen Keppie registered when she turned eighteen in 1881

and continued on with her classes as an 'art student', not as a teacher like her sister, until 1889. Jane was studying in the early 1890s.

60. S. N. Morgan and R. Trainor, 'The Dominant Classes', W. H. Fraser and R. J. Morris, eds, *People and Society in Scotland, Volume II, 1830–1914*, Edinburgh: John Donald Publishers, 1990, p.113.

61. See Chandra Talpade Mohanty, 'Under Western eyes: feminist scholarship and colonial discourses', *Boundary 2*, vol. 3, pp.333–58 for a discussion of women's economical and educational 'advancement' as it relates to the women, including the domestic workers, around them.

62. For a discussion of the employment of highlanders as domestics in Scottish homes see T. M. Devine, 'Temporary Migration and the Scottish Highlands', *Exploring the Scottish Past: Themes in the History of Scottish Society*, 1995.

63. Class differences amongst women existed within communities and without those communities as Britain expanded its Empire; realignments or expansions of class differences had repercussions that extend much beyond locale or nation. See, for example, Rosemary Hennessy and Rajeswari Mohan, 'The Construction of Woman in Three Popular Texts of Empire: Towards a Critique of Materialist Feminism', *Textual Practice*, Winter 1989, pp.323–37 and 354–7.

64. Katherine Cameron was born 26 February 1874 when her family was living at 16 Sardinia Terrace in Hillhead. By the late 1880s they were living in a large ten-room house at 10 South Park Terrace still in Hillhead and hence close to the Glasgow School of Art. Her father was a moderately well-off United Presbyterian minister with a large family thus all the children were prepared for careers. For example, one of Cameron's sisters worked as a governess while another was studying music the same time Katherine was studying art. For a discussion of Cameron's artist-brother, D. Y. Cameron which includes material about Katherine Cameron and the family, see Bill Smith, *D. Y. Cameron: The Visions of the Hills*, 1992.

65. *Artist*, August 1896, p.352.

66. 'Landscapes and Flowers: Pictures by Katherine Cameron', *Glasgow Herald*, 13 March 1931, p.6.

67. Minutes of the Royal Scottish Society of Painters in Water Colours, 3 February 1897. Margaret Macdonald, ten years older than Cameron, was elected the following year. Frances Macdonald was a candidate for membership the same year as her sister but she was not elected. James Kay (1858–1942), the watercolour painter elected to membership the same year as Cameron, was not related to Cameron's future husband Arthur Kay. Cameron, at twenty-three, was sixteen years younger than James Kay; that she was elected an RSW at such a young age was quite remarkable.

68. H. C. Marillier, 'The Romantic Water-Colours of Miss Cameron', *Art Journal*, vol. 52, 1900, p.149.

69. Female students tended to study at either Colarossi or the Académie Julian which was slightly more expensive. In addition, some of the women, Mary Cameron for example, took private lessons at the same time as they followed their studies at one of the schools. For one contemporary account of the practise of women from Britain studying in Paris, see Clive Holland, 'Lady Art Students in Paris', *Studio*, December 1903, pp.225–33.

70. Kathleen Bruce (Lady Kennet) *Self-Portrait of An Artist*, London: John Murray, 1949, pp.23–4. I thank Catherine MacKenzie for bringing Bruce's book to my attention. For an earlier, slightly frivolous description of the living conditions for a student in Paris, see 'Domestic Life of a Lady Art Student in Paris', *Queen*, 29 May 1886, p.578.

71. See Griselda Pollock, 'Modernity and the Spaces of Femininity', *Vision and Difference: Femininity, Feminism and the Histories of Art*, 1988, pp.50–90, and Janet Wolff, 'The Invisible *Flâneuse*: Women and the Literature of Modernity', *Feminine Sentences: Essays on Women and Culture*, Cambridge: Polity Press, 1990, pp.34–50.

72. Pollock, p.67.

73. E. Wilson, 'The Invisible *Flâneur*', in S. Watson and K. Gibson, eds., *Post Modern Cities and Spaces*, 1995, p.71.

74. ibid.

75. Smith, op. cit., p.67.

76. *Glasgow Herald*, 21 March 1903, p.9.

77. Jennifer Harris, 'Embroidery in Women's Lives 1300–1900', *The Subversive Stitch*, 1988, p.25.

78. Rosi Braidotti, *Nomadic Subjects: Embodiment and Sexual Difference in Contemporary Feminist Theory*, 1994, p.156.

79. J. Burkhauser, ed., *'Glasgow Girls': Women in Art and Design, 1880–1920*, 1990, p.19.

80. Margaret H. Swain, 'Mrs. J. R. Newbery 1864–1948', *Embroidery,* Winter 1973, p.104.

81. Margaret H. Swain, 'Mrs. Newbery's Dress', *Costume*, October 1978, pp.64–73.

82. In conversation with Margaret Swain, September 1995.

83. *Glasgow Evening News*, 25 February 1913, p.6.

84. *Glasgow Evening News*, 25 February 1913, p.6.

85. Juliet Kinchen, 'Women in Industry', in Jude Burkhauser, ed., *'Glasgow Girls': Women in Art and Design 1880–1920*, 1990, p.42.

86. ibid. Eleanor Gordon has found that of over 59,000 labourers working in Scottish textiles in 1839, almost 41,000 were women. E. Gordon, 'Women's Spheres', in W. H. Fraser and R. J. Morris, eds, *People and Society in Scotland 1830–1914*, Edinburgh: John Donald Publishers, 1990. However, studies need to be conducted about the numbers of women designing for industry after 1890.

87. Gleeson White, 'Some Glasgow Designers and Their Work, Part III', *Studio*, October 1897, p.51.

88. Jude Burkhauser, 'The Glasgow Style', *'Glasgow Girls': Women in Art and Design 1880–1925*, 1990, p.105.

89. R. Braidotti, *Nomadic Subjects*, p.157.

90. *Paisley and Renfrewshire Gazette*, 27 March 1920, p.3.

91. Francis Newbery was a 'self-made' man, the son of an illiterate cobbler; he and Jessie Rowat were married on 28 September 1889. For more information about Newbery see George Rawson, *Fra H. Newbery: Artist and Art Educationist 1855–1946*, 1996.

92. Elspeth King, *The Strike of the Glasgow Weavers 1787*, 1987, p.11.

93. Fiona C. Macfarlane and Elizabeth F. Arthur, *Glasgow School of Art Embroidery 1894–1920*, Glasgow: Glasgow Museums and Art Galleries, 1980, p.4.

94. Satina M. Levey, *Discovering Embroidery of the 19th Century*, 1977, p.21.

95. Harris, 'Embroidery in Women's Lives 1300–1900', p.25.

96. I used this term to describe the collaboratively produced work of Margaret and Frances Macdonald and it could also apply to this work by Newbery and Macbeth. See 'Collaboration among the Four', Wendy Kaplan, ed., *Charles Rennie Mackintosh*, 1996, pp.89–114.

97. For a contemporary comment on Macbeth's embroidery see F. H. Newbery, 'An Appreciation of the Work of Ann Macbeth' in *Studio*, 1902, pp.40–47.

98. Ann Macbeth to Francis Newbery, 20 May 1910, Glasgow School of Art Archives.

99. Macbeth was earning exactly the same amount as her counterpart in the Metalwork Department, P. Wylie Davidson. By 1914, she was earning more than Davidson – she earned £220 per year, Davidson, £175.

100. Macbeth was a supporter of the Society even though the group, as a whole, refused to assume an active role in support of the suffrage movement. In 1907, for example, the Society refused to allow 'a memorial in favour of women's enfranchisement lie on the Hall Table for signatures', Minutes of the Council, Glasgow Society of Lady Artists, 10 January 1907, Mitchell Library, Glasgow. It was unanimously agreed that the Society was non-political.

101. Ann Macbeth to John Groundwater, 11 May 1912. Glasgow School of Art Archives.

102. Rozsika Parker, *The Subversive Stitch: Embroidery and the Making of the Feminine*, 1989, p.197.

103. 'Society of Lady Artists', *Glasgow Herald*, 6 March 1888, p.6.

Chapter 4

1. An earlier version of this chapter was published in *Rural History: Economy, Society, Culture*, vol. 8, no. 2, 1997, pp.149–64.

2. This is not intended to romanticize the concept of 'clan'. As T. M. Devine wrote, 'dominant families liked to trace their origin from a heroic figure of antiquity in order to give prestige, status and legitimacy to their position while at the same time providing the ordinary clansman with a common sense of identity with the elite. Most of these pedigrees were created and

recreated with scant regard for historical accuracy'. T. M. Devine, *Clanship to Crofters' War: The Social Transformation of the Scottish Highlands*, 1994, p.7.

3. The stone remains of Ardencaple Castle can be found in Helensburgh, a Scottish town whose quiet streets lead uphill away from the North Clyde Estuary. The stone remains of the castle are a short walk from the waterfront esplanade, almost hidden behind a naval housing estate (1957); parts of the castle probably date from the thirteenth century but most date from the eighteenth century. The large, imposing building once stood upon vast grounds, housing the chief of the Clan MacAuley (or Macaulay).

4. Eric Richards, *A History of the Highland Clearances: Agrarian Transformation and the Evictions 1746–1886*, 1982, p.484.

5. T. M. Devine, *Exploring the Scottish Past: Themes in the History of Scottish Society*, 1995, pp.165–6.

6. See for example, *Turner in Scotland*, Aberdeen Art Gallery, 1982; and Gerald Finley, *Landscapes of Memory: Turner as Illustrator to Scott*, Berkeley: Berkeley University Press, 1980.

7. Andrew Hemingway, *Landscape Imagery and Urban Culture in Early Nineteenth-Century Britain*, 1992, p.7.

8. Minutes of the Scottish Society of Water Colour Painters, 21 December 1877. I thank Roger Frame, Glasgow for giving me access to the Minutes of the Society. The Society formed as the Scottish Society of Water Colour Painters in 1878 and became the Royal Scottish Society of Painters in Water Colours in 1888.

9. *Glasgow Herald*, 19 January 1878, p.3.

10. *Glasgow Herald*, 19 January 1878, p.3.

11. For a complete history of the formation of the London societies, see S. Fenwick and G. Smith, *The Business of Watercolour: A Guide to the Archives of the Royal Watercolour Society*, 1997.

12. *Glasgow Herald*, 20 December 1879, p.3. The press rarely lost an opportunity to praise the Scottish artists at the expense of London ones; for example, in 1880, the 'London Water-colour Societies have nothing so luscious' as the pictures by John Gilmour Whyte (one of the founder-members of the Scottish Society). *Glasgow Herald*, 10 December 1880, p.5.

13. The *Queen*, for example, routinely announced the openings of the Scottish exhibition in its short column 'A letter from Edinburgh' which also covered music and the comings and goings of aristocrats and the upper classes. Leading journals such as the *Magazine of Art* and the *Art Journal* made only very short comments about Scottish exhibitions.

14. Pierre Bourdieu, 'The Field of Cultural Production, or: The Economic World Reversed' in *The Field of Cultural Production*, 1983, p.37.

15. *Glasgow Herald*, 12 January 1878, p.4.

16. *Glasgow Herald*, 31 October 1878, p.7.

17. *Glasgow Herald*, 2 February 1880, p.5.

18. *Glasgow Herald*, 6 February 1882, p.7.

19. Minutes of the Scottish Society of Water Colour Painters, 18 March 1878 and the *Glasgow Herald*, 5 April 1878, p.10. Francis Powell was President of the Society, Charles Blatherwick its treasurer. See also the catalogue of the *First Exhibition of the Scottish Society of Water Colour Painters, 1878*.

20. Minutes of the Scottish Society of Water Colour Painters, 18 March 1878 and 3 April 1878.

21. Simon Fenwick, 'An Outline of the History of the Royal Watercolour Society', *The Business of Watercolour: A Guide to the Archives of the Royal Watercolour Society*, 1997, pp.37–8.

22. The Society formed with 25 artists then added 13 associates for a total of 38 in their first year of organization. Minutes of the Scottish Society of Water Colour Painters, 29 December 1877 to 18 March 1878. There were to be no more than 40 members and 20 associates at any given time. The Society's rules of procedure stipulated that two-thirds of the members must approve the electing of an associate; thus, the female associates had secured the support of well over half of the male members of the group. Minutes of the Scottish Society of Water Colour Painters, 3 February 1879.

23. Georgina Greenlees participated in the organizational meetings chaired by her father and was originally designated a 'member'. Her status shifted when Francis Powell took over at first as Chair, then as the first President suggesting that he was not so predisposed to having women obtain equality within the fledgling Society. Robert Greenlees chaired the early meetings in

November and December 1877. By mid January, Francis Powell was 'called to the Chair'. The Minutes do not indicate why the change took place.

24. Pamela Gerrish Nunn, *Victorian Women Artists*, 1987, p.99.

25. *Glasgow Herald*, 9 April 1878, p.7. The exhibition opened on 8 April 1878 in Yuille's Gallery, 89 Union Street, Glasgow. The purpose of the exhibition was to obtain watercolour drawings 'direct from the studios of the artists'.

26. For further information about the Helensburgh painters see Ailsa Tanner, *Helensburgh and The Glasgow School*, 1972.

27. For a discussion of the terms 'amateur' and 'professional' as they apply to nineteenth-century watercolour painters, see S. Fenwick and G. Smith, 'Watercolour: purpose and practice', *The Business of Watercolour: A Guide to the Archives of the Royal Watercolour Society*, London: Ashgate, 1997, pp.1–34.

28. See Pierre Bourdieu, 'The Aristocracy of Culture', *Distinction: A Social Critique of the Judgement of Taste*, 1983.

29. *Glasgow Herald*, 8 October 1878, p.4. The private view was held on 1 November 1878.

30. *Glasgow Herald*, 31 October 1878, p.7.

31. Nicholas Morgan and Richard Trainor, 'The Dominant Classes' in W. H. Fraser and R. J. Morris, eds., *People and Society in Scotland, Vol. II, 1830–1914*, 1990, p.124.

32. *Glasgow Herald*, 5 February 1877, p.4.

33. *Glasgow Herald*, 15 February 1877, p.4.

34. *Glasgow Herald*, 15 March 1877, p.2.

35. ibid.

36. *Glasgow Herald*, 2 November 1878, p.4.

37. *Glasgow Herald*, 15 November 1878, p.3.

38. Minutes of the Scottish Society of Water Colour Painters, 21 October 1878 and 13 November 1878.

39. *Glasgow Herald*, 14 December 1878, p.7, and 28 December 1878, p.4.

40. *Art Journal*, April 1890, p.128.

41. Minutes of the Scottish Society of Water Colour Painters, 16 January 1879.

42. *Glasgow Herald*, 20 December 1879, p.3.

43. ibid.

44. Ross was one of three newly elected associate members; Pollock Nisbet and J. H. Lorimer were elected along with her. Minutes of the Scottish Society of Water Colour Painters, 2 February 1880, and *Glasgow Herald*, 3 February 1880, p.4.

45. Deborah Cherry, *Painting Women, Victorian Women Artists*, 1993, pp.165–74.

46. Allan I. Macinnes, 'Scottish Gaeldom: The First Phase of the Clearances', in T. M. Devine and Rosalind Mitchison, *People and Society in Scotland, Volume 1, 1760–1830*, 1988, p.70.

47. Those suffering the most, the Highland crofters and the urban poor, would not have seen these pictures but many members of the middle-classes would have been aware of the situation. See for example, Alexander Mackenzie's *History of the Highland Clearances* first published in 1883 or William Annan's photographs of Glasgow's destitute (1868–71).

48. E. Richards *A History of the Highland Clearances*, p.484.

49. N. Morgan and R. Trainor 'The Dominant Classes', p.124.

50. The Catalogue of the 1878 exhibition of the Scottish Society of Painters in Water Colours lists Greenlees's pictures *By the River Side, Callander, At the Roman Camp, Callander, Near to the River* among others.

51. Brochure produced by the Scottish Tourist Board, Edinburgh.

52. *Glasgow Herald*, 18 March 1878, p.8.

53. *Glasgow Herald*, 23 April 1878, p.4. Greenlees was also selling pictures from the exhibitions of the Glasgow Institute of the Fine Arts; in 1880 she sold *A Woodland Path* for £40 and *On the Moor*

Above Callander for £6 6s; she quite likely sold other pictures as well but this gives some indication of her income. Greenlees earned £25 a year as a student teacher at the Glasgow School of Art in 1872; her salary by 1876 had been raised to £40 per year (Governors' Minutes, Glasgow School of Art, 31 July 1872 and 5 October 1876). An annual average wage income in Glasgow in 1880 was £24; thus Greenlees was earning above average but she would have had to buy paints and supplies from her sales. For information on incomes in Scotland during the late nineteenth century, see Morgan and Trainor, op. cit. pp.103–37.

54. In June 1855 Elizabeth Patrick was employed as an assistant teacher at the Glasgow School of Art; her salary was £10 per year. In the autumn of 1861 she was appointed to the new 'special class for females', and by 1872 she was earning £40 per year (Governors' Minutes, Glasgow School of Art, 5 June 1855 and 29 November 1869). Obviously, like Greenlees, selling watercolour pictures supplemented her income, for example, in 1878 she sold *On the Kintyre Coast* for £20.

55. *Glasgow Herald*, 18 March 1878, p.8.

56. *Glasgow Herald*, 3 February 1879, p.4.

57. *Glasgow Herald*, 17 March 1879, p.4.

58. *Glasgow Herald*, 26 December 1878, p.7.

59. See the Catalogue for the 1880 exhibition.

60. *Glasgow Herald*, 10 April 1880, p.7. Two years later she sold what was probably a genre picture *The Village Belle* for £15 15s attesting to her ability to earn money with this kind of picture as well, *Glasgow Herald*, 19 October 1882, p.4. In 1883 she sold *The Favourite Air* for £30 and *After the Dance* for £25, *Glasgow Herald*, 6 February 1883, p.4 and 16 April 1883, p.6. During the 1880s she also became more known for her portraits probably because she took on more commissions upon leaving her teaching position.

61. Dorothy Wordsworth, *A Tour in Scotland in 1803*, Edinburgh: The Mercat Press, 1981. A facsimile of the 1894 edition published by David Douglas.

62. Elizabeth Bohls, *Women Travel Writers and the Language of Aesthetics 1716–1818*, 1995, p.195.

63. Elizabeth Helsinger, 'Turner and the Representation of England', W. J. T. Mitchell, *Landscape and Power*, Chicago: Chicago University Press, 1994, pp.105–6.

64. *Victoria in the Highlands: The Personal Journal of Her Majesty Queen Victoria*. With notes and Introductions by David Duff, 1968, Taymouth, Thursday, September 8 [1842], p.40.

65. Windsor Castle, 18 September 1842 and Blair Castle, 22 September 1844, ibid., p.26.

66. W. J. T. Mitchell, 'Imperial Landscape', in *Landscape and Power*, 1994, p.17.

67. Minutes of the Meeting of the Council of the Scottish Society of Water Colour Painters, 2 February 1880.

68. *Glasgow Herald*, 10 December 1880, p.5 and 22 September 1881, p.3.

69. She exhibited *A well in Tangier* in 1886, and *Gateway in the Alhambra* and *Court of the Myrtles in the Alhambra* in 1887.

70. *Scotsman*, 26 October 1885, p.4.

71. Anna S. F. Hardy, 'Fontarabbia [sic]', *Woman's World*, 1889, pp.127–30.

72. Amanda Vickery, 'Golden Age to Separate Spheres? A Review of the Categories and Chronology of English Women's History', *The Historical Journal*, vol. 36, no. 3, 1993, p.391.

73. The 1881 census shows Ross living with her parents in an eight-room flat at 78 Queen Street; valuation rolls for Edinburgh in the 1880s show Ross renting a studio in the same block of flats for £32 per year.

74. As indicated above Ross was in Spain in 1885 but in addition she seems to have spent much of 1887 in Europe. She exhibited only one picture in 1887 with the SSW, then the following year exhibited a number of pictures from the Netherlands, Belgium and Normandy. Her earliest visit to the Netherlands appears to have been in 1882 or 1883.

75. In the 1891 census Ross listed herself as 'neither employee nor employer, but working on own account'.

76. Macaulay also stated that she was related 'to the illustrious historian of that name', Thomas Babington Macaulay (Lord Macaulay). *Queen*, 8 May 1888, p.510.

77. Stuart Hall, 'Cultural Identity and Diaspora', J. Rutherford, ed., *Identity: Community, culture, difference*, 1990, p.223. My use of Hall does not suggest that I view Macaulay's experience as similar to/the same as the black diaspora.

78. Hector John Macaulay was posted to Melbourne, Australia when Kate Macaulay was about ten years old. Records of Officers and Soldiers, Commission Books, 1660–1873. Public Record Office, London.

79. John Irving, *Dumbartonshire County and Burgh: From the beginning of the Nineteenth Century to the present time*, 1924, p.436.

80. ibid., pp.437–41.

81. Kate Macaulay was a member of the London Society of Lady Artists from 1874 until at least 1896 during which time she exhibited regularly with them.

82. *Glasgow Herald*, 10 December 1880, p.5. For those who are unfamiliar with Scottish geography Tarbert is in Kintyre near Loch Fyne and Tarbet is a small town on Loch Lomond.

83. *Glasgow Herald*, 22 September 1881, p.7. During the 1870s and 1880s, Macaulay painted several pictures of Dunstaffnage Castle near Oban, Dunollie Castle, Oban and coastal scenes which often included Kerrera or the coastal cliffs of Argyllshire.

84. *Glasgow Herald*, 3 April 1882, p.9.

85. An 1887 estate sale in Oban listed three of her pictures. Thus, Macaulay had patrons in this area. *Catalogue of Valuable Pictures and other Effects belonging to the Sequestered Estate of James Nicol* (removed from Craigievar), 17 November 1887. I thank Murdo MacDonald, Archivist, Argyll and Bute District Council, for bringing this to my attention.

86. Minutes of the Scottish Society of Water Colour Painters, 23 December 1878.

87. *Glasgow Herald*, 20 December 1880, p.4.

88. Macaulay lived with her parents who in turn lived on Hector Macaulay's retirement pay. Macaulay was the sole inheritor of her father's estate (he died in 1896) which was valued at just over £2600. When Macaulay died in 1914 her estate was valued at almost precisely the same amount. The £28 I managed to track down would not represent all the sales she made; she may well have earned at least twice that much, definitely enough to supplement her income and provide supplies to continue painting.

89. Doreen Massey, *Space, Place and Gender*, 1994, p.5.

90. Greenlees married landscape painter Graham Kinloch Wylie in October 1885.

91. Gillian Rose, *Feminism and Geography: The Limits of Geographical Knowledge*, 1993, p.104.

Chapter 5

1. Mary Rose Hill Burton was born in Edinburgh 20 August 1857; she died in Rome 6 June 1900.

2. The castle belonged to the Roses of Kilravock and was the home of Burton's grandmother Isabella Rose until she married Cosmo Innes in 1826. Nora Geddes wrote about the panels painted in her parents' home by Burton: 'over the fireplace the pictures were the crocuses of early spring on the lawns of Kilrauk [sic] Castle'. Unpublished memoirs, National Library of Scotland, MS19266, f.26. I thank Belinda Thomson for telling me about the memoirs.

3. *Studio*, vol. 13, 1898, pp.48–9. For discussions of Patrick Geddes's vision for Edinburgh see Elizabeth Cumming, 'A "Gleam of Renaissance Hope": Edinburgh at the Turn of the Century' in W. Kaplan, ed., *Scottish Art and Design, 5000 Years*, 1991, and N. Gordon Bowe and E. Cumming, *The Arts & Crafts Movements in Dublin and Edinburgh*, 1998.

4. Ramsay Lodge, which became such an important part of Geddes's scheme for tenement re-development, had been owned by Thomas Innes, Katherine Burton's uncle. K. Burton, *Memoir of Cosmo Innes*, Edinburgh: William Paterson, 1874, p.15.

5. Florence Eliza Haig was born in Marylebone, London in 1855; she died in London in 1952.

6. In 1894 in a letter to Patrick Geddes, Burton wrote that she had given her 'tenth & last lesson in the School of Art yesterday', and in her discussion of one of the students wrote that the student had 'long been' a student of hers, suggesting that she had taught the student privately. Mary Rose Hill Burton to Patrick Geddes, 6 March 1894, Strathclyde University Archives, T-GED9/82.

7. Burton first exhibited with the Royal Scottish Academy in 1881. In 1885 she contributed a picture

done in Munich (*Alter Hof, München*) suggesting that she studied there during the winter of 1884–5 (she did not exhibit with the RSA in 1884).

8. Mary Rose Hill Burton, 'A Hedge School in Airaines, Picardy', *Scottish Art Review*, vol. 2, 1889, pp.135–8. Hedge school was a term used in nineteenth-century Ireland for groups of students meeting to study the Irish language.

9. *Artist*, 1897, p.208. According to the 1881 census Burton's half-sister Elizabeth was a wood engraver. As the census rarely included women's occupations it would seem that Elizabeth Burton worked for a printer or bookmaker; she did not exhibit pictures.

10. Viewforth, the area in which the Burtons lived, was comprised largely of tenements with flats, while Merchiston since the mid 1880s had been a favoured area for the building of villas. Katherine Burton owned 6 Montpelier Terrace which was rented out for £85 per year and 7 Montpelier Terrace in which the family lived.

11. See Katherine Burton, *A Memoir of Mrs. Crudelius*, 1879; printed for private circulation, Edinburgh. The Edinburgh Association differed from its Glaswegian counterpart in following strictly a university curriculum. Lecturers in Glasgow were not exclusively from the teaching faculty of the university. For a highly informative comment about the two associations, see 'The Higher Education of Women in Scotland', *Queen*, 10 October 1885, p.360.

12. *Reports of the Edinburgh Association for the University Education of Women*, Special Collections Library, University of Edinburgh.

13. Dora Meeson Coates, *George Coates, His Life and Work*, London: Dent, 1937, p.37. Florence Haig was one of Dora and George Coates's 'kindest friends'. I thank Gifford Lewis for telling me about Coates's biography.

14. Katherine Burton, *A Memoir of Mrs. Crudelius*, 1879.

15. Mary Burton was born in Aberdeen in 1819 and died there in 1909; she lived most of her adult life in Edinburgh. During the early 1890s she was president of the Edinburgh Women's Liberal Association. See, for example, *Scotsman*, 4 February 1890, p.4 and *Glasgow Herald*, 30 October 1894, p.4.

16. *Glasgow Herald*, 4 March 1881, p.6.

17. *Scotsman*, 19 March 1884, p.5.

18. *Glasgow Herald*, 20 November 1888, p.6. Mary Burton's association with union organization does not align her with radical working-class organization. As Gareth Stedman-Jones has suggested, 'The most well organized and articulate section of the working class, the skilled trade union movement, remained firmly under the hegemony of Gladstonian liberalism'. Gareth Stedman-Jones, 'History: The Poverty of Empiricism' in R. Blackburn, ed., *Ideology in Social Science: Readings in Critical Social Theory*, 1972, p.102. Burton's concerns were firmly connected with class and middle-classness.

19. See Janice Helland, 'Artistic Advocate: Mary Rose Hill Burton and the Falls of Foyers', *Scottish Economic and Social History*, Autumn 1997, pp.127–47.

20. Mary Burton presented the paper in 1877, *Glasgow Herald*, 22 September 1877, p.3.

21. E. R. Simpson, *The Clelands of Beaumont: A History of 26 Generations of a South Australian Family*, National Library of Scotland, Acc 9557, p.59. These lively but critical reminiscences uttered by John Hill Burton's daughter of his first marriage also attest to her dislike of her stepmother and her aunt. Matilda Lauder Burton married William Lennox Cleland in 1877 and moved to Australia.

22. 'Miss Burton and Destitute Children', Letter to the editor from M. Burton, *Scotsman*, 19 November 1886, p.6.

23. Katherine Burton to Patrick Geddes, 1895, Strathclyde University Archives, T-GED9/1991/2.

24. Sarah A. Tooley, 'A Slum Landlady: An Interview with Miss Mary Hill Burton', *Young Woman*, vol. IV, October 1895, p.164. I thank Mary Gordon for bringing this interview to my attention.

25. ibid., p.167.

26. Mary Rose Hill Burton and Anna Geddes attended activist Margaret Irwin's 1894 lecture about the economic position of women and spoke at the event, but how strident or active Hill Burton was in political circles remains unknown; see the *Glasgow Herald*, 2 November 1894, p.4.

27. James Haig was a barrister-at-law of Lincoln's Inn, London. The house in Hartington Place

rented for £60 per year. The family may have moved to smaller quarters as the sisters married or to save money.

28. Cecilia Wolseley Haig left her estate to her two unmarried sisters; it was valued at £4539. Assuming that the older sisters already held similar assets, Florence Haig can be located securely in the upper middle class.

29. Amelia Paton Hill (1820–1904) kept her own studio near The Mound. She was also commissioned to sculpt the David Livingstone Monument which is located in East Princes Street Gardens.

30. Amanda Vickery, 'Golden Age to Separate Spheres? A Review of the Categories and Chronology of English Women's History', *Historical Journal*, vol. 36, no. 3, 1993, p.412.

31. *Scotsman*, 28 October 1889, p.8.

32. *Scotsman*, 24 November 1890, p.6.

33. Eric Hobsbawn, 'Mass-Producing Traditions: Europe, 1870–1914', in E. Hobsbawm and T. Ranger, eds, *The Invention of Tradition*, 1983, p.299.

34. ibid., p.3000.

35. D. Coates, *George Coates*, p.37.

36. Haig's father, James Haig, was born in Ireland and educated at Dublin University.

37. Edith Somerville and Violet Ross, *Through Connemara in a Governess Cart* (1893), 1990.

38. *Alphabetical Index to the Townlands and Towns of Ireland 1851*, 1861. Connemara, particularly the area around Clifden and Kylemore Abbey, is today an area of intense tourism.

39. *Artist*, 1897, p.208. In 1890 she exhibited *An Irish Potato Digger* and *By the Owenriff, Galway* with the RSA. *An Irish Potato Digger* was also exhibited with the Royal Society of British Artists in London in 1892/93; it was selling for £10 10s.

40. *Magazine of Art*, January 1893, p.xiv.

41. *Scotsman*, 25 March 1890, p.4.

42. *Scotsman*, 23 October 1890, p.7. In September Burton assisted with the organization of a demonstration 'in connection with the annual Convention of the Irish National League of Great Britain'. She was 'the only woman amongst many men on the committee'. *Scotsman*, 30 September 1890, p.7.

43. Review of the Annual Exhibition of the Edinburgh Ladies' Art Club, *Scotsman*, 24 November 1890, p.6.

44. *Keening* was exhibited in 1893 with the Walker Art Gallery (Liverpool) and the Royal Academy in London. In London, the picture was selling for £31 10s.

45. *Scotsman*, 26 December 1891, p.8.

46. Anna Parnell (1852–1911), who had studied in Dublin's Metropolitan School of Art, organized a famine relief fund in 1879 and helped found the Ladies' Land League in 1881; the League was disbanded by Parnell within a year. See R. F. Foster, *Modern Ireland, 1600–1972*, 1989, and Margaret Ward, *Maud Gonne: Ireland's Joan of Arc*, 1990.

47. *Scotsman*, 14 November 1894, p.6. The exhibition was held at Wilson's Fine Arts Gallery, 121 George Street.

48. Lorraine Code, *Rhetorical Spaces: Essays on Gendered Locations*, New York: Routledge, 1995, p.ix.

49. Sally Alexander, *Becoming a Woman and Other Essays in 19th and 20th Century Feminist History*, 1994, p.88.

50. William Burton (1856–99) was one of a number of British engineers working in Japan; he taught engineering to Japanese students (in English) at the Imperial College of Engineering. The practice of hiring British-trained engineers began in 1873 after Glaswegian Henry Dyer was hired to head the then new Imperial College of Engineering. See, for example, *Art for Industry: The Glasgow Japan Exchange of 1878*, Glasgow Museums and Art Galleries, 1991.

51. Meg Wright, a colleague of Haig's and Burton's, exhibited her untraced picture of a bondager with the Edinburgh Ladies' Art Club in 1894. Wright's *Harvester* depicted a young woman gathering 'grass to her feet with a wooden rake' in an East Lothian landscape 'in which the harvester very naturally takes her place'. *Scotsman*, 14 November 1894, p.6.

52. Linda Nochlin, 'The Imaginary Orient', *The Politics of Vision: Essays on Nineteenth-Century Art and Society*, 1989, p.35.

53. 'The artist as ethnographer: Holman Hunt and the Holy Land', M. Pointon, ed., *Pre-Raphaelites reviewed*, Manchester: Manchester University Press, 1989, pp.26–7.

54. ibid., p.30.

55. *Artist*, May 1896, p.208.

56. M. R. Hill Burton, 'Photography and Colour-Printing in Japan', *Studio*, September 1898, pp.245–54.

57. *Christie's Scotland: Fine Paintings and Drawings*, 28 April 1987, reproduced this picture as *Japanese girls fishing in a terraced garden* but the 1896 Clifford's Catalogue includes a small pencil sketch made by the original owner of the catalogue that clearly identifies the picture as *Fishing under the Cherry Tree*, cat. 51.

58. Tani Kankan's eighteenth-century painting shows a woman in a small boat fishing under a knarled, old tree. Patricia Fister, *Japanese Women Artists 1600–1900*, 1988, p.94.

59. ibid., p.163.

60. ibid., pp.165–6.

61. ibid., p.167.

62. ibid., p.175.

63. Reproduced in *Christie's Scotland: Fine Paintings and Drawings*, 13 May 1993.

64. Sharon H. Nolte and Sally Ann Hastings, 'The Meiji State's Policy Toward Women, 1890–1910', in G. L. Bernstein, ed., *Recreating Japanese Women, 1600–1945*, 1991, p.153.

65. ibid., p.158.

66. ibid., p.157.

67. Mary Rose Hill Burton to Patrick Geddes, 20 February 1895. Strathclyde University Archives, T-GED9/114.

68. *Japan: The Land of Flowers*. Catalogue of a Collection of Water Colour Drawings by Miss M. R. Hill Burton. At the Clifford Galleries, 21 Haymarket, London, May and June, 1895.

69. Karen R. Lawrence, *Penelope Voyages: Women and Travel in the British Literary Tradition*, 1994, p.xii.

70. Will of Elizabeth Paton Burton (1848–1905), St. Joseph's Convent, Perth. Scottish Record Office, SC49/31/199.

71. Mary Rose Hill Burton to Patrick Geddes, 7 September 1894, Sapporo, Japan. National Library of Scotland, MS 10526 ff55–58.

72. I thank Jane Sellwood for the information about Hohheikan and for the tourist information she kindly sent to me.

73. Mary Rose Hill Burton to Patrick Geddes, 7 September 1894.

74. Tim Mason and Lynn Mason, *Helen Hyde*, 1991, p.17.

75. *Glasgow Evening News*, 17 March 1896, p.8.

76. Hornel and Henry were back in Glasgow by July 1894. *Glasgow Evening News*, 16 July 1894, p.2.

77. Mary Rose Hill Burton to Anna Geddes, Salerno, Italy, 26 May 1900. National Library of Scotland, MS 10577/ff304–7.

78. Letter to Anna Geddes from Caroline Carcano, Italy, 13 June 1900. National Library of Scotland, MS 10577/ff310–13. Burton died in Rome from what was thought to be a brain haemorrhage on 6 June 1900 and was buried in the Catholic Cemetery at San Lorenzo. Jeanne Curry in a letter to Anna Geddes (19 June 1900) wrote that 'for her life was a very lonely one, but she seemed so much better & had hopes for the future'. National Library of Scotland, MS10531/f257.

79. C. Gasquoine Hartley, 'The Paris Club for International Women Artists', *Art Journal*, September 1900, p.284.

80. *Globe and Mail*, 15 April 1996.

81. Hartley, op. cit., p.284.

82. Barbara Robertson, 'In Bondage: The Female Farm Worker in South-East Scotland', in E. Gordon and E. Breitenbach, eds, *The World Is Ill Divided: Women's work in Scotland in the Nineteenth and Early Twentieth centuries*, 1990, p.127. A local newspaper in Roxburghshire, the *Kelso Mail* reported that during the annual spring fairs in 1899, a ploughman with a woman worker could be offered '12s a week, cow, and 1600 yards of potatoes, dinner and supper'; a ploughman with

two women workers could be offered '13s per week, cow's keep, 1800 yards of potatoes'. Contrasted to this, women workers might be offered '1s 6d a day, the year through, with 3s for twenty days in harvest'. The March fairs reported were in Kelso, Langholm, Hawick, Alnwick, Wooler and Rothbury. *Kelso Mail*, 8 March 1899, p.6.

83. This figure was for the latter part of the nineteenth century. 'Stalwarts of the domestic routine', *Scottish Farmer*, 1 October 1994.

84. Eleanor Gordon, 'Women's Spheres', in W. H. Fraser and R. J. Morris, *People and Society in Scotland, 1830–1914*, 1990, p.214.

85. T. M. Devine, 'Women Workers, 1850–1914', *Farm Servants and Labour in Lowland Scotland, 1770–1914*, 1984, pp.99–103, and R. A. Houston, 'Women in the economy and society', in R. A. Houston and I. D. Whyte, *Scottish Society, 1500–1800*, 1989, p.121.

86. *Kelso Mail*, 22 March 1899, p.5.

87. Devine, op. cit., pp.100, 102. While bondaging went into decline in the 1860s, it persisted in Berwick and Roxburgh, and some aspects of it survived until 1914.

88. As quoted in Devine, op. cit., p.101.

89. As quoted in Devine, op. cit., p.119.

90. *Kelso Mail*, 8 February 1899, p.5.

91. Liz Taylor, 'Women in Bondage', *Scotsman*, 8 September 1986. Clipping in the Scottish Ethnographic Museum, Edinburgh.

92. 'The days of the bondager: Liz Taylor interviews Mary Rutherford', *Scotsman*, 5 July 1978. Clipping in the Scottish Ethnographic Museum, Edinburgh.

93. Liz Taylor, 'To Be a Farmer's Girl . . . Bondagers of Border Counties', *Country Life*, 12 October 1978, p.1110.

94. Sue Glover as quoted in Jo Roe, 'Using their imagination to free the bondagers', *Scotsman*, 3 May 1991, p.19.

95. Keith Bruce, 'The Bondagers, Tramway, Glasgow', *Glasgow Herald*, 4 May 1991, p.8.

96. Kate Taylor, 'Of human bondage, Scottish style', *Globe and Mail*, 15 April 1996.

Chapter 6

1. *Scotsman*, 9 August 1901, p.6, and the *Glasgow Herald*, 2 June 1910, p.7.

2. The Spanish term for the 'bullfight' is *la corrida de toros* or the 'running of the bulls'. According to Garry Marvin, in Spain 'there is no sense of men fighting – as engaged in a physical struggle – with the bull'. G. Marvin, 'Violence in the Spanish Bullfight' in D. Riches, ed., *The Anthropology of Violence*, 1986, p.132.

3. *Art Journal*, 1909, p.95.

4. *Queen*, 18 June 1910, p.1100.

5. *Haddingtonshire Courier*, 1 July 1910, p.3.

6. In conversation with Alan Cameron, Oban, October 1995.

7. Mary Margaret Cameron was born 9 March 1865 in Portobello and died 15 February 1921 at Turnhouse just outside Edinburgh. She was the third oldest of six children born to Mary Brown Small Cameron and Duncan Cameron.

8. *Scotsman*, 28 October 1889, p.8.

9. See for example, the *Scots Pictorial*, 29 November 1902, p.177.

10. *Scotsman*, 3 March 1890, p.7.

11. Elihu Rich, *A Popular History of the Franco-German War, Vol. II*, London: James Hagger, *c*.1874, p.436.

12. Cameron resigned from the Women's International Art Club in 1908.

13. I thank the Cameron family for their willingness to provide me with information about Mary Cameron. She studied under Courtois and Rixen in Paris, *Glasgow Herald*, 22 June 1910, p.7.

14. Cameron exhibited *J. W. J. Paterson Esq., Terrona, Master, Eskdaill Hounds* with the RSA in 1899.

15. *Ladies' Field*, 30 April 1898, p.287.

16. Letter to Mary Cameron from Alexander Roche, 6 July 1898. Private collection. The portrait of Professor A. E. Mettam, Professor of Anatomy and Histology at the Royal Dick Veterinary College was also exhibited with the Glasgow Institute of the Fine Arts in 1899.

17. James Caw to Mary Cameron, Paris, 13 June 1904. Private collection. Cameron was awarded an Honorable Mention in the Paris Salon of 1904 for a large portrait of her sister, Flora Cameron with her two Russian borzois.

18. 'Miss Mary Cameron: Work of a Woman Artist in Spain', *Westminster Gazette*, 14 June 1910, p.12.

19. *Scotsman*, 4 August 1887, p.5. Interest in the fishwives grew when the colourfully-dressed 'yellow butterflies' participated in the London Fisheries Exhibition in the Crystal Palace in 1883; Queen Victoria invited eighteen of the Newhaven women to Windsor Castle. Because of the attention they attracted 'for a short while, their dress became a fashion copied in silks and satins by enthusiastic young ladies all over the country'. See, Tom McGowran, *Newhaven-on-Forth: Port of Grace*, 1985, p.23.

20. Janet Cadell as quoted in McGowran, ibid., pp.25–6.

21. ibid., p.25.

22. *Glasgow Herald*, 22 September 1877, p.3.

23. *Scots Pictorial*, 24 December 1898.

24. The picture also might be *Hurst Park Races* which sold in auction in 1990 for £12,500.

25. *Art Journal*, vol. 52, 1900, p.127.

26. *Scots Pictorial*, 29 November 1902, p.177.

27. *Ladies' Field*, 20 July 1901, p.96.

28. *Queen*, 18 June 1910, p.1101.

29. *Scotsman*, 20 August 1901, p.7.

30. Unidentified press clipping in Mary Cameron's 'clipping book'. Private collection. See also, *Scotsman*, 20 August 1901, p.7.

31. *Glasgow Herald*, 9 July 1901, p.6, and the *Scotsman*, 9 July 1901, p.8.

32. *Sphere*, 31 August 1901, p.ii

33. *Scotsman*, 9 July 1901, p.8.

34. José Bergamín as quoted in Timothy Mitchell, *Blood Sport: A Social History of Spanish Bullfighting*, 1991, p.7.

35. Letter from George Hay to Mary Cameron, 6 February 1901. Private collection. Cameron exhibited *Matador, Madrid* with the RSA that year.

36. Meg Wright, a former colleague from the Edinburgh Ladies' Art Club, and Phoebe Traquair both were denied membership at the same time. *Studio*, May 1901, p.282.

37. Review of the Royal Scottish Academy's Exhibition, *Scotsman*, 3 March 1902, p.9.

38. Letter to the Editor from James Halden, Edinburgh, 9 March 1903, *Glasgow Herald*, 10 March 1903, p.7.

39. Letter to the Editor from J. Boyd, London, 10 March 1903, *Glasgow Herald*, 13 March 1903, p.9.

40. *Glasgow Herald*, 22 June 1910, p.7.

41. *Sol y Sombra*, 20 November 1902. I am grateful to Marco Topalian for his thoughtful translation of this text.

42. *Scotsman*, 29 November 1902, p.6.

43. *Ladies' Field*, 20 July 1901, p.96, and the *Glasgow Herald*, 22 June 1910, p.7.

44. Cameron spoke French and Spanish fluently and colloquially, she had a good knowledge of German and Italian and she learned enough Russian to be able to read and translate. I thank the Cameron family for this information.

45. James Clifford, *The Predicament of Culture: Twentieth-Century Ethnography, Literature, and Art*, 1988, p.9.

46. ibid., p.23.

47. Mary Cameron as quoted in the *Westminster Gazette*, 14 June 1910, p.12.

48. *Edinburgh Magazine*, 31 October 1908, p.12.

49. ibid. Cameron had forty-four pictures in the solo exhibition in Edinburgh and although there were numbers of portraits and landscapes, it was the Spanish pictures that attracted the most attention. The French Gallery was located at 131 Princes Street; the exhibition was open from 26 October to 14 November 1908.

50. *Westminster Gazette*, 14 June 1910, p.12.

51. Carrie B. Douglas, *Bulls, Bullfighting, and Spanish Identities*, 1997, p.5.

52. ibid., p.3.

53. After the mid 1850s, when the railway made Spain more accessible, numbers of European and American artists made their way to this 'colourful' country. In January 1999 an exhibition opened in the United States which celebrated the American artistic 'invasion' of Spain: *España: American Artists and the Spanish Experience*, New Britain Museum of American Art, New Britain, Connecticut.

54. *Haddingtonshire Courier*, 6 November 1908, p.2. Mary Cameron and her husband Alexis Millar were living in a family home, Waverley House, Gullane, when this review was written.

55. *Dundee Advertiser*, 27 October 1908, p.2.

56. *Evening Standard and St. James Gazette*, 6 June 1910, p.7.

57. *Queen*, 18 June 1910, pp.1100–1101.

58. *Daily Telegraph*, 17 June 1910, p.15.

59. *The Times*, 5 June 1910, p.15.

60. *Sol y Sombra*, 20 November 1902.

61. *Haddingtonshire Courier*, 1 July 1910, p.3.

62. T. Mitchell, *Blood Sport*, pp.3–4.

63. ibid., p.4.

64. For a discussion of the gendered identification of the sublime and the beautiful see, for example, C. Battersby, *Gender and Genius: Towards a Feminist Aesthetics*, 1989 or L. Nead, *The Female Nude: Art, Obscenity and Sexuality*, 1992.

65. *Westminster Gazette*, 14 June 1910, p.12.

Chapter 7

1. *Scots Pictorial*, 15 November 1902, p.136.

2. *Glasgow Evening News*, 2 August 1911, p.3. This is one of a series of photographs of 'Artists in their Studios' published by the Glasgow Evening News in 1910 and 1911; many of the pictures were of women.

3. Crawford studied at the Glasgow School of Art between 1881 and 1888; she taught there from 1894 to 1914. She had recurring cancer during the last years of her life which probably accounted for her resignation from teaching.

4. Crawford was exhibiting with the Royal Society of Painter-Etchers by 1893; in 1894 she became an associate member of the Society exhibiting regularly until 1910.

5. *Glasgow Herald*, 17 October 1908, p.3.

6. *Glasgow Herald*, 16 October 1909, p.11. Crawford did travel to Europe but she did not spend as much time there as Paterson. An earlier exhibition contained Paterson's *An Old Dutch Waterway* which, according to the critic, was 'charged with a spirit of the picturesque Low Country' and Crawford's 'admirably composed' *Loch Leven Castle*. *Glasgow Herald*, 13 October 1906, p.3.

7. *Glasgow Herald*, 4 March 1911, p.9.

8. R. Barthes, *Michelet*, trans. R. Howard, 1987.

9. A. Rich, 'Resisting Amnesia: History and Personal Life' (1983), in *Blood, Bread and Poetry, Selected Prose, 1979–1985*, 1986, p.145.

10. ibid., p.146.

11. ibid., p.155.

12. Edna O'Brien, *House of Splendid Isolation*, London: Orion Books, 1994, p.3.

Bibliography

Unpublished papers

Archive of Art and Design, Arts and Crafts Exhibition Society, Minutes of the Society and Exhibition Catalogues.
General Registry Office, Edinburgh, Census of Scotland.
Glasgow School of Art, Board of Governors' Minutes.
Glasgow School of Art, the letters of Ann Macbeth.
Glasgow School of Art, School of Art Annual Reports.
Mitchell Library, Glasgow, Glasgow Institute of the Fine Arts, Sales Records and Exhibition Catalogues.
Mitchell Library, Glasgow, Minutes of the Council, Glasgow Society of Lady Artists.
National Art Library, Royal Society of Painter-Etchers, Catalogues for the exhibitions, 1890–1910.
National Library of Scotland, Mary Rose Hill Burton correspondence, Special Collections.
Public Record Office, London, Censuses of England and Wales.
Public Record Office, London, Records of Officers and Soldiers, Commission Books, 1660–1873.
Scottish Life Archive, National Museum of Scotland.
Scottish Record Office, Board of Manufactures, Minutes of the Trustees of the Board.
Scottish Record Office, Valuation Rolls for Edinburgh and Glasgow.
Scottish Society of Water Colour Painters, Glasgow, Minutes of the Society and Exhibition Catalogues.
Special Collections, University of Edinburgh, Edinburgh Association for the University Education of Women, Minutes and Record Books.
Strathclyde University, Glasgow, Patrick Geddes Papers.

Newspapers and journals

Source information for references cited in the text is given fully in the accompanying notes.

Apollo

Art Journal

Art Monthly

Artist

Arts Review

Books in Scotland

Boundary 2

Costume

Country Life

Courant (Edinburgh)

Daily Review (Edinburgh)

Daily Telegraph (London)

Dundee Advertiser

Embroidery

Evening Standard and St James Gazette

Gentlewoman

Glasgow Evening News

Glasgow Herald

Globe and Mail (Toronto)

Haddingtonshire Courier

Historical Journal

Independent

Journal of Art and Design Education

Kelso Mail

Ladies' Field

Magazine of Art

New York Review of Books

Observer

Paisley and Renfrewshire Gazette

Pall Mall Gazette

Queen

Quiz

Scots Pictorial

Scotsman

Scottish Art Review

Sol y Sombra (Madrid)

Sphere

Stirling and Journal Advertiser

Studio

The Ladies' Pictorial

The Times

Vote

Westminster Gazette

Woman's Art Journal

Woman's World

Young Woman

Books and Articles

Aberdeen Art Gallery, *Turner in Scotland*, 1982.

Adams, A., ' "Archi-ettes" in Training: The Admission of Women to McGill's School of Architecture', *Society for the Study of Architecture in Canada Bulletin*, September 1996, pp.70–73.

Alexander, S., *Becoming a Woman and Other Essays in 19th and 20th Century Feminist History*, London: Virago, 1994.

Alphabetical Index to the Townlands and Towns of Ireland 1851, Dublin 1861.

Art for Industry: The Glasgow Japan Exchange of 1878, Glasgow: Glasgow Museums, 1991.

Barrell, J., *The Dark Side of the Landscape: The Rural Poor in English Painting 1730–1840*, Cambridge: Cambridge University Press, 1980.

Barrett, M. and A. Phillips, eds, *Destabilizing Theory: Contemporary Feminist Debates*, Cambridge: Polity Press, 1992.

Barthes, R., *Michelet*, trans. R. Howard, New York: Wang and Hill, 1987.

Battersby, C., *Gender and Genius: Towards a Feminist Aesthetics*, Bloomington, Indiana: Indiana University Press, 1989.

Beckett, J. and D. Cherry, eds, *The Edwardian Era*, Oxford: Phaidon, 1987.

Bernstein, G. L., ed., *Recreating Japanese Women, 1600–1945*, Berkeley: University of California Press, 1991.

Blackburn, R., ed., *Ideology in Social Science: Readings in Critical Social Theory*, London: Fontana, 1972.

Bohls, E., *Women Travel Writers and the Language of Aesthetics, 1716–1818*, Cambridge: Cambridge University Press, 1995.

Bourdieu, P., *The Field of Cultural Production*, trans. R. Johnson, New York: Columbia University Press, 1983.

—, 'The Aristocracy of Culture', *Distinction: A Social Critique of the Judgement of Taste*, 1983.

Bowe, N. Gordon and E. Cumming, *The Arts & Crafts Movements in Dublin and Edinburgh*, Dublin: Irish Academic Press, 1998.

Braidotti, R., *Nomadic Subjects: Embodiment and Sexual Difference in Contemporary Feminist Theory*, New York: Columbia University Press, 1994.

Breitenbach, E. and E. Gordon, eds, *Out of Bounds: Women in Scottish Society 1800–1945*, Edinburgh: Edinburgh University Press, 1992.

Bruce, K., *Self-Portrait of An Artist*, London: John Murray, 1949.

Burkhauser, J., ed., *'Glasgow Girls': Women in Art and Design, 1880–1920*, Edinburgh: Cannongate, 1990.

Burton, K., *A Memoir of Cosmo Innes*, Edinburgh: William Paterson, 1874.

—, *A Memoir of Mrs. Crudelius*, 1879; printed for private circulation, Edinburgh.

Caine, B., *English Feminism, 1780–1980*, Oxford: Oxford University Press, 1997.

Carruthers, A., ed., *The Scottish Home*, Edinburgh: National Museums of Scotland, 1996.

Chadwick, W., *Women, Art and Society*, London: Thames and Hudson, 1990.

Cherry, D., 'Women Artists and the Politics of Feminism', Campbell, C., ed., *Women in the Victorian Art World*, Manchester: Manchester University Press, 1995.

—, *Painting Women: Victorian Women Artists*, London: Routledge, 1993.

Clifford, J., *The Predicament of Culture: Twentieth-Century Ethnography, Literature, and Art*, Cambridge, Massachusetts: Harvard University Press, 1988.

Coates, D. M., *George Coates, His Life and Work*, London: Dent, 1937.

Code, L., *Rhetorical Spaces: Essays on Gendered Locations*, New York: Routledge, 1995.

Crawford, A., *Charles Rennie Mackintosh*, London: Thames and Hudson, 1995.

Davidoff, L., *Worlds Between: Historical Perspectives on Gender and Class*, London: Routledge, 1995.

Davis, T., *Actresses as Working Women: Their Social Identity in Victorian Culture*, London: Routledge, 1991.

de Laperrière, C. B., ed., *The Society of Women Artist Exhibitors*, Calne, Wiltshire: Hilmarton Minor Press, 1996.

Devine, T. M., and R. Mitchison, eds, *People and Society in Scotland, Volume I, 1760–1830*, Edinburgh: John Donald Publishers, 1994.

Devine, T. M., *Farm Servants and Labour in Lowland Scotland, 1770–1914*, Edinburgh: J. Donald, 1984.

—, *Exploring the Scottish Past: Themes in the History of Scottish Society*, East Linton: Tuckwell Press, 1995.

—, *Clanship to Crofters' War: The Social Transformation of the Scottish Highlands*, Manchester: Manchester University Press, 1994.

Douglas, C. B., *Bulls, Bullfighting, and Spanish Identities*, Tucson: University of Arizona Press, 1997.

Doy, G., *Seeing and Consciousness: Women, Class and Representation*, Oxford: Berg, 1995.

Ehrlich, C., *The Music Profession in Britain since the Eighteenth Century*, Oxford: Clarendon Press, 1985.

Fenwick, S. and G. Smith, *The Business of Watercolour: A Guide to the Archives of the Royal Watercolour Society*, London: Ashgate, 1997.

—, 'Watercolour: purpose and practice', *The Business of Watercolour: A Guide to the Archives of the Royal Watercolour Society*, London: Ashgate, 1997.

Finley, G., *Landscapes of Memory: Turner as Illustrator to Scott*, Berkeley: University of California Press, 1980.

Fister, P., *Japanese Women Artists 1600–1900*, Lawrence, Kansas: Spencer Museum of Art, 1988.

Fraser, W. H., and R. J. Morris, eds, *People and Society in Scotland, Volume II, 1830–1914*, 1990.

Garb, T., *Sisters of the Brush: Women's Artistic Culture in Late Nineteenth-Century Paris*, New Haven and London: Yale University Press, 1994.

Gomersall, M., *Working Class Girls in Nineteenth-Century England*, London: Macmillan, 1997.

Gordon, E., 'Women's Spheres' in Fraser, W. H. and R. J. Morris, eds, *People and Society in Scotland, Vol. II, 1830–1914*, Edinburgh: John Donald, 1990.

Gordon, E. and E. Breitenbach, eds, *The World is Ill Divided: Women's Work in Scotland in the Nineteenth and Early Twentieth Centuries*, Edinburgh: Edinburgh University Press, 1990.

Green, L., *Music, Gender and Education*, Cambridge: Cambridge University Press, 1997.

Hall, C., *White, Male and Middle-Class: Explorations in Feminism and History*, New York: Routledge, 1992.

Hall, S., 'Cultural Identity and Diaspora', in Rutherford, J., ed., *Identity: Community, culture, difference*, London: Lawrence & Wishart, 1990.

Harris, J., 'Embroidery in Women's Lives 1300–1900', *The Subversive Stitch*, Manchester: Whitworth Art Gallery and Cornerhouse, 1988.

Helland, J., *The Studios of Frances and Margaret Macdonald*, Manchester: Manchester University Press, 1996.

—, 'Artistic Advocate: Mary Rose Hill Burton and the Falls of Foyers', *Scottish and Social History*, Autumn 1997, pp.127–47.

Helsinger, E., 'Turner and the Representation of England', Mitchell, W. J. T., ed., *Landscape and Power*, Chicago: Chicago University Press, 1994.

Hemingway, A., *Landscape Imagery and Urban Culture in Early Nineteenth-Century Britain*, Cambridge: Cambridge University Press, 1992.

Hennessy, R. and R. Mohan, 'The Construction of Woman in Three Popular Texts of Empire: Towards a Critique of Materialist Feminism', *Textual Practice*, Winter 1989, pp.323–37 and 354–7.

Hobsbawn, E. and T. Ranger, *The Invention of Tradition*, Cambridge: Cambridge University Press, 1983.

Houston, R. A. and I. D. Whyte, *Scottish Society, 1500–1800*, Cambridge: Cambridge University Press, 1989.

Hunt, L., ed., *The New Cultural History*, San Francisco: Berkeley University Press, 1989.

Irving, J., *Dumbartonshire County and Burgh: From the beginning of the nineteenth century to the present time*, Dumbarton: Bennett & Thomson, 1924.

Kaplan, W., ed., *Scottish Art and Design, 5000 Years*, New York: Harry N. Abrams, 1991.

—, ed., *Charles Rennie Mackintosh*, New York: Abbeville Press, 1996.

King, E., *The Strike of the Glasgow Weavers 1787*, Glasgow: Glasgow Museums and Art Galleries, 1987.

Lawrence, K., *Penelope Voyages: Women and Travel in the British Literary Tradition*, Ithaca, N. Y. and London: Cornell University Press, 1994.

Leeson, R. A., *Travelling Brothers: The Six Centuries' Road from Craft Fellowship to Trade Unionism*, London: G. Allen & Unwin, 1979.

Leneman, L., *A Guid Cause: The Women's Suffrage Movement in Scotland*, Aberdeen: Aberdeen University Press, 1991.

Levey, S. M., *Discovering Embroidery of the 19th Century*, Aylesbury, Bucks.: Shire Publications, 1977.

Macfarlane, F. C., and E. F. Arthur, *Glasgow School of Art Embroidery 1894–1920*, Glasgow: Glasgow Museums and Art Galleries, 1980.

Macinnes, A. I., 'Scottish Gaeldom: The First Phase of the Clearances', in Devine T. M. and R. Mitchison, eds, *People and Society in Scotland, Volume 1, 1760–1830*, Edinburgh: John Donald, 1988.

Mackenzie, A., *History of the Highland Clearances*, 1st published 1883, Edinburgh: The Mercat Press, 1991.

Mackenzie, T., ed., *Art Schools of London*, London: Chapman & Hall, 1895.

Mason, T. and L. Mason, *Helen Hyde*, Washington: Smithsonian Institution Press, 1991.

Massey, D., *Space, Place and Gender*, Minneapolis: University of Minnesota Press, 1994.

Mavor, E., *The Ladies of Llangollen*, Harmondsworth, Middlesex: Penguin Books, 1971.

McGowran, T., *Newhaven-on-Forth: Port of Grace*, Edinburgh: John Donald Publishers, 1985.

Mills, S. and L. Pearce, eds, *Feminist Readings/Feminists Reading*, Hemel Hempstead: Prentice Hall, 1996.

Mitchell, J. and A. Oakley, eds, *The Rights and Wrongs of Women*, Harmondsworth, Middlesex: Penguin, 1976.

Mitchell, T., *Blood Sport: A Social History of Spanish Bullfighting*, Philadelphia: University of Pennsylvania Press, 1991.

Mitchell, W. J. T., ed., *Landscape and Power*, Chicago: University of Chicago Press, 1994.

Moon, K., *George Walton: Designer and Architect*, Oxford: White Cockade, 1993.

Nead, L., *The Female Nude: Art, Obscenity and Sexuality*, London: Routledge, 1992.

Neat, T., *Part Seen, Part Imagined: Meaning and Symbolism in the Work of Charles Rennie Mackintosh and Margaret Macdonald*, Edinburgh: Canongate, 1994.

Nenadic, S., 'The Rise of the Urban Middle Class' in Devine, T. M. and R. Mitchison, eds, *People and Society in Scotland, Volume 1, 1760–1830*, Edinburgh: John Donald, 1994.

Newbery, F. H., 'An Appreciation of the Work of Ann Macbeth', *Studio*, 1902, pp.40–47.

Nochlin, L., *The Politics of Vision: Essays on Nineteenth-Century Art and Society*, New York: Harper & Row, 1989.

—, *Women, Art, and Power and Other Essays*, New York: Harper & Row, 1988.

Nunn, P. G., *Victorian Women Artists*, London: The Women's Press, 1987.

Oban. *Catalogue of Valuable Pictures and other Effects belonging to the Sequestered Estate of James Nicol*, 1887.

O'Brien, E., *House of Splendid Isolation*, London: Orion Books, 1994.

O'Connor, P., *Friendships Between Women: A Critical Review*, Hemel Hempstead: Harvester Wheatsheaf, 1992.

Orr, C. Campbell, ed., *Women in the Victorian Art World*, Manchester: Manchester University Press, 1995.

Paret, P., *The Berlin Secession: Modernism and its Enemies in Imperial Germany*, Cambridge, Massachusetts: Harvard University Press, 1980.

Parker, R., *The Subversive Stitch: Embroidery and the Making of the Feminine*, London: Routledge, 1989.

Patrick, A., 'Boy Trouble: Some Problems Resulting from "Gendered" Representation of Glasgow's Culture in the Education of Women Artists and Designers', *Journal of Art and Design Education*, vol. 16, no. 1, 1997, pp.7–16.

Pears, I., *The Discovery of Painting: The Growth of Interest in the Arts in England, 1680–1768*, New Haven and London: Yale University Press, 1988.

Perrot, M., ed., *A History of Private Life: From the Fires of Revolution to the Great War*, Cambridge, Massachusetts: Harvard University Press, 1990.

The Poems of Henry Wadsworth Longfellow 1823–1866 with an introduction by K. Tynan, London: J. M. Dent & Sons, 1930.

Pointon, M., 'The artist as ethnographer: Holman Hunt and the Holy Land', in Pointon, M., ed., *Pre-Raphaelites reviewed*, Manchester: Manchester University Press, 1989.

—, ed., *Art Apart: Art Institutions and Ideology across England and North America*, Manchester: Manchester University Press, 1994.

—, *Strategies for Showing: Women, Possession, and Representation in English Visual Culture 1665–1800*, Oxford: Oxford University Press, 1997.

Pollock, G., *Vision and Difference: Femininity, Feminisms and the Histories of Art*, New York: Routledge, 1988.

Poovey, M., *Uneven Developments: The Ideological Work of Gender in Mid-Victorian England*, Chicago: Chicago University Press, 1988.

Prochaska, F. K., *Women and Philanthropy in 19th Century England*, Oxford: Oxford University Press, 1980.

Rawson, G., *Fra H. Newbery: Artist and Art Educationist 1855–1946*, Glasgow: Glasgow School of Art, 1996.

Rich, A., *Blood, Bread and Poetry, Selected Prose 1979–1985*, London: W. W. Norton, 1986.

Rich, E., *A Popular History of the Franco-German War, Vol. II*, London: James Hagger, c.1874.

Richards, E., *A History of the Highland Clearances: Agrarian Transformation and the Evictions 1746–1886*, London: Croom Helm, 1982.

Riches, D., ed., *The Anthropology of Violence*, Oxford: Basil Blackwell, 1986.

Rose, G., *Feminism and Geography*, Oxford: Polity Press, 1993.

Scott, J. W., *Gender and the Politics of History*, New York: Columbia University Press, 1988.

Self-Portrait of an Artist: From the Diaries and Memoirs of Lady Kennet, London: John Murray, 1949.

Simon, R., *Gramsci's Political Thought*, London: Lawrence & Wishart, 1991.

Smith, B., *D. Y. Cameron: The Visions of the Hills*, Edinburgh: Atelier Books, 1992.

Solkin, D. H., *Painting for Money: The Visual Arts and the Public Sphere in Eighteenth-Century England*, New Haven and London: Yale University Press, 1993.

Stirling Fine Art Association for the Exhibition, 1894.

Tanner, A., *A Centenary Exhibition to Celebrate the Founding of the Glasgow Society of Lady Artists in 1882*, Glasgow: Collins Gallery, 1982.

—, *Helensburgh and The Glasgow School*. Helensburgh: Helensburgh and District Art Club, 1972.

Thompson, E. P. *William Morris: Romantic to Revolutionary*, New York: Pantheon Books, 1976.

—, *The Making of the English Working Class*, Harmondsworth, Middlesex: Penguin, 1991.

Tickner, L., 'Feminism, Art History, and Sexual Difference', *Genders, 3*, Fall 1988, pp.92–128.

Toulmin Smith, L. 'Introduction' to Toulmin Smith, *English Gilds*, London: N. Trübner & Co., 1870.

Vicinus, M., *Independent Women: Work and Community for Single Women, 1850–1920*, Chicago: University of Chicago Press, 1985.

Vickery, A., 'Golden Age to Separate Spheres? A Review of the Categories and Chronology of English Women's History', *Historical Journal*, vol. 36, no. 3, 1993, pp.383–414.

Victoria in the Highlands: The Personal Journal of Her Majesty Queen Victoria. With notes and Introductions by David Duff, 1968, Jaymouth, Thursday, September 8 [1842], p.40.

Vogel, L., 'Fine Arts and Feminism: The Awakening Consciousness', *Feminist Studies*, vol. 2, no. 1, 1974, pp.3–37.

Walker, F. A. and F. Sinclair, *North Clyde Estuary, An Illustrated Architectural Guide*, Edinburgh: Royal Incorporation of Architects in Scotland, 1992.

Wilson, E., 'The Invisible *Flâneur*', in Watson, S. and K. Gibson, eds, *Post Modern Cities and Spaces*, Oxford: Basil Blackwell, 1995.

Wolff, J., 'The Invisible *Flâneuse*: Women and the Literature of Modernity', *Feminine Sentences: Essays on Women and Culture*, Cambridge: Polity Press, 1990.

Index

Page references in **bold** type indicate illustrations.